They're Called the "Throwaways"

They're Called the "Throwaways"

Children in Special Education Using Artmaking for Social Change

Edited by

Christa Boske

BRILL SENSE

LEIDEN | BOSTON

The editor and publisher have done everything in their power to protect the privacy of the students and teachers who contributed to this book.

All chapters in this book have undergone peer review.

Library of Congress Cataloging-in-Publication Data

Names: Boske, Christa, editor.
Title: They're called the "throwaways" : children in special education using
 artmaking for social change / edited by Christa Boske.
Description: Leiden ; Boston : Brill Sense, [2019] | Includes bibliographical
 references
Identifiers: LCCN 2018039912 (print) | LCCN 2018044886 (ebook) | ISBN
 9789004383890 (E-book) | ISBN 9789004383876 (pbk. : alk. paper) | ISBN
 9789004383883 (hardback : alk. paper)
Subjects: LCSH: Special education--United States--Art. | Children with
 disabilities--Education--United States. | Children with social
 disabilities--Education--United States. | Art--Study and teaching--United
 States. | Art and society--United States. | Art therapy for youth. |
 Social justice.
Classification: LCC LC3970 (ebook) | LCC LC3970 .T54 2019 (print) | DDC
 371.9--dc23
LC record available at https://lccn.loc.gov/2018039912

Typeface for the Latin, Greek, and Cyrillic scripts: "Brill". See and download: brill.com/brill-typeface.

ISBN 978-90-04-38387-6 (paperback)
ISBN 978-90-04-38387-6 (hardback)
ISBN 978-90-04-38389-0 (e-book)

Copyright 2019 by Koninklijke Brill NV, Leiden, The Netherlands.
Koninklijke Brill NV incorporates the imprints Brill, Brill Hes & De Graaf, Brill Nijhoff, Brill Rodopi,
Brill Sense, Hotei Publishing, mentis Verlag, Verlag Ferdinand Schöningh and Wilhelm Fink Verlag.
All rights reserved. No part of this publication may be reproduced, translated, stored in a retrieval system,
or transmitted in any form or by any means, electronic, mechanical, photocopying, recording or otherwise,
without prior written permission from the publisher.
Authorization to photocopy items for internal or personal use is granted by Koninklijke Brill NV provided
that the appropriate fees are paid directly to The Copyright Clearance Center, 222 Rosewood Drive, Suite
910, Danvers, MA 01923, USA. Fees are subject to change.

This book is printed on acid-free paper and produced in a sustainable manner.

Advance Praise for
They're Called the "Throwaways"

"This is an inspiring book which re-establishes the primacy of the arts in enabling learners to understand their own identities and begin the long journey to self-hood. It is long overdue and will go a long way to creating a more balanced curriculum than the sole concentration on math and science."
– **Fenwick W. English, R. Wendell Eaves Senior Distinguished Professor of Educational Leadership, School of Education, University of North Carolina at Chapel Hill**

"Could this book be the *WAKE-UP call* that the field of educational administration has so desperately needed? In these inspirational, though often heartbreaking 'first-telling' stories by 'throwaway' children and their caring teachers and school leaders, we see the answers to leadership for social justice, if only we ourselves had the courage to stand up and shout. Intellectually, to see giants such as Elliot Eisner, Howard Gardner and especially Maxine Greene brought together by the author, Christa Boske, once again brings hope that we will find our way out from the quantitative prison of management theories which hold public education hostage under the guise of productivity and school improvement."
– **Ira Bogotch, Professor of Educational Leadership, Florida Atlantic University and co-editor (with Carolyn Shields) of the new** *International Handbook on Social (In)Justice and Educational Leadership*

"A phenomenal book for a time such as this and for students, teachers, staff, administrators, parents, professors, and community such as us. If we subscribe to the 'all children can learn' philosophy, then we must acknowledge that arts-based education is vital for children to succeed. This should be required reading in Schools and Colleges of Education across this country."
– **Judy A. Alston, Professor in the Department Doctoral Studies and Advanced Programs, Ashland University and author of** *School Leadership and Administration* **(9th edition)**

"In this beautifully crafted book, Christa Boske concludes that 'artmaking actively engag[es] children in developing a critical consciousness, and stronger sense of self.' All school leaders need to read this research and understand how to encourage and support teachers and community members in capturing the power of first-tellings."
– **Margaret Grogan, Professor, Dean of the College of Educational Studies, Chapman University and Effie H. Jones Humanitarian Award from the American Association of School Superintendents (AASA)**

"This text courageously affords children who have been marginalized to have not only voice but a demand that their humanity cannot be disregarded simply because of their learning differences. The alignment of leadership, social justice, the call for policy and practice reform and art making as sense making opens notions of educational leadership to new frontiers that have long needed to have men explored. Christa Boske dares to combine authors who challenge educators to transform their thinking regarding students with learning differences. Additionally, Boske requires readers to advocate for ways to diminish the minimizing of students' humanity because of intellectual challenges that have historically cast students in a negative light. The book demands that we search deeply to unearth ways to welcome the creativity of children as a means to give voice to their very being. It is a call and challenge for policy transformation through a critical leadership that is grounded in social justice, equity, and celebrating difference."
– **Michael Dantley, Professor, Dean of the College of Education, Health and Society, Miami University and Master Professor Award from the University Council for Educational Administration (UCEA)**

"Boske and her contributors have created a volume that is a poignant chorus of first-tellings of resilience and oppression. This is an excellent read for those engaged in the work of improving society through service to learners and their families, teachers, and school leaders. Aspiring educators and leaders in both educational policy and school administration would do well to absorb the *jaw dropping and profound stories* offered by some of the most vulnerable in our society. As readers we are given us no choice but to catch our breath mid-chapter to consider simultaneously the power of art beyond traditional understandings, and our responsibility to the everyday experiences of learners and educators. The magic of this effort is rooted in the elegant examination of the overlooked and obscured truths about the power of self-expression in the face of strife. I simply could not put it down."
– **Autumn Tooms Cyprès, Dean, University of Alabama-Birmingham and Graduate Studies, St. John's University and President, International Council of Professors of Educational Leadership**

"This book provides *tangible evidence* of the power of providing students on the margins with the tools to make their voices heard. We need to take the education of students with disabilities seriously in a wholistic, inclusive and enriching fashion and this work provides key insights into this essential work."
– **George Theoharis, Professor, Syracuse University and author of *The School Leaders Our Children Deserve: Seven Keys to Equity, Social Justice, and School Reform***

Many of us may skip past dedications in a book, because we are eager to get to the heart of what we are reading. I ask those who read this book to honor the inspirational voices of the children, teachers, and leaders who call upon us to live the imaginative possibilities that exist within each of us, to respond to our moral responsibility to create places in which all children may call home, and to see the beauty within all of our children. They are our hope, make us want to be our very best selves, and remind us of how much we still have to learn. No one, I mean no one, should ever be deemed a "throwaway."

∴

Contents

List of Figures XIII

1 Introduction: Artmaking as Sensemaking as a Portrait of Resilience
 for Children with Learning Differences 1
 Christa Boske

PART 1
Youth Voices

2 You Can't Get in My Shoe 41
 S

3 The Cage 55
 N

4 One of the Best (Because I Worked so Hard on This) 62
 C

5 "Acception" 69
 T

6 Princess 80
 A

7 The Flame of Anger 87
 L

8 I Want People to Listen 98
 J

9 Animal Land 106
 L

10 Helping Hands 111
 M

CONTENTS

11 Treat Women Like Flowers – They Are Gentle 116
 J

12 Magna Shoe 121
 P

13 Deep Blue 128
 L

14 Barricade 133
 A

15 My Story 141
 S

16 Freedom 149
 V

17 The Cycle #Dark Side 159
 W

18 I Look Fabulous 168
 A

19 Life Is Strange 171
 M

PART 2
Adult Voices

20 Born for Bred 179
 A

21 The Tension of Duality 183
 B

22 Diversity Is My Degree 188
 C

23 Adversity 193
 D

CONTENTS

24 The Sky Is the Limit 195
 E

25 They Lived Their Art 198
 F

26 The Children Touch My Heart 200
 G

27 Raw: The Thread That Connects Us 203
 H

28 Confronting Anxieties on a Small Scale 206
 I

29 Leading through Artmaking: Recognizing the Power of Arts-Based
 Approaches 211
 J

30 Developing My Approach to Working with Children 218
 K

31 The "Red R" Kid: Disrupting My Deficit-Laden Label 221
 B

32 Living the Dream 238
 M

33 Afterword: The Power of the Artmaking as Sensemaking 248
 Christa Boske

Figures

1.1	Social justice museum exhibit	28
2.1	My fortress	41
2.2	Thinking about my art	43
2.3	Hard as a rock	48
2.4	Symbolic of my life	49
2.5	I can see you for who you really are	51
2.6	It's hard for me to get close	51
3.1	Walk in my shoe	58
3.2	The cell	59
4.1	Art and comics	62
4.2	I am deadpool	63
4.3	I can relate to deadpool's life	64
4.4	The candle symbolizes hope for me	65
4.5	How could you leave me behind?	66
5.1	All should be welcome: Kids like me	70
5.2	Reflecting and understanding me	71
5.3	Learning and growing in my art	72
5.4	What does it mean to be different?	74
5.5	People actually cared about my art	74
5.6	Looking through the window of my door and what do you see?	75
5.7	The door, the lock, and the key	76
6.1	My life and school time line	80
6.2	All my feelings	81
6.3	Love	82
6.4	K's face is made of hearts	83
6.5	Show me you love me	84
6.6	K, my princess	84
6.7	I need to feel safe and loved to learn	85
7.1	This girl is on fire	88
7.2	This girl is still on fire	89
7.3	What I need and want to learn and grow	90
7.4	Looking deep inside the flame	92
7.5	My heart wants this	93
7.6	People who love me give me advice	95
8.1	I put it all out there for people to see	99
8.2	I want people to listen	101
8.3	I am angry and I am loved	102
8.4	Don't hurt me	103

8.5	My likes	103
8.6	I want love!	104
9.1	The fence	106
9.2	I do not trust people. I trust horses	107
9.3	I am not ready to trust people. I trust horses	108
9.4	Horses mean like people	109
10.1	My art is all about me	112
10.2	In my art I am more than aggravating	113
11.1	My art calmed me	117
11.2	My best friend	118
11.3	I need a place to call home	119
12.1	Magna: A first for me	122
12.2	Volcano of anger	124
12.3	I miss him	125
13.1	I don't smile. I'm not a good liar	129
13.2	My candle of hope at the top	131
14.1	The barricade	134
14.2	Unwelcomed in schools	137
14.3	Magnifying the real me	138
14.4	They surrounded kids like me	138
14.5	Caution	139
15.1	My story matters	142
15.2	My teachers don't know what matters to me	144
15.3	This is the person who hurt me	146
15.4	Teachers and principals need to listen and love us	147
16.1	All I want is a family and home to call my own	149
16.2	Weaving lyrics and life	150
16.3	My story weave	151
16.4	The family I want and need	152
16.5	Two sides	154
16.6	The outside is real	154
16.7	My two halves split down the middle	155
16.8	I want a family to have dinner with	157
17.1	My art	160
17.2	Telling my story through art	161
17.3	Anxiety surrounds me	164
17.4	What is inside of me	166
18.1	I like my art	168
18.2	I did not fit in	169
31.1	My artmaking	229
31.2	A young child	231

FIGURES XV

31.3 The system told me I didn't matter 232
31.4 I will overcome 233
31.5 I am not a puppet on string 234
31.6 Limitless 235

CHAPTER 1

Introduction: Artmaking as Sensemaking as a Portrait of Resilience for Children with Learning Differences

Christa Boske

The arts played a vital role for every author in this book. And in most cases, the arts transformed how they understood themselves, their sense of self, sense of self to others, and in some cases, their sense of self in relation to their salvation. For these young authors, who were identified as children in need of special education services, the pursuit of integrating the arts into their daily lives played a critical role in their ways of knowing as learners. All of the children were identified by teachers, school leaders, and staff throughout most of their academic career as "sped students." They were also informed they were "incapable of learning."

When these same children were afforded opportunities to engage in artmaking as sensemaking in a leading for social justice art exhibit, they were at first, quite shy, but after providing them with spaces to critically think about the implications of their work, the children were excited about the possibilities. Throughout the artmaking process, they came to understand the power of imagination and the role their new understandings played in their capacity to understand the lived experiences of self and others.

As the students engaged in artmaking, they shared the extent their imaginations came alive and the role artmaking played in promoting their new understandings and responses to the world in which they lived. Every child duly noted the arts fully engaged them in developing their sense of self and emotionally connected them to a renewed sense of the world. Before actively participating in artmaking focused on social justice and equity-oriented issues, the students often reflected upon their prior schooling experiences and shared daily conditions in which they identified as loners at heart. All of the children expressed feeling ostracized by their school communities, society, neighbors, peers, and/ or families. Many shared they were abused within the foster care system, became wards of the state, and struggled to find acceptance in school. They often discussed the discrimination they faced as children with exceptionalities in special education (i.e., due to social, emotional, cognitive, and/or physical learning differences).

© KONINKLIJKE BRILL NV, LEIDEN, 2019 | DOI:10.1163/9789004383890_001

As the school community engaged in artmaking as sensemaking, the title of this book evolved as children shared their perceptions of self within K-12 schools, authors' lived experiences, and school community insights. The children's lived experiences are at the heart of this book: *The Throwaways*. The title emerged after several months of conversation with teachers, staff, and children. I remember engaging in conversation with a special education teacher. We discussed the power of children's first-tellings and the extent these understandings influenced how they made meaning from their lived experiences; and in turn, we recognized how these lived experiences not only impacted students' perceptions of self, but directly influenced their artmaking. One teacher noted, with tears in her eyes, "Christa, our kids are the throwaways...no one wanted them...no one believed them...so many of our children have been thrown unwillingly into a system that no longer validates their existence...it's shameful and unacceptable...they think of themselves as throwaways." From there, we engaged in dialogue with the children about commonalities among their lived experiences in school. Everyone, including teachers, staff, children and school leaders, agreed the term "throwaways" often reflected the lived realities of children receiving special education services.

A myriad of school-community members share their first-tellings and experiences with artmaking as a means of interrupting deficit-laden oppressive beliefs, practices, and policies they contend with on a daily basis. Their hope: the oppressive messages, practices, and policies they experienced throughout their childhood as children receiving special education services will be eliminated after teachers, school leaders, and other decision-makers read this book. Authors want school communities to understand the vital role arts-based practices play in an individual's capacity to develop critical consciousness and act upon new understandings to authentically serve children with exceptionalities. Together, authors call upon school communities, as well as those who prepare teacher and school leaders, to understand the power of artmaking as sensemaking. This school community identifies artmaking as one means of engaging in transformative social justice and equity-oriented work. Throughout these first-tellings, authors share the extent this transformative work critically impacted their lives. Artmaking as sensemaking afforded spaces that fostered self-reflection, increased critical consciousness, activism, self-advocacy, and hope.

One of the students insisted the dialogue below be embedded in the first chapter as an example of critical conversations in which a young person discusses the power of translating ways of knowing into artmaking:

> *Student:* "Did you know I was a bad kid? I am known as a hardass. Does that bother you?"

INTRODUCTION 3

Me:	"That's interesting…I haven't seen that side of you and I have been working with you for over six months." [The student smiles.]
Student:	"You know I go to this school, right? It's for bad kids like me."
Me:	"Can you tell me more about that?"
Student:	"I am too old to go to a normal school and I don't even think I will ever graduate because I am too slow. I don't learn like other kids."
Me:	"What does that mean?"
Student:	"I am hard on the outside because I have been through too much for any kid to handle. It's not right to make kids go through what I have gone through…That's why I chose to make my art out of the toughest boot…it's tough like me…it can withstand anything…especially dangerous weather like snow or rain or floods or mud…this boot is just like me, but I am harder than even the boot…this is why I wanted to cover the boot with rocks…there is no way anyone is getting in…"
Me:	Can you tell me how you are a bad kid or even a hardass?
Student:	"Well, I am…I mean, I cuss people out and go off on them…"
Me:	"But I haven't seen you do that with me…or your teachers…or the staff members…you have demonstrated more courage than children I have met in other schools…more insight than adults who are in college…" [The student smiles.]
Student:	"No…that's not true…"
Me:	"But it is…you provided me the opportunity to work with you and you didn't have to do that…you have looked inside yourself and made connections so many adults do not know how to do…"
Student:	"Really?"
Me:	"Yes, really."
Students:	"But I have my walls, Miss Christa…and I don't let them down hardly at all…maybe a brick every now and then…it's like I have a stone wall…and I use them to keep people out…that's why I'm putting stones on my boot…if people are going to walk in my shoes and understand what it's like to be me, then I need to cover this boot with some heavy rocks…."
Me:	"Is it possible that although you feel the need to protect yourself that you also have demonstrated courage to let people in a little at a time?" [Student smiles.]

Student:	"I haven't thought about it like that before...I didn't realize I did that [Student smiles] ...I haven't cussed you out though... you're right..."
Me:	"It's not about being right or wrong...I am just wondering if there is a need to cover your art entirely with rocks, because it seems as though you may be slowly let some people in...just a little..."
Student:	"I think I should cover my art, my boot with rocks, but I think I want to stop right about here [student points to mid-way up the boot] ...and then I think I want to put moss on it...you know...to soften it up...cause I am growing, you know" [Student starts to swell with tears in her eyes.]
Me:	"What does that mean to you?"
Student:	"I think the moss symbolizes I am growing... [student wipes a tear from her eye] ...I am not as hard as I thought I was...I have been hurt...I mean really hurt...I can't talk about it... but I am going to write a book one day about it someday... bad things happened to me, Miss Christa, and nobody knew about it... nobody thought about why I was acting the way I was in school...I mean nobody...not one teacher...not the principal... everyone just turned their backs and acted like I wasn't really there and I was just an angry troubled badass kid...but I wasn't all bad...I wasn't born that way...I just needed someone to care...to know what was goin' on in my life...how different it would have been Miss Christa if someone would have just noticed me...I got to put this in my shoe...I got to make sure teachers know...and even the principal know what to do...they just don't I think...I think I should put a gate on top of my art... to symbolize it's closed, but maybe one day it will be open... but you have to have the key to open it...and those keys are earned..."
Me:	"How do you earn a key?"
Student:	"Let's talk about that...I want to make it like steps...you know... like you have to earn one key and work your way up...if you earn all of the keys...then maybe you can unlock that gate...it's not going to be easy...probably impossible because I have had such a rough life...and I am not very smart..."

These conversations played a crucial role with students understanding how their lived experiences and meaning-making shaped their ways of knowing

INTRODUCTION 5

and responding to the world. The process of understanding self and self in relation to others involved trust, care, commitment, and nurturance. It was an honor and privilege to work with this school community, especially the students who mustered the courage to share their lived experiences as children with learning differences in K-12 public schools. Their commitment to this work was inspiring. Students committed themselves to creating art aligned with their lived experiences in oppressive special educational systems. And, as a result of their artmaking, they decided to call upon teachers and school leaders to deepen their understanding of what it means to be serve children with exceptionalities versus children identified "throwaways."

I was humbled throughout my experiences working with this school community. Authors shared their first-tellings regarding special education services, especially, negative perceptions often aligned with deficit-laden label. Some of these oppressive terms included, but were not limited to "dumb," "lazy," "crazy," "prison material," "reject," "waste of space," and of course, "throwaway." Throughout the students' artmaking, critical dialogue played a significant role in providing them with opportunities to reflect upon their understandings of self and translate their meaning-making into artmaking. In students' dialogue with teachers, staff, school leaders, and peers, they emphasized the extent their artmaking deepened their ways of knowing about themselves, relationships with others, and relationships with their school communities (see Apple, 1993). For these authors, the way in which they learned mattered. Students utilized artmaking as a creative reflective process to better understand themselves as learners as well in relation to one another. They reflected on the nuances and surprises within their meaning-making. Students' new understandings were not only self-identified as accomplishments, but became the foundation of their work (see Eisner, 2008).

In order to contextualize the authors' lived experiences, it is important to note all of the children in this book attended a day/residential school. They often struggled with believing they could achieve success in school (i.e., socially, emotionally, and academically). Many of the children were expelled from traditional K-12 public schools for physical/verbal assault, self-harm, bullying, and academic failure. Often times, these young authors were transferred to this school from their neighborhood schools. Some traveled between 20 to 120 miles back and forth to school; and for others, they were mandated to live on campus, which was as far as 200 miles from their primary residence. Most of the children who attended the school identified as Children of Color (i.e., Black), male, wards of the state, juvenile delinquents, and received special education services for the majority of their academic lives.

Their experiences in school, especially in receiving special education services, often led to feeling isolated and alone. Adolescents shared how often

they were "made fun of for being a sped kid," how often they ate lunch alone, played at recess by themselves, and sat by themselves in class. After children reflected on the myriad of their K-12 schooling experiences in special education, no one could identify anyone they called a "friend." Throughout the process of translating their lived experiences into artmaking, a common theme emerged. Children "wished" they could "make one friend." Children held this "wish" close to their hearts. They wanted someone to "care about them" or "to have lunch with" or "to talk to." Overall, the children wanted someone to care deeply, to worry, to support, to cheer on, and to love them. They did not feel connected to teachers, school leaders, staff, and/or their families; therefore, they did not trust anyone. Children shared a myriad of experiences in which they were humiliated by teachers, ostracized by their peers, earned failing grades, ate lunch alone or chose not to eat in order to avoid continued social isolation, suspended or "kicked out" of school, and internalized deficit-laden self-perceptions aligned with terminology such as "failures," "misfits," "retarded," and/ or "something wrong with them."

As they made meaning of their educational experiences, their artmaking and first-tellings spoke to their resilence. They often asked why teachers and school leaders did not seem to understand how to work with children who received special education services. They wanted to know: "Do teachers have to learn how to love kids like us before they get to teach? Do principals just get to have their jobs if they don't love kids?" The children discovered extant literature in educational leadership has largely ignored the relevance of children receiving special education services in schools, especially when considering the influence of racial, cultural, ethnic, and competencies as they relate to the resilience and strengths of youth with learning differences. Youth did not understand how teachers and school leaders in training could not support the learning of all children or understand the extent a "good school" considers the environment in which they learn and grow.

Authors in this book recognize gaps in educational research regarding the lived experiences of children in special education, especially children facing mental illness, homelessness, abuse, prison, abandonment, social/emotional isolation, failing grades, and other chronic trauma. Youth assert teachers, staff, and school leaders should be trained to acknowledge and build upon student strengths versus focusing on deficit-laden beliefs and attitudes that often pigeon-hole children and their capacity to succeed. Authors recognize the need for high student expectations, and most importantly, the need for authentic care throughout their academic careers. They contend teachers and school leaders should deepen their ways of knowing regarding protective components of resilience. Authors want readers to understand their complex lived

INTRODUCTION 7

experiences. They are involuntary members of marginalized communities due to their exceptionalities, race, gender, sexual orientation, family dynamics, mental health, and other differences. Their intimate first-tellings throughout this book are a wake-up call to anyone interested in education. Their courageous artmaking provides insights to the cultural oppression they face as children receiving special education services; and for most of the authors, they expose subtle and pervasive forms of discrimination throughout K-12 public schooling.

Authors (i.e., children, teachers, and school leaders) contend there is a need to recognize, honor, and respond to children's resilience and strengths to further develop and promote a strong sense of self in all learners. Youth expressed the extent artmaking afforded them with spaces to critically think about the impact of being subjected to multiple mental health/cognitive diagnoses, discriminatory practices, and deficit-laden policies that seemed to limit their schooling experiences. For these children, the interplay of their first-tellings, artmaking, and meaning-making play a vital role in developing new ways of knowing, being, and responding to their world. Their new ways of knowing were often experienced through acknowledging their emotions. Adolescents learned the significance of emotional self-regulation as they couragous navigated the impact their lived experiences had on their sense of self. Youth utilized these catalysts throughout their artmaking to navigate and address their lived realities (see Geertz, 1983). Together, authors call upon school community decision-makers to provide children with exceptionalities with spaces to utilize authentic art-pervasive curricula. This arts-based curricula engages children in meaningful learning. Youth assert that artmaking inspired them to express themselves, reflect on the impact of their lived experiences in their development of self, and navigate their new ways of knowing and being to contribute to a world beyond their classroom walls. Their first-tellings provide opportunities for school leaders, educators, and other decision-makers to recognize the extent artmaking as sensemaking impacts students' daily lives, sense of self as learners, and relation of self to others.

Authors contend artmaking as sensemaking has the capacity to liberate traditionally silenced voices, perspectives, and deficit-laden understandings. Their first-tellings highlight students' protective competencies, strengths, and insights they assert have largely been ignored. Children hope their artmaking provides the next generation of teachers, school leaders, and policymakers with a lens to understand the significance of artmaking as sensemaking. They stress that it was artmaking that encouraged them to develop themselves as social justice and equity-oriented learners, and in presenting this work through this book, as activists for meaningful systemic change. Authors stress

not only the need for the integration of these arts-based approaches in K-12 schools, but also believe this transformative process provided them with hope. This hope emerged from understanding how their meaning-making shaped their perceptions of self. Their capacity to share their first-tellings in meaningful ways through form and feeling inspired them to engage and promote social justice and equity-oriented work. Together, they present insights to transform curricula, school policies, and practices that embrace exceptionalities. Throughout their narratives, authors call upon teachers, school leaders, and community members to not only acknowledge children's lived realities, but to realize the impact these realities play in the development of a child's mind, body, and spirit.

Authors urge teachers and school leaders to acknowledge the toxic, abusive, and deficit-laden language/policies/practices they endured. Adolescents were often "at-risk" of being bullied and ostracized because they received special education services. Authors share their experiences of being labeled "at-risk" by teachers and school leaders; however, authors recognize they were actually "at-risk" because they were exposed to dysfunctional student-teacher/school leader-student interactions, oppressive practices/beliefs/attitudes, under-resourced schools, negative peer interactions, bullying, and family disruptions. Youth shared schooling experiences ranging from low expectations to institutional barriers to social and physical isolation to ability/family/cultural profiling. Children also disclose how often they were subjected to excessive oppressive institutional reactivity. These experiences emerged in part due to negative experiences with teachers, school leaders, peers, and police officers. Throughout authors' first-tellings, children draw upon their personal protective factors, capacity to regulate their emotions, and ability to utilize these protective components of resilience to navigate their world. Their artmaking suggests school communities need to deepen their understanding of children's strengths, protective components of resilience among children with exceptionalities, cultural integrity, and unique experiences as "sped ed" students in an oppressive system.

Authors contend there is a need to understand how their feelings and perceptions of self and lived experiences influence the extent their environment contributes to risks and protective factors. For example, one individual focused on feeling abandoned in school due to the student's gender expression. The adolescent said, "So many kids just didn't know what to do with me in school. I was in special education and people made fun of me...not only because of that but I also looked like a boy because of how I dressed and talked and walked... and it was hard...I don't know about my gender...I feel like me on the inside but people treat me like I am weird or something because I am a girl but I don't

INTRODUCTION 9

look like one...and then I am not with my real family...I am lost in school and at home...I just couldn't fit in anywhere because I was me...and my art helped me think about all of this and how hard it was to be me sometimes and how many things I deal with every day just to survive...and then I am expected to learn in school with all of this on my mind?" The student continued emphasizing, "I am much more than what teachers see. I am not just a kid in special education who can't learn anything. I was born a girl and feel like a boy. I am adopted. I am troubled. I have been told I am at risk, but have no idea what this means. I have a family. I have anxiety. I am OCD, have depression, and anxiety. I am mixed. I was in juvy (juvee) [adolescent detention center]. I was taken out of my family because of my anger. I am lonely. I want teachers to know there was and is so much more to me, but they don't take the time to see it...but my art told them. I wonder if they see it."

It is important for those who work with children receiving special education services to remember the influence of children's multiple identities on their sense of self. The way in which school communities frame these lived experiences may influence not only a child's understanding of self and well-being, but how students understand themselves as part of a system in which they are identified as "troubled at-risk" youth. With this in mind, I refer to Lerner, Dowling, and Anderson's (2003) portrait of resilience for Black youth to frame this discussion. The lens promotes the integration of culturally responsive practices and policies. The framework encourages future scholarship in this area of interest, especially in considering the role artmaking as sensemaking may play in problematizing the role of resilience in students their developing ways of knowing and responding to the world.

Throughout this artmaking as sensemaking process, youth utilized the following: (1) critical mindedness which helped students protect themselves against discrimination and provided spaces to deepen their understanding of existing social conditions; (2) active engagement with artmaking encouraged youth to proactively impact their home, school, and community environments; (3) each student understood artmaking as sensemaking as a means to share emotional, social, and physical situational demands across multiple experiences in diverse contexts; (4) the process created spaces for adolescents to build social bonds among self, others, and their community. Artmaking as sensemaking also encouraged them to reflect on their interdependence and collective well-being. The process inspired youth to engage in artmaking for social action/ social duty as a means of promoting culturally responsive practices and policies across school communities for children receiving special education services.

Artmaking as sensemaking placed youth in positions of being "at promise" versus deficit-laden school communities labeling them as "at-risk." Therefore,

within this process, youth were identified as intellectual activists for the first time in their academic careers. They internalized these new identities through their arts-based meaning-making process and self-identified as "scholars" and "social justice activists." Their artmaking interrupted and eliminated deficit-laden perceptions of self and created new, highly charged understandings of self, self in relation to others, and responses toward oneself.

The arts-based approach charted new territories of understanding. The struggle engaged students, teachers, staff, and school leaders in deepening their critical consciousness and insights the personal and often tragic experiences of children in special education. As students engaged in their new ways of knowing and responding, so too did the school community-at-large. As youth grew more courageous, taking risks, and sharing their narratives through artmaking, teacher-student relationships, as well as student-student relationships underwent a transformation. Teachers afforded adolescents with spaces to share their understandings in small groups as well as within the entire school community. The school witnessed student behaviors shifting from hostile and aggressive to empathic and nurturing. Disciplinary data suggested student infractions were significantly decreasing, affording students more time in class to learn content material and build upon their interpersonal interactions. Students actively engaged in therapeutic discussions utilizing their artmaking and first-tellings as bridges to foster meaningful relationships within the school community. Teachers witnessed students not only engaging in class discussions, but applying their lived experiences to the curricula. They engaged in self-regulated behaviors centered on sharing their emotions, social/emotional/intellectual risk-taking in school, and ways in which they were overcoming challenges, which prior to their artmaking, were identified as insurmountable barriers. This arts-based pedagogy reflected ways in which youth made meaning from their experiences and understood the extent these understandings shaped their ways of knowing and being. The school community deemed artmaking as sensemaking as a personal and systemic transformative experience for learners. They stressed the extent children's minds, hearts, and spirits were actively engaged in meaningful struggles and the extent the children believed they had the capacity to overcome emotional, academic, social, physical, and familial challenges. Their insights translated their lived experiences into artmaking and created spaces that encouraged and inspired youth to emerge as agents for meaningful and sustainable change. Teachers observed students engaging in service-oriented work as well as articulating injustices facing marginalized populations. As students became more passionate about serving the needs of all students, they wanted to promote inclusive policies and practices. Adolescents asserted these changes should be made within K-12 schools as well

INTRODUCTION

as teacher and school leadership programs to provide these aspiring educators opportunities to engage in meaningful work with children, but especially children in special education.

Youth critically examined injustices they faced within special education, including experiences their peers, families, teachers, staff, school leaders, and other decision-makers who played a role in K-12 schooling. Their examination of oppressive educational systems encouraged them to inquire about the lived experiences of their peers as well as others serving this institution. These authentic learning spaces created a participatory democratic environment (see Ellsworth, 2005). Throughout this process, youth thrived as scholars, activists, and leaders for social justice. Their artmaking considered multiple levels of influence in understanding their sense of self, adaptive responses to their lived experiences, and long-term outcomes. Children actively engaged in deepening their understanding of self, including: (1) identity (i.e., race, class, learning differences, religion/beliefs/faith, native language, geographic location, gender, gender expression, sexual orientation, family structure, family membership, and other cultural differences) (see McLoyd, 1998); (2) emotional development (i.e., coping, empathic responses), (3) social development (i.e., interactions with others and capacity to make and sustain friendships), (4) cognitive development (i.e., understanding the influence of lived experiences on their ways of knowing and responding to the world), and (5) physical health (i.e., the impact of emotions and physical resources). All of these understandings influenced how youth made sense of their world and the extent these new understandings shaped their new identities as social justice and equity-oriented leaders.

Their positive and powerful self-identities also played an essential role in understanding the personal as well as school-wide transformation. As youth engaged in their artmaking, they continued to develop a positive sense of self within multiple communities (i.e., school, classroom, family, community). These new understandings were in drastic contrast to their prior lived experiences in which they were often devalued. Authors shared negative assumptions (i.e., "you can't learn," "you're retarded," "you will never make it"), deficit-laden stereotypes (i.e., "if you can work with 'those' kids then you can teach anyone," "they can't learn because they are sped ed kids"), and perceptions of teachers and school leaders (i.e., "they only work here because they get paid," "they couldn't find another job, so they are stuck here with us"). They often assumed these experts knew what was best for them, their capacity to learn and grow, and their ability to love others.

Throughout their written narratives and artmaking, these students often associated their self-worth with the deficit-laden beliefs and attitudes in

receiving special education services. Their negative identities often included low academic achievement, high dropout rates, poor attendance, involvement in crime, gang association, violent behaviors, low self-esteem, and limited interpersonal skills. Students deepened their understandings regarding the intersection of multiple identities (i.e., ability, race, class, family membership). Their understandings of self were embedded throughout their school communities often leaving children feeling depressed, isolated, and worthless. However, as youth internalized a new sense of self by increasing their critical consciousness, their new sense of self acted as a protective factor. They began to understand the extent their lived experiences shaped their identity as well as responses to their identity.

School leaders, teachers, and staff, who played an instrumental role in developing this educational mileau, also played an instrumental role in transmitting the values, beliefs, and ideas regarding artmaking as sensemaking. The school community's support was essential to promoting artmaking as sensemaking throughout the students' daily experiences. Staff, teachers, case managers, and school leaders deemed artmaking as essential to deepening the children's ways of knowing and responding to the world. School community members witnessed students internalizing their new sense of self and responding to their new sense of self by utilizing new ways of knowing to promote humanity. Students inquired about other students' lives. They volunteered to listen, support, and advise their peers. Students encouraged children to take risks and enhance their understanding of self to grow, learn, and develop into the young social justice and equity-oriented leaders they *now* aspired to be. Students also welcomed intergenerational involvement from school community members who often mediated negative messages from prior educators, school leaders, family members, and community members. The artmaking and narratives that accompanied their work encouraged those interested in this line of inquiry to consider exploring the influence artmaking plays in establishing new identities and the extent these new identities may play in interrupting oppressive elements within school communities and communities-at-large, especially for children with learning differences.

Teachers, staff, and school leaders witnessed students' capacities in developing increased emotional regulation. They recognized students' responses toward engaging in conflict. Students seemed to engage in empathic versus aggressive verbal and physical responses. Not only did students change interactions among staff, teachers, school leaders, and their peers, but students changed their self-aggressive behaviors. Adults saw a significant decrease in self-harm (i.e., self-harm talk, cutting, hitting, banging body parts); and

INTRODUCTION 13

in many cases, these same behavior changes were also evident in children's homes and residential facilities. Noting these self-regulatory behavior changes is significant, because students often engaged in aggressive behaviors toward self and others prior to engaging in artmaking. This is particularly salient knowing how often these youth were judged as excessively reactionary, aggressive, and hostile.

Youth utilized their artmaking and one-on-one support throughout the artmaking process to deepen their critical mindedness, especially in tense settings. They exhibited increased flexibility across diverse contexts deemed critical for emotional regulation (i.e., group therapy, individual therapy, academically challenging courses). All of the staff, teachers, case managers, and school leaders recognized an increase in students' positive social interactions. The collective culture and socialization throughout the artmaking process seemed to help youth buffer harmful forms of emotional expression. Students renewed meaningful relationships (i.e., teacher- student, student-staff, student-school leader, student-artmaking facilitator) to create effective emotional self-regulation. Their new ways of knowing and responding to their world became evident in their artmaking and capacity to reflect on the impact of their new reflective practices in understanding self as learner.

The Beginning: Drawing Meaning from Lived Experiences

We created spaces for children to think critically about the power of developing empathic responses. Youth were provided opportunities to dialogue about their relations with others as well as their own treatment of self. This reflective process was initiated to support students in understanding the purpose of the art production: understanding the power of empathy and its relationship to social justice-oriented work. We afforded youth with opportunities to discuss children wanting, needing, receiving, and giving love. Students, teachers, school leaders, and staff engaged in meaningful dialogue regarding the extent relationships play in developing a strong sense of self.

The principal, teachers, and myself asked students an overarching question with subsequent questions aligned with developing empathic responses. The overarching question was: "Who is your champion?" We asked children to watch a video on Ted Talks featuring Rita Pearson (see https://www.ted.com/talks/rita_pierson_every_kid_needs_a_champion), a retired elementary school teacher who suggests relationships are the foundation for all student learning, especially those who live on the margins.

After watching the short video, children were randomly divided into small groups. Teachers and staff were randomly assigned to groups. They facilitated the following questions:

1. What is a champion?
2. What does it mean to be someone's champion?
3. What messages did you take away from Ms. Pearson?
4. Do you know any champions?
5. If you had a champion in your life, what do you like about this person/ those champions? Do you have a champion in your life? If yes, who are/ is your champion(s)? If no, what does that mean to you? Describe this champion to the small group.
6. When a child is with a champion, how might/does it feel?
7. Do you believe every child should have a champion? Why or why not?

After responding to the questions, we came together as a school community. Students volunteered to share their responses. After discussing the role of champions in people's lives, one of their teachers shared his artmaking focused on the role champions played in his life as a child with learning differences. The teacher shared his first-tellings as a young Black male growing up in an impoverished community with a single parent and being identified as a child with learning differences. He walked children through the process of drawing meaning from his lived experiences and how he translated his ways of knowing into artmaking. He wanted the students to understand how often he felt ostracized by society because he was "different." The teacher provided the students with a deeper understanding of his lived experiences and how those lived experiences influenced his attitude, beliefs, and responses.

Students proceeded to ask the teacher questions such as: (1) "What was is it like to be Black?"; (2) "Were you the only Black kid at your school?"; (3) "Did kids make fun of you because you were different?"; (4) "Did you learn in a different classroom?"; (5) "Were you smart?"; (6) "Were you always as big as you are?," (7) "Did teachers make fun of you?"; (8) "Was it hard to share what happened to you?," (9) "How come I didn't know that about you?"; (10) "Did your teachers help you?"; (11) "Are you a real artist?" and other questions regarding the teacher's lived experiences.

The teacher and I walked the students through this artmaking and asked if they wanted to participate in their own artmaking. Every child wanted to participate. They were informed their art would be exhibited at an art museum. Children expressed their fear of engaging in artmaking and "not being good enough" or "good artists." We reassured them there were no "right or wrong ways of engaging in artmaking" and proceeded to share several examples of artmaking from prior leading for social justice exhibits. All of the students

INTRODUCTION 15

decided they wanted to participate in the exhibit focused on developing empathy for marginalized populations.

I scheduled small group conversations with teachers and students. Throughout these discussions, we further examined individualized and large group responses to questions regarding the extent children needing champions. After sharing large and small group responses with students, I scheduled individual sessions with students. They were each afforded opportunities to reflect on ways they drew meaning from relationships they encountered in school, at home, and within their community.

All of the children expressed frustration, disappointment, and sadness when discussing their relationships with school communities. Often times, the children were ostracized for "being different," "stupid," "retarded," "weird," "freaks," or "dumb." Children stressed how often these labels determined the extent school community members would engage with them.

Together, we problematized the word empathy and discussed the extent champions demonstrate empathy towards others. After these conversations, students shared how they understood who they were, how they became the person they were today, how others perceived them, and what their future held. An underlying theme throughout their conversations centered on the development of cognitive skills: stressing the need for high expectations, but often experiencing low expectations in school and in the community. Students recognized the extent they lived in a culturally conscious society that often oppressed versus uplifting children who received special education services. Students often spoke of feeling vulnerable, which often led discussions regarding injustices they faced. Students examined the impact of these hardships on their development of self and understood the need to develop critical thinking skills, which they believed were only encouraged for "normal kids."

We discussed the extent these characteristics operated as protective factors. For example, children examined how these protective factors often influenced their choice of activities or the amount of effort they put into a relationship or how they worked toward completing a goal or the level of persistence for achieving a goal. Youth concluded self-efficacy played an important role in understanding how to develop a strong sense of self, embrace their identities, and utilize their adaptive cognitive functioning.

Many of the adolescents identified as wards of the state, which means their families were no longer legally responsible for their welfare. In other words, the state became their legal guardian and was responsible for ensuring they received shelter, schooling, transportation, medical attention, counseling, and other services aligned with their overall health. Children expressed valuing adults in their lives who shared similar values, attitudes, and actions

aligning with developing meaningful, nurturing, and caring relationships. Many spoke of wanting "more structure," "more rules," "people who want more for me," and "people who will be there no matter what." Having a sense of belonging with adults, especially if they were wards of the state, played a significant role in making sense of their lived experiences. Although children often expressed wanting adults in their lives who nurtured and cared for them, the children often remained emotionally and socially distant from these adults. They were often fearful of abandonment, rejection, isolation, and criticism.

As the children engaged in their day-to-day activities in school, they recognized how often they experienced high levels of stress, anxiety, anger, and sadness. They felt disconnected from their school communities. None of the children identified their peers as their friends. They did not have someone with whom they trusted or confided. Many students shared that their teachers and school leaders identified them as "at-risk." One student exclaimed, "At-risk from what? From them, of course, because they don't want us around and think we are nothing."

Teachers and school leaders' discriminatory attitudes and relationships often posed a risk for these children. When teachers, staff, and school leaders demonstrated or expressed authentic concern for their well-being, all of the students recognized they in turn, wanted to form meaningful relationships with these adults, which improved their schooling experiences.

Students emphasized the role peer groups, staff members, teachers, case managers, and school leaders played in providing support throughout the artmaking as sensemaking process. Youth shifted from individualistic and isolated behaviors to communal orientations. These shifts included sharing personal information with school community members. Youth shared their artmaking, engaged in critical conversation regarding their ways of knowing and being, and engaged in behaviors to encourage communal activities (i.e., group discussions, posing questions, offering insights). Below is an example of a middle school student's insights. The student requested his narratives be included in the introduction and discusses, for the first time, someone who mattered to him and why that relationship positively impacted his life and sense of self.

> My champion is Ms. F and my grandpa. I love Ms. F...when I am frustrated...when I need some help with my anger...I change my attitude and try to keep her happy...I try to stay good to be in her class as long as I can... she is important to me...I try to build trust with her...I even love her more than I trust her...I live here...did you know that?

INTRODUCTION 17

Next, the student explained his current situation and why he chose the champions he did by sharing some of his childhood experiences with his biological family:

> I have lived here at this school for eight months, almost nine. I lived in foster care before this. I was in foster care a couple of months. They moved me away to another city. Before foster care I was with my mom and step dad...they started beating me and throwing things at me and hitting me with extension cords and throwing me around up and down steps...lately they have been trying to get ahold of me so they can cuss me out...I don't want to talk with them...I don't trust them...I went to school and they saw bruises on me and told me I had to tell the truth...I didn't know what to say. I was scared. I don't think they really cared. It wasn't like their family was going to change.

The student began to further discuss his efforts to think empathically after sharing the realities he was living in his home. He shared deep concern for his siblings, because he was the oldest:

> After I spoke to someone there, I told them to get my brothers and sisters out too...they were being hurt...you know, you can't just think of yourself...you have to think of other people too...

After he discussed his family situation and events impacting his residency and being identified as a foster child, the student noted how the artmaking process was creating a community in which students were beginning to know one another in different ways, as a collective:

> ...did you know I am learning this has happened to so many of us here... I didn't know...and now that I know...I showed my abstract to some people in my class and my teachers...I never did that before...they all said I did a great job...how brave I was for sharing...how much courage it took to tell someone what was going on...and how proud they were that I looked out for my brothers and sisters...I didn't know they felt that way...and I didn't know so many kids here went through that too...it brought us closer...I showed them my abstract and my shoe [artmaking] and we just started sharing...

In addition to sharing his artmaking and first-tellings with his peers, the process afforded spaces for him to deepen his understanding of self and internalize

these new ways of being. As a result, the student felt empowered to reflect on his lived experiences, share his new understandings, and engage in social justice-oriented ways. Artmaking created unexpected opportunities in which he felt encouraged to utilize his new insights to make changes in his world:

> well...I think I need to do something with my art...and I also know I need to work on myself...I have a lot of work to do because I am very angry...I am angry all the time...I need to learn how to control it...I don't know how...

The student continued to engage in his artmaking and utilized the process to examine the extent the "telling" of his bruises impacted his sense of self:

> ...but I wanted you to know so, ever since then, when someone saw my bruises at school, we have been separated...six children total...one is with their dad...the other five are in foster care...and my little brother, well, he went with his dad....and then my new born baby sister and two year old sister and five year old brother are in foster care together....I was separated from all of them...I am so lonely...I don't get to see them, ever...I don't know why I was separated from them...I saw a couple of them 3–4 weeks ago...when I couldn't see my family, I kept threatening to hurt myself....

As the student continued to engage in his artmaking, he reflected on the impact exclusive education played in forming his sense of self and how being labeled as a "sped kid" influenced his life:

> When I did this art, I am realizing I need to be nicer to myself...I have been through a lot and none of my teachers knew anything about it... they always thought I was just a bad kid...I was no good...and no one wanted to hang out with me or be my friend...I was in that special class and everyone made fun of me...I had no friends and no one to talk to...I never did...I was on my own...and my shoe [artmaking] tells my story...it stands all by itself without the other shoe...it's not a pair...it's alone, like me...I am all that I've got and I need to take care of it...

He continued to describe the impact of attending a "special" school and his feelings of being powerless and out of control:

> I didn't have a choice to be beaten...I just was...and I didn't get to decide where I wanted to live...my county worker put me here...everything gets

INTRODUCTION 19

decided for me...I don't get a say in anything, just told what to do, who to
talk to, and what not to do...I get in trouble a lot...I don't have a say in any-
thing...seeing my new family...nothing...I have to prove that I can handle
being in a family... I have to prove I can leave this school, but I will just
end up in another class like this...the one for kids like me...the ones that
nobody wants around...but when I do this art...I feel I can do anything...
I'm free, Miss Christa...

Upon reflecting on the possible outcomes of attending this school and work-
ing his way through the program, the student made an announcement while
working on his artmaking:

I saw my foster family yesterday and tomorrow I am going overnight with
them...I can't wait....They have kids, but they are all grown...I love them...
I love that they help me out when I need help and give me shelter and
clothes and feed me...I love how they always give me respect...they don't
treat me with respect if I don't respect them...they use words like "no"
when I am disrespectful...I might be going back with them at the end
of this month or before or after. I'm going to go to another place...I love
that school...eventually I want to get back to a regular school...I miss my
old school...I miss learning like what my level was...I miss being with my
other family...I miss going through the woods and going down the path...
I miss like learning together and being happy....

As he edited his art abstract and considered how he would translate his lived
experiences into artmaking, he stressed:

I learned now I have people to talk to...I shared my abstract with so
many people...people I never talked to before, but when I did, they told
me they didn't think I could ever do this...I didn't think I could either... I
was scared at first, cause you know, I never did anything like this before
and thought I would mess it up like I do everything else, but you told me
I couldn't mess it up because it was about my life...and it is...my case
worker, my county worker, Miss A, Miss B, and Miss C, Miss D , Miss E,
my grandpa and grandpa, and my brothers and sisters are so proud of
me, Miss Christa. I am an artist. I never went to a museum before...and
look, I told them my art and my story will be in a museum so people can
learn from me...they need to know why it's important to know kids like
me...really know us...teachers have no clue what's going on...they really
don't...we kids need someone we can trust...I have that here...and did

you know my grandma and grandpa hate my mom and dad because they are always putting stuff on me and hurt me. I am the oldest one and all I had to do was tell sooner and maybe my mom would have done something sooner and we could have done something and this would have been different....I took care of my brothers and sisters....I have been going in and out of foster care 4 or 5 times....my sisters and brothers were taken too....I should have told someone it was happening a long time ago...I was scared that if I told someone at school, I didn't think they would believe me and then I would have gotten beaten more when I got home.

The student explored what he wanted teachers and school leaders to rethink how they served children in special education. He emphasized relationships matter, especially relationships with adults in school:

I want teachers and principals to know they need to pay closer attention to what's going on...my counselor saw my mom getting beat by my step dad...and my counselor did nothing...my mom was crying...I hate my mom because she let my step dad beat us...I do feel bad for her because he just follows her...she is afraid she will get beat by him...I don't think she can get out...because he follows her everywhere she goes...If they don't pay attention to what's really going on and caring about the students and kids, then someone is going to get hurt. And I went through all of this because I don't think most teachers wanted to know what was going on...think about what my life would have been like if someone would have known something sooner...or just asked...or just wondered... it wasn't the first time I went to school with bruises...and because I had a problem with my anger, I get told I am a behavior problem...I am not the problem...I had bad things happen to me...can't they see that? This is the first time I was ever asked about what happened to me...I mean, I go to counseling, but that's not the same...they tell me how to control my anger...no one ever listened like this...I never got to do this kind of stuff before...I worked really hard so I could come here and do my art...I am an artist now...my art will be in a museum and I have never even been to one...I felt calm when I did this...I was really me...I was free...like a bird looking down on my life...I could see things happening...I thought about it like I was outside of myself...and then I would come back in...I liked it...I liked it a lot...and did I tell you my grades are going up? And I am coming to school? ...I don't understand why teachers and principals don't get that...art is cool and I made something about me...I wrote more about myself my teachers said than they ever thought I could...one of

INTRODUCTION

my teachers cried when she read this stuff...she said she had no idea...
hmmmm...I shared it with them and it felt good to do it and now thou-
sands of people will learn about me and learn that it's important not to
judge me just because I am at this school...I can learn too...I am smart...
I am an artist...and this shoe, it's me...it's all of me wrapped up in one
shoe...cool...

Artmaking as sensemaking for this student seemed to provide opportunities
to develop a positive cultural identification. The student's new ways of under-
standing seemed to influence his academic achievement, especially when
artmaking was infused throughout the curriculum. This process afforded him
the necessary skills for critically thinking about the world and offered flexible
thinking and problem-solving. The artmaking process increased his capacity
to negotiate societal discrimination. As he became more self-aware, for the
first time, this student experienced hope. He wanted scholars in the field to
understand the significance of promoting love, nurturing, and care for anyone
interested in working with children, especially children who live on the mar-
gins. The student believed he had the capacity to become more resilient and
navigate turbulent waters, such as school and family. What he needed were
school leaders and teachers who did not identify him as maladjusted; rather,
he needed educators who wanted to "know" him, to support him, and to recog-
nize all children do the best they can to adjust to the world.

Students explored how other children understood their lived experiences as
well as opportunities to utilize their new understandings for a higher purpose:
to help those who want to become teachers and school leaders understand
what it takes to provide learning spaces for children who receive special educa-
tion services. It was within these intimate school community spaces authors
most benefited from by establishing close relationships with themselves and
others throughout the artmaking process. Their caregivers (i.e., teachers, school
leaders, staff) played a critical role in setting behavioral norms, valuing their
work, and promoting spaces for children to conceptualize their self-develop-
ment. The relationships created throughout the artmaking process provided
opportunities for reparation and healing. The process facilitated emotional
and social support, deepening empathic responses among students, teachers,
staff, famillies, and school leaders. Throughout the artmaking, because the
process is inherently relational, students found spaces to utilize their art to
take risks by sharing their first-tellings, trusting others, and choosing to reach
out and build meaningful relationships.

The larger community context also played a critical role in the artmak-
ing process. The process focused on further developing the well-being of

each child. Artmaking became a protective resource. As youth became more attuned to their beliefs, values, and impact of their lived experiences in developing their understandings of self, they in turn, became more mindful of their actions, feelings, and empathic responses. This learning space was identified by the students as their safe haven. Artmaking as sensemaking was no longer an elective or special class; rather, artmaking played a vital role in the curriculum and an integral part of their daily routine. And over time, with sustained support for this individual, classroom, and school-community work, artmaking as sensemaking addressed pertinent issues facing students, families, and their communities. This school-wide support enhanced student interactions, academic participation, and attendance. Teachers and staff witnessed children believing in themselves, engaging in more independent work, and critically thinking their work. Students demonstrated flexible thinking and often shared their "newly formed" expertise of self. These new understandings played a fundamental role in their capacity to engage in higher order information processing (i.e., influence of lived experiences on their sense of self and responses to the world around them).

Their artmaking as sensemaking shed light on the unique qualities and lived experiences each child brought to their learning. Students made connections between their artmaking and imaginative thinking. They were learning how to make personal connections with their artmaking and imaginative thinking. Students recognized this process as the first time they were invested in their learning by problem-solving, reflecting, and engaging in social justice and equity-oriented work. As they critically thought about their experiences as children receiving special education services, their commitment to making a personal connection with preparing teachers and school leaders flourished. Their creative responses increased and students witnessed transformations among their peers, teachers, and of course, themselves. Students thought at higher levels, developed interpersonal skills by sharing their first-tellings, and increased their sense of self by valuing and honoring their experiences and understanding. Artmaking as sensemaking increased students' cultural-conscious versus their disenfranchisement. Together, youth identified artmaking as a means to promote self-efficacy. They believed they had the capacity to further develop their academic and emotional competencies. Adolescents made themselves vulnerable and openly shared their ways of knowing and being with one another. Students stressed throughout their artmaking and first-tellings that they shifted their ways of knowing themselves from "never knowing they could write" to "this is the most I ever wrote in my life" to "I have powerful things to share with people" to "I have things to say and never realized that until now."

INTRODUCTION

Their artmaking as sensemaking provides those who work with vulnerable populations opportunities to consider this innovative arts-based social justice pedagogy to exploring students' ways of understanding the world, capacity to engage in meaningful problem-solving, and their capacity to further develop their resilience. Authors provide a holistic perspective on the influence of artmaking as sensemaking, especially for children receiving special education services. They acknowledge artmaking as a holistic process comprised of interdependent dimensions of hope individually and collectively interwoven that inspire possibilities.

The Implementation of Arts-Based Approaches

I never imagined working with the authors in this book when this art exhibit was orginally developed to provide aspiring school leaders with spaces to translate social justice issues facing K-12 schools into artmaking. As aspiring leaders continued to collaborate with one another in producing their artmaking, the exhibits moved audiences in unexpected ways. I was honored to receive invitations to work with youth across K-12 schools to support them in understanding artmaking as sensemaking encouraging them to promote social justice-oriented work.

Over the last eight years, those engaged in this artmaking process identified these learning spaces as "sacred." These spaces afforded learners with opportunities to deepen ways of knowing, being, and responding to the world (see Vasquez, 1998). Throughout the process, I co-created curricula that liberated school community members. Together, they utilized artmaking to interrupt oppressive practices and policies, propose research-based solutions to overcoming challenges, and promoting possibilities to empower marginalized populations. We utilized artmaking as sensemaking to authentically transform the lived experiences of youth, families, and communities that live on the margins. Artmaking as sensemaking was not only identified as transformative learning by school communities, but was recognized as a necessity by educators to promote and sustain meaningful change.

Those who engaged this work came to understand themselves as storytelling organisms. They deepened their ways of knowing and need to further develop the capacity to reflect on their historicity-the capacity to uncover personal truths and reconcile the impact these truths play in their thinking and actions taken. They came to understand that artmaking as sensemaking did not play a neutral role in their learning; rather, the process provided spaces to

reflect on the impact social and cultural constructs have in their ways of knowing and responding to the world.

Throughout this reflective process, text-based and non-texted based approaches (i.e. artmaking) are utilized. This critical reflection plays a significant role in the development of internalizing and becoming social justice-oriented community leaders (see Eisner, 2008). Artmaking has the capacity to reflect the extent society is responsible for ensuring children, especially those from marginalized populations, are honored, valued, and empowered. The process encourages students to seek out connections among self and others, explore imaginative possibilities, and deepen their commitment to uncover meaning in their work (see Greene, 2001). Youth often come to understand those deemed other are often members of vulnerable populations (i.e., due to race, class, gender, gender identity, gender expression, sexuality, sexual orientation, family structure, native language, citizenship, ability (cognitive, emotional, social, physical), religion/beliefs/faith, geographic location, and other cultural differences). They often reconsider what it means to nurture individual faculties and promote collective capacities to humanize and actualize school community potential. As youth engage in artmaking, they cultivate a critical consciousness and deepen their ways of knowing and being. They recognize the extent their conscious actions impact their sense of self as they act upon their new ways of knowing. Students often discover their capacity to engage and promote social justice-oriented work recognizing self-transformation as a continuous process.

The Authors' Experiences

Students share overwhelming feelings of anxiety due to being bullied, abandoned, and ostracized by their school communities. They often perceived themselves as "worthless." Students often perceived themselves as "bad kids" who were "unwanted" by society. Once artmaking as sensemaking was introduced to the students, the process became an integral part of their academic life. Youth utilized this one-on-one space to deepen their ways of knowing about themselves as learners and as well as ways to promote humanity and social justice-oriented work. They engaged in new behaviors including, but not limited to, actively participating in class, demonstrating empathy towards others, and engaging in meaningful dialogue about their understandings of self with school community members.

Children committed to engaging in artmaking that reflected the "raw realities" they lived, and at first, did not want to discuss in school. Over time,

INTRODUCTION

students wanted their artmaking to foster conversation among diverse school community members in addition to those interested in pursuing teaching and school leadership careers. They believed their artmaking could provide a myriad of teachers, staff, school leaders and other decision-makers ways to deepen their understanding and responses to the lived realities facing many children who receive special education services. Adolescents stressed the significance artmaking played in fostering meaningful dialogue among school community members to encourage them to "know" them as "capable," "responsible," and "intelligent" people.

Teachers and students identified artmaking as "special class time" and considered this space sacred. Students enjoyed their freedom to make decisions, share insights, and reflect on the impact of their lived experiences on their understandings of self. Children developed new understandings of selves as learners. They were "capable," "smart," "scholars," "hopeful," "courageous," "giving," and "good." These new understandings of self contrasted the ways in which teachers and school leaders perceived them. Adults often told them they did not make a difference in the world.

This book captures the lived experiences of youth, who were identified by K-12 school community teachers and school leaders as the "throwaways." Their first-tellings describe how they utilized artmaking to interrupt injustices they lived as children with learning differences. The authors invite readers to recognize the "raw realities" these children faced in schools. Their experiences include, but are not limited to, deficit-laden practices and policies that directly impacted how students understood themselves.

These youth are first-time authors committed to addressing injustices they faced through artmaking. They hope to inspire an overhaul in teacher and school leadership preparation programs to promote humanity and authentic inclusive practices and policies, especially for marginalized children. One of the students, who authored a chapter, requested the narrative below be integrated into this chapter. The student emphasized the need for meaningful relationships and empathic responses towards all children, especially those with learning differences:

> First of all, let's make this clear. I have been bullied my whole life. I only had one teacher who cared about me. I never had any friends in school. Everyone made fun of me because I was different. I live with my grandparents and I don't get to see my parents. They don't want me either. I think school should be a place where kids can be loved...where they can be welcomed...and I hope my art helps teachers and principals see that... they didn't see that in my other schools...I was very lonely...I have a hard

time trusting people and letting people in...but teachers should learn how to make sure all kids are welcome...that's important...and principals need to make sure the teachers are doing their jobs and making school a place where everyone can have friends, even people like me. I don't know why kids didn't like me. It's hard to be in school. I hope teachers read this book and see us...I mean really see us...for who we are...we are good kids...and we have feelings too...don't they see that? Can you see me in my art? Do you finally get what's important now? So why aren't you doing anything about it?

Teachers, staff members, and school leaders who serve children with learning differences need to stress the significance of preparing educators and school leaders to serve children receiving special education services in authentic ways (see Theoharis, 2007). Authors promote artmaking as a means of meeting the diverse needs of students.

Students and educators witnessed an increased consciousness and commitment to engaging in social justice and equity-oriented work in their school. They collaborated to interrupt oppressive practices and policies within their school as well as preparation programs for educators interested in working with children in special education.

Authors share their experiences regarding institutional practices and policies that often promoted inherent power differentials. These power differentials often led to children feeling excluded, engaging in relational aggression, or experiencing hostile learning environments. Although students were aware of federal mandates that promote inclusive practices and policies, students share continued disparities facing children receiving special education services.

This book is a call for those who serve all children, especially those receiving special education services, to consider the power of artmaking as a means of providing children with spaces to critically reflect on their development of self, relation of self with others, and capacity to engage in social action. One of the adolescents stressed the significance of including this narrative in the introduction:

It amazes me how many teachers just either don't want to work with us or don't know how or don't actually care. I don't know why they went into teaching in the first place. Don't they understand that they need to get to know me? Why don't they get that? Don't they know I don't like myself ? Don't they know most kids like me don't like themselves and we constantly put ourselves down in our heads? Doesn't anyone teach them this stuff ? And if they don't, why don't they? I don't think these teachers

INTRODUCTION 27

can do anything if they don't understand we need to be loved. Is that so hard? Can you see anything good in me? Am I just a bad kid? A failure? I am so much more than a sped ed kid who causes trouble. Those teachers couldn't believe I could think. They didn't think I could do anything. I can. I showed them. I did this. I never worked so hard in my life. I did something they never thought could be done. You have to have people believe in you. They have to want to really know you. And I got to do art and never did that before. It made it so much easier to say what I was thinking. I love it that we get to make art that tells people about us and that we will be able to tell teachers what they need to do in order to do their job better. We deserve that, don't we? No one ever asks kids what they think. Not us kids. How come? Why is this the first time? Will this book go to teachers where I came from? I hope so. They have so much to learn.

Each student's ways of knowing are comprised of many weaves within the fabric of life. The authors want school communities, especially teachers and school leaders, to recognize and honor their lived experiences. Children are story-telling organisms, and often times, authors were not encouraged to explore the significance of context in their development of self as learners, as contributing citizens. Authors contend there is a need for those working with children in special education to consider the impact of situated contexts in a student's development. One means of deepening empathic responses may be to integrate artmaking to better understand a child's intent, influence of contextual phenomena on learning, and the power of first-tellings to increase critical consciousness. Youth actively utilized their visual creative work as a pathway to express and communicate what mattered most, their values, and how they understood their world.

Exhibiting Their Artmaking in a Museum

Youth exhibited their artmaking in a contemporary art museum to encourage the public to play a role in addressing the realities they faced as children with learning differences (see Figure 1.1). The exhibit captivated diverse audiences. Students exhibited their artmaking with a myriad of artists ranging from K-12 children, educators, community organizations, aspiring school leaders, and community artists. Together, they addressed prevailing struggles and inequalities facing K-12 U.S. public schools.

The exhibition is the only communal and intergenerational work of its kind intended to raise critical consciousness, build community, and promote

FIGURE 1.1 Social justice museum exhibit

social change in K-12 schools. Authors describe their artmaking as a vehicle for personal and communal transformation. Students had difficulty imagining their artmaking as a means to invigorate local, global, and personal histories. The artmaking process afforded students with spaces to explore social justice issues they faced, and brought these significant issues to the forefront. Together, students wanted the public to pay close attention to decisions made that directly impacted their experiences in special education.

Youth utilized their lived experiences to deepen people's understandings of what it meant to receive special education services. They discussed the significant role empathic responses play in developing understanding and meaningful relationships. As a result of those conversations, the school community recognized empathy or "walking in someone else's shoes" as a metaphor for this work: *Walk a mile in our shoes and understand what it means to be me.*

INTRODUCTION 29

Students asked educators and school leaders to pay close attention to their lived experiences as well as the impact these experiences had on their sense of self as learners. Youth wanted to be recognized and valued as a human beings capable of contributing to society. They recognized the power of artmaking as a non-text-based method to encourage critical consciousness and empathic responses. They voluntarily shared their first-tellings with peers, staff, teachers, counselors, family, and school leaders. Overall, artmaking was perceived as a liberatory process of self and self in relation to others. Youth translated their ways of knowing and responding into personal narratives.

Students utilized the metaphor of walking in someone's shoes as a pathway to translate their lived experiences into artmaking. This translation process involved utilizing their voice. Youth often felt controlled, manipulated, and isolated. As they engaged in artmaking, they recognized how often they were in control of their learning. This was a new way of learning for all of the authors. Artmaking afforded students with opportunities in which they were in control. These opportunities ranged from choosing to enage to artistic materials to creating representative symbols to expressing emotion to translating understandings into artmaking.

Two hundred and fifty pairs of footwear were donated for the exhibition. Students were asked, "What shoe is like you?" Each student chose a shoe/boot with the understanding the footwear aligned with how they understood themselves as story-telling organisms. As students engaged in their artmaking with their symbolic footwear, they continued to re-evaluated their development of self. Something changed within. Youth recognized personal transformations. These transformations influenced the ways in which they understood themselves. A passion for learning, a desire to share with others, and requests for meaningful relationships emerged. Their artmaking encouraged those who served them to be present, increase empathic responses, and view students from a strengths perspective.

The Power of First-Tellings

I recognize, respect, and honor the authors' courage and commitment demonstrated throughout this book. I want to thank everyone for inviting me to work with them. Each student, teacher, staff member, and school leader exhibied the courage I aspire to as a scholar, teacher, and former school leader. Authors are exemplars of what it means to look within and critically examine the implications of internalizing deficit-laden messages and translating their personal narratives into artmaking. Their first-tellings call upon school community

decision-makers to deepen their ways of knowing about the power of arts-based practices. And in this case, authors emphasize the impact of artmaking in the lives of children identified as the "throwaways." Artmaking not only deepened educators' understandings of what it meant to provide students with meaningful learning experiences, but also, and more importantly, the extent deficit-laden labels, policies, and practices influence personal understandings of self as learner. Adolescents in this book came to understand the power of artmaking as a vehicle to promote social action for students often ostracized because of their learning differences.

Authors' first-tellings encourage decision-makers to utilize artmaking as a catalyst for disseminating research, deepening awarness, increasing consciousness, inspiring imaginative possibilities, and capitalizing on critical dialogue to promote social change in schools. Throughout this critical reflective process, authors suggest school communities address their prevailing struggles, such as those facing the "throwaways," through arts-based approaches. They also share how this reflective artmaking process utilized the senses (i.e., sight, touch, sound) and hopefully, encourages those who prepare teachers and school leaders to provide these candidates opportunities to give feeling to form and form to feeling through artmaking (Langer, 1953). As authors moved from verbal expressions to text to visual expressions to artmaking, they came to know and live their social justice-oriented inquiries. Together, they uncovered the extent their inquiries centered on social justice issues aligned with being identified as "unable," "retarded," "disabled," "stupid," "handicapped," "worthless," and "throwaways."

The interconnectedness among the senses afforded authors with spaces to create multiple meanings centered on an evolving social justice-oriented identity. Authors share how they made connections among what they saw, heard, and experienced as students who endured deficit-laden practices in school. As youth deepened their ways of knowing, they translated their new understandings into artmaking. They realized the way they made meaning from their lived experiences directly impacted their ways of knowing and responding to the world around them and thus, influenced their artmaking (Langer, 1953). The process provided youth with spaces in which they considered the extent the senses increased their critical consciousness (Boske, 2012; Eisner, 2002), deepened their understanding of beliefs and attitudes towards power (Allen, 1995), and created spaces centered on an ethic of care. Artmaking as sensemaking encouraged adolescents to engage in imaginative possi- bilities for the purpose of proposing authentic social change in K-12 schools for children receiving special education services (Greene, 1995; Noddings, 1984).

INTRODUCTION 31

For these authors, and for the first time in their academic career, they learned in an equitable environment: every student had equal access to art space. This accessible space invited and embraced all school community members in new and meaningful ways. Teachers, students, staff, and school leaders discussed and explored a myriad of social justice issues. They also encouraged one another to engage in self and collective reflective practices; and ultimately, youth transcended their new understandings of self and self with others into artmaking. Their artmaking exemplifies the capacity to develop new ways of knowing, including what it means to be identified as a student with learning differences or exceptionalities in the face of being identified as "retarded" or "stupid."

Students increased their critical consciousness. They deepened their ways of knowing about the intersections of race, sexuality, class, immigration, gender, learning differences, gentrification, native language, identity, unconstitutional school funding, gender expression, religion/beliefs, ability (i.e., social, emotional, physical, cognitive), family composition, geographic location, immigration status, and other dimensions of cultural diversity through artmaking. Their artmaking provided voice, equitable access, and opportunities to engage in social justice-oriented work in their school community, general public, and preparation programs for teachers and school leaders interested in serving students in special education.

Students examined how they moved from identifying themselves as "voiceless" and "disempowered" to *becoming* individuals with voice. They had a new sense of purpose and identified themselves as activists. Students honored vulnerable voices, especially students with learning differences who were often ostracized in school and within their communities.

Publicly exhibiting student artmaking promoted a communal social justice-oriented voice by raising awareness and encouraging citizens to take action. Their artmaking bridged school community members and promoted inclusive practices and policies, and ultimately, socal change. Students share their first-tellings in hope of transforming schools and the way universities prepare teachers and school leaders to serve youth with learning differences. Youth assert that artmaking as sensemaking plays a significant role in personal and communal transformations. Students believe their artmaking has the capacity to invigorate school communities to explore artmaking as sensemaking to empower vulnerable populations. They contend there is a need to deepen ways of knowing regarding the influence of local, global, and personal histories to better understand students as learners. Artmaking, therefore, is one pathway for school communities to consider. They assert that these approaches provide students with opportunities to critique, disrupt, and promote cultural responsive practices and policies.

Authors emphasize the extent these arts-based approaches create learning in which they believe "they are receiving the very best" opportunities. Students engage with "real artmaking," because of high expectations, capacity to consider imaginative possibilities, and access to artist materials. Throughout the process, students feel valued and respected. Their lived experiences matter. Youth recognized the extent their academic files often utilized deficit-laden language and assumptions regardinig their limited capacity to think and repond critically to the world. The special education "labels" uncovered did not inhibit students from engaging in the artmaking process; rather, artmaking as sensemaking provided spaces for students to engage in innovative curriculum and transformative pedagogy for all those involved (see Dewey, 1934, 1938, 1961).

Youth met with local artists and exhibited their work in a public art museum. As they prepared to showcase their work, students expressed an increasing sense of belonging among their peers, teachers, staff, and school leaders. These learning spaces were declared sacred. Students witnessed their insights were honored, diverse thoughts embraced, and high expectations embedded throughout the process. Students no longer identied themselves as a "disability;" rather, artmaking afforded them with opportunities to identify themselves as scholars who reflected, problem-solved, and took action.

Students shifted their ways of understanding themselves as learners as well as school community members. Teachers shared situations in which students increased not only their engagement in class, but utilized more inclusive language. They noted the need to "include everyone" to "I feel like I belong" to "I can do this" to "my art is powerful" to "my story matters" to "everyone matters" to "I am teaching teachers how to teach so other kids like me can learn better." The school not only recognized a shift in student language, but also, and more importantly, organizational culture. As students began working with one another in more authentic ways, including, but not limited to sharing their first-tellings and artmaking, student discipline decreased, daily attendance increased, and students focused on achieving their academic goals.

Adolescents uncovered similarities among their lived experiences with peers and sometimes, even staff. These similarities included being heard, friendships, academic success, acceptance, empathic responses, and wanting to be included in regular education classes. As students increased their engagement, most teachers reported increased student-to-student peacemaking, collaboration, and capacity to be present. Other teachers, as well as staff, observed higher levels of student academic performance and positive interactions.

Although some teachers and staff were initially concerned about artmaking "taking away from academic time," they concluded the following: (1) youth

INTRODUCTION 33

spent more time on classroom work; (2) students shared their personal narratives; (3) interpersonal relationships improved and (4) students engaged in more inclusive behaviors (i.e., helping other students, including their peers, and learning together) (see Cosier, 2010).

First-Tellings

Please keep in mind that all of the children, teachers, and community members in this book are first-time authors. We worked together to support authors throughout the process. Authors centered their first-telling on vulnerabilities associated with engaging in artmaking, lived experiences, sharing with others, and critically thinking about ways to translate ways of knowing into artmaking.

As authors documented their lived experiences throughout their artmaking, they did not want to remain anonymous. As active "scholars" and "artists," authors asserted they played a vital role in sharing their first-tellings; therefore, youth, staff, teachers, and school leaders committed themselves to sharing their ways of understanding by choosing to author book chapters. They recognize their first-tellings as bridging among themselves, school communities, and decision-makers interested in promoting artmaking for social justice work in schools.

This book explores a shared emerging theme: Bridging is more than theory. Artmaking as bridging has the capacity to transform beliefs and practices through individuals as story-telling organisms. These critical reflective spaces play a significant role in recognizing individuals as story-telling organisms who have the capacity to deepen their understanding of historicity: exploring personal truths and reconciling these truths as personal ways of knowing and responding to the world. Authors illustrate the extent artmaking as sensemaking creates opportunities for bridging by deepening understanding, developing a stronger sense of self, and identifying as social justice leaders.

Because authors were empowered to share their first-tellings in ways they deem most appropriate, each author chose how to share their understandings; therefore, chapters do not follow a similar format. Throughout the process of supporting authors in sharing their first-tellings, they recognize the role resilience played in navigating their lived experiences and translating these understandings into artmaking.

Artmaking facilitated the creation of individual and system-wide "protective tools." These tools were identified as the sacred learning conditions and positive attributes from teachers, staff, and school leaders that emerged throughout the process. Artmaking promoted student well-being and focused

on a strengths perspective. These new understandings and sense of self created a buffer for students who often identified themselves as "worthless." These protective tools provided merit as authors asserted artmaking as signficant to their development of self as social justice leaders. They contend that artmaking manifests empowerment and communal development within school commmunities.

Structuring the Book

This book is divided into two sections: Youth Voices and Adult Voices. The first section focuses on the children and how they understood the artmaking as sensemaking process. The second section centers on the narratives of the teachers, staff, school leaders, and community leaders regarding the influence of artmaking and sensemaking on the children within this school. As a side note, only one letter appears as each author's name to protect their anonymity. In "You Can't Get in My Shoe," S discusses the way in which resilience played a significant role in her capacity to survive an oppressive system in which she created multiple modes of defense to protect herself and successfully navigate the special education system. In "The Cage," N provides readers with ways of understanding how to create optimal learning spaces, which include "learning him" in authentic and meaningful ways. C, in "One of the Best (Because I Worked so Hard on This)" engages readers in understanding relationships among comic book "unheroes" and how often "unheroes" relate to children "caught up in the system." In "Acception," T creates a new term playing with the word "exception" and encouraging teachers, students, and school leaders to be more "accepting" of differences. In the chapter "Princess," A helps readers understand the significance adults play in a child's development and learning. Author L, in "The Flame of Anger," explores the role anger plays in her life as a foster child and student receiving special education services. L also provides additional insights as a child who entered the juvenile prison system. J's chapter "I Want People to Listen" is a powerful first-telling. This is the first time he has shared what is at the heart of his world-understanding himself and how he evolved into the person his is today. Next, "Animal Land" is a telling chapter with L analyzing the influence of oppressive practices and policies for children who have not volunteered to become part of an oppressive educational and social service system. M's chapter "Helping Hands" provides an uplifting view of the way his family understands his strengths and how those understandings compare to his experiences in school as a child receiving special education services. In J's chapter, "Treat Women Like Flowers – They Are Gentle," he explores

INTRODUCTION 35

the impact of his lived experiences in understanding himself as a learner, son, brother, and friend. "Magna Shoe" explores how P navigates his anger as his world turned upside down when admitted into a special education program while addressing issues at home. In the next chapter, L explores the role depression plays throughout his learning and development in "Deep Blue." He discusses the hope he holds onto to overcome these overwhelming feelings. In "Barricade," A provides insights to the way in which she understands her learning and development as a young person striving for success in school. Next, S shares her journey in "My Story." She explores the extent her lived experiences influence her development of self as a learner navigating an oppressive system in which she often feels invisible. In "Freedom," V captivates readers when she courageously explores the influence of mental illness on her learning, family, and sense of self, and two worlds she contends with every minute of her life. In "The Cycle #Dark Side: The Old Me and the New Me," W discusses the influence the "dark side" plays in his understanding of self as a learner and the way in which artmaking helped in transforming his sense of self in an oppressive educational system. Next, A explores the role gender expression plays in his development in "I Look Fabulous." For the first time, A shares what he has been contending with since he was a child. And finally, M completes Part 1 with the chapter "Life is Strange." This chapter focuses on internal tensions regarding multiple cultural identities and the process of making sense of these identities through artmaking.

In the second section, Adult Voices, teachers, staff members, a school leader, and a community leader explore the role artmaking plays in understanding the lived experiences learners served in special education. In "Born for Bred," A explains how he finds his way working with children with learning differences. He discusses the transformation he witnessed in the children and himself when the students engage in artmaking and leading for social justice-oriented work. In "The Tension of Duality," B helps readers understand the changes that occurred for students who engaged in the artmaking process. C's chapter, "Diversity Is My Degree," explains his role in the children's lives and what it takes to empower children who receive special education services. Next, D explains, in the chapter "Adversity," the role artmaking plays in providing children with opportunities to overcome challenges in their lives through artmaking. In "The Sky is the Limit," E explores the role artmaking as sensemaking plays in providing students with imaginative possibilities. Next, F explores these self-transformations throughout the artmaking process in "They Lived Their Art." She explores how students internalize what they were learning about themselves and others and how these understandings play a significant role in their artmaking. In "The Children Touch My Heart,"

G explains the power of relationships in providing children with opportunities to deepen their ways of knowing about themselves as learners, especially children placed in oppressive systems. Next, H begins the chapter "Raw: The Thread That Connects Us" with her own artmaking. She presents a poem she wrote. H reflects on the art- making process as a parent, teacher, and member of the community. Next, I explores the role artmaking played in calming students in "Confronting Anxieties on a Small Scale." Next, J, the school leader, articulates the role artmaking plays in the students' lives as the curriculum and instructional leader. She discusses her responsibilities as a facilitator of professional development in "Leading through Artmaking: Recognizing the Power of Arts-Based Approaches" and the significance the arts play in student learning. In K's chapter, "Developing My Approach to Working with Children," the author explores her role in promoting artmaking as sensemaking for children who receive special education services. Next, in "The 'Red R' Kid: Disrupting My Deficit-Laden Label," B shares his self-transformation of moving from "knowledge is something we learn from information" to a paradigm shift in which artmaking as sensemaking values all children, especially those who live on the margins. He explores the extent artmaking renews students' knowledge, truths, and understandings. B concludes the chapter inviting educators to foster artmaking as a critical reflective pedagogical process in which all learners, including adults, play a vital role in student learning. Next, author M, in "Living the Dream," reiterates the need to uphold artmaking as a value, belief, and practice. He encourages each of us to think about artmaking holistically. M contends artmaking has the capacity to uplift the mind, body, and spirit of children, especially those who are members of disenfranchised populations. And in the final chapter, I discuss the extent artmaking represents authors' living selves and their capacity to live this work by addressing social injustices in schools.

Artmaking as sensemaking is a liberatory process. Although many of the children's spirits were wounded due to being bullied, abandoned, abused, and ostracized, they identify artmaking as sensemaking as an integral part of their healing process. And within their healing, adolescent voices were no longer silenced. Their lived experiences were recognized, honored, and valued.

Authors deepened their consciousness throughout the artmaking process. Youth thought critically about their understanding of self, influence of lived experiences on selves as learners, and capacity to engage in social justice-oriented work. Adults who worked alongside these students emphasize their own personal growth as educators. They recognize artmaking as sensemaking as a relational pedagogy, because of their increasing engagement and authentic dialogue with students. Conversations often center on the intersections of

the adolescents' identities, artmaking, and understanding of self in relation to others. As teachers, staff, and school leaders actively participated in supporting and co-facilitating this artmaking process, they recognize an emergence of renewed responses throughout the students. And as they witness the impact of these arts-based approaches, they too increasingly commit themselves to integrating wholistic arts-based pedagogies throughout the curricula. This recognition ultimately transforms the way in which teachers, staff, and school leaders engage with children, understand their capacity to reflect and critically think about their experiences, and assess students' meaning-making.

These first-tellings provide those who work with children receiving special education services to problematize what it means to reconceptualize authentic arts-based learning spaces. Authors critically examine the influence artmaking plays in their transformation of self as social justice leaders. They illustrate how these arts-based approaches continue to prepare them to deepen their ways of knowing and ways of being. Specifically, they share ways to address oppressive conditions children with learning differences face on a day-to-day basis. The authors' first-tellings capture the passion and moral purpose these school community members feel while engaging in this significant work. As they commit to engage in artmaking as sensemaking, they emphasize their vulnerability throughout the artmaking process. As authors chose to make themselves more vulnerable, they opened themselves to experiencing artmaking as a means of translating their understandings of self into authentic art productions (see Spencer, Harpalani, Cassidy, Jacobs, Donde, & Goss, 2006); and throughout their feelings of vulnerability, they witnessed themselves becoming fully present. They not only became fully present with and for themselves through an increasing awareness of self, but by developing empathy for others. Their first-tellings capture the essence of self-discovery. Youth engage in a process by which they uncover a new sense of self. They emphasize this new understanding evolved as they engaged in authentic arts-based pedagogies. Authors conclude creating imaginative possibilities, addressing internal conflict, and promoting hope are the rewards and power of artmaking; therefore, artmaking has the capacity to transform the mind, body, and spirit of all those involved.

References

Apple, M. W. (1993). *Official knowledge: Democratic education in a conservative age.* New York, NY: Routledge.

Boske, C. (2012). Sense-making reflective practice: Preparing school leaders for non-texted-based understandings. *Journal of Curriculum Theorizing, 27*(2), 82–100.

Cosier, M. (2010). *Exploring the relationship between inclusive education and achievement: New perspectives* (Unpublished doctoral dissertation). Syracuse University, Syracuse, NY.

Dewey, J. (1934). *Art as experience.* Toms River, NJ: Capricorn Books.

Dewey, J. (1938). *Experience and education.* New York, NY: Collier Books.

Dewey, J. (1961). *Democracy and education.* Old Tappan, NJ: Macmillan.

Eisner, E. (2008). Art and knowledge. In A. Cole & J. Knowles (Eds.), *Handbook of the arts in qualitative research: Perspectives, methodologies, examples, and issues* (pp. 3–12). London: Sage Publications.

Ellsworth, E. (2005). *Places of learning: Media, architecture, pedagogy.* New York, NY: Routledge.

Geertz, C. (1983). *Local knowledge.* New York, NY: Basic Books.

Greene, M. (2001). *Variations on a blue guitar.* New York, NY: Teachers College Press.

Langer, S. K. (1953). *Feeling and form: A theory of art.* New York, NY: Scribner.

Lerner, R. M., Dowling, E. M., & Anderson, P. M. (2003). Positive youth development: Thriving as the basis of personhood and civil society. *Applied Developmental Science, 7,* 172–180.

McLoyd, V. C. (1998). Socioeconomic disadvantage and child development. *American Psychologist, 53,* 185–204.

Spencer, M. B., Harpalani, V., Cassidy, E., Jacobs, C. Y., Donde, S., & Goss, T. N. (2006). Understanding vulnerability and resilience from a normative developmental perspective: Implications for racially and ethnically diverse youth. In D. Cicchetti & D. J. Cohen (Eds.), *Developmental psychopathology: Theory and method* (2nd ed., Vol. 1, pp. 627–672). Hoboken, NJ: Wiley.

Theoharis, G. (2007). Social justice educational leaders and resistance: Toward a theory of social justice leadership. *Educational Administration Quarterly, 43*(2), 228–251.

Vasquez, J. A. (1988). Context of learning for minority students. *Educational Forum, 56,* 6–11.

PART 1

Youth Voices

∵

CHAPTER 2

You Can't Get in My Shoe

S

I know the first thing you might be thinking is, "Those kids are really messed up!" By 'those' kids, I mean my 11 brothers and sisters. We have been so much abuse and neglect, and you might be wondering, "How could they survive this? How could you go through all of that without being messed up?" It was so normal to us. We didn't know being abused the way we were, we all thought it was "normal." We were crying when we were taken away from our parents. Once we left there, and we discovered this is not how children should be treated, that's when we got angry. This is when I was acting out in school. That's when I was fighting and getting kicked out of school. Trouble became my middle name. People in school didn't understand this. Teachers and principals didn't care. They thought I was just a "messed up kid." People give up on us so easily. My worst fear is not having a home. Can you imagine living like this every single day? Can you imagine what it is like to lose someone? What would happen to me if my mom died? I think about stuff this every day. It weighs on my mind and on my heart.

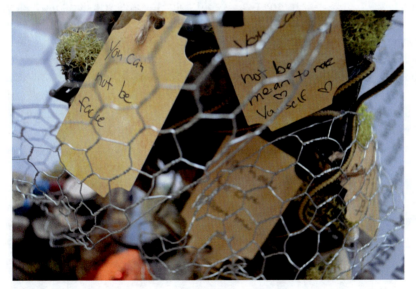

FIGURE 2.1 My fortress

In order to do this artmaking, you need to know something. First, you need to be able to think about yourself and second, you need to know what matters to you. It's not easy. This is where the art process really begins. It's not about the art as much as it is about the story. It's the story that drives the art. And thinking about what matters most to me was challenging to work through, but my artmaking was a release for me and a way to teach you what we need to be doing differently for kids like me.

As foster kids, we need to know we are loved. We need to know people will be there for us no matter what. People just can't talk about this stuff. People need to do something to show us. People think we are just "messed up" and make us feel "out of place," like we are just "objects." It's the first thing my teachers and principals did when they met us. They would just look at all of us and think "we just weren't right." But something has to be right with me, because I am still here and standing strong. I am successful. I will walk across the stage with a gown on and then go for my next goal, which can range from being a lawyer, singer, writer, artist, and being a role model for kids so they know they aren't alone. I want to be around people who understand me and understand life is about risks.

I was asked if I wanted to participate in a Leading for Social Justice art exhibit taking place at a museum. The first thing that came into my head was "Wow! My art is going to be in a museum!" I was so excited about this. It finally gave me a chance to get my artwork out there. I gave up on it, because of my twin. Growing up, me and my twin would color together. He had Spiderman and I had Cinderella. I remember painting with my twin. We painted our feet and stepped all over paper. I stopped doing art, because I am sad knowing he is not in my life. He is currently in detention for stealing stuff from other people, especially his adopted family. He stole it for his mom who would say, "We will be together," but all she wanted was the money and he couldn't see that. Art used to make me happy and then it made me sad, because he isn't in my life anymore. When I am feeling a certain type of way, like when I feel emotional or tired or when I feel like I want to do something stupid or I am afraid, then I feel better. I realize in art, there is no wrong way of doing something. I can't make a mistake in art, because it's not possible. Everything I do in the world, there are always opportunities for me to get in trouble. I feel pressured to do what is right all of the time. I do art, because I can't disappoint anybody. I can't make a mistake. And this is the only place in my life where I feel like I can just be. It's a time for me to be free.

So, I wasn't only thinking "Wow!" I was also wondering if I could do this artmaking. I needed to put myself first for once. I always put my twin first. I didn't like it at first, you know, putting myself first. I didn't know if I could handle it.

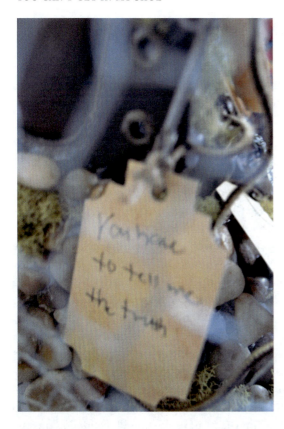

FIGURE 2.2
Thinking about my art

I didn't want it to start bringing up memories. I just wanted to initially put everything away. I just wanted to forget my past. They say, "It's not easy...you know...putting it all away." I realized how much I enjoyed this process, even though my twin wasn't with me.

Throughout the process, I just remembered something positive. I got so into it, I just let myself go. I was excited. I was putting all of the pieces together and it came into a whole new way of understanding. Everything came into place. I wasn't sure if all of my stories would work, but it did. I didn't believe it was possible, but it did. I felt like I was unstoppable. The last time I felt like this was in basketball in middle school. When I was on the court, I was on fire. I had choices on the court, but in life I didn't have choices. You have to learn to take care of yourself and you have to make hard decisions. It's not easy. The last time I was excited like this was so long ago. It was exciting. It was relaxing. And I didn't have to worry about if people liked it or not. It was my story. My story mattered.

In my art, I could make choices. I decided what story I would tell, how I would tell the story, and how I would represent everything. It was overwhelming.

In life, I never had this many choices to make. For most of my life, people made choices for me, and in many ways, still do. But in my art, I was in control. And it turned out just like I thought of it in my imagination.

When I was actually putting this all together, I wondered if the materials I chose would stay. I wondered if the size of the rocks mattered. I thought the rocks were important, because the size of the rocks mattered. I wanted them to be big. I wanted them to represent what this meant. I protected myself. The small rocks just didn't fit me, so I stayed with my original idea. Originally, I wanted all rocks on my boot. I wanted the biggest, toughest boot I could find. I didn't want to be rejected or hurt, because in my life, I am usually hurt and disappointed. When I worked with Christa, I started to respond to her the way she treated me. I felt she respected me. Christa has a nice voice and took all of that scaredness and shyness away. It showed me that people can really make a difference in our lives. Christa made me feel open and not afraid. I knew I could talk with her. She listened to me. I realize this has been happening more and more in my life. I am noticing people being more respectful because I have changed how I am acting. My teachers and my family treat me with respect. It makes a difference. When I realized I wasn't always hard on the outside, but remember, I need to be sometimes be, because that's all I have to protect myself, I decided to put moss between the rocks. The moss symbolized space with room to breathe and trust in other people.

I decided initially I wanted the keys to be in a bottle, no one has access to them. Then, as we were working on the front of the boot, I decided to put the keys on the gate and in the rocks. I made it more difficult and decided there were steps people had to take to get into my heart. I liked that idea. You know, being a foster kid means you aren't adopted. When you aren't adopted, you can be told you are moving to another family, just like that. All this moving around is difficult, because you never know what you are walking into. It makes me more adaptable, but it also makes it so hard to get close to people. When you are in foster care, and a parent gets tired of you, they can send you to respit. What is respite? It's when foster kids get sent somewhere so their foster parents can relax or go on vacation without them. That doesn't happen in real life. If you are a parent, you can't just give your kids away when you are tired of them, overwhelmed, or want to go somewhere without them. You have to be in it for the long haul. But that is not what happens to kids like me. We switch houses, families, and schools all the time. The more we move, the more disconnected we are with people around us. The more often we move, the less likely we will open our hearts up and let someone in. Why should we? They are either going to give up on us or we will be taken away. That's reality.

YOU CAN'T GET IN MY SHOE

I decided to write what the steps were for anyone looking at my art. I wanted them to know they could get in, but it sure wasn't going to be easy. I made it clear what I needed from them, but again, it wouldn't be easy. I feel the only person in my life who is gaining access to those keys is my mom. She is honest with me and I know I can trust her. One person is enough for now. Maybe I will let others in when I consider the future.

Once it was completed. I thought, "Wow! This is awesome!" I couldn't believe I did it. I knew I could do it. I couldn't resist it. I really enjoyed it. I faced my fears. Even though it was a little challenging for me. This artmaking has made a HUGE difference in my life. I am more focused. I am listening more. I am trying harder in school. I feel motivated. It made me open myself up and try art again. I wasn't sad this time. I overcame my fears. I used art to tell my story. I kept that story inside of me for such a long time. It felt good to finally get it out. The art helped me bring out what was on my mind. I didn't have to use words. I used objects to tell my story and put this all together.

I was afraid if my piece wasn't sold, then it wasn't important. I realize now, it was my story that mattered. People read my abstract. I think it is awesome to know over 600 people read what I wrote and looked at my art. It took courage to do this, because I didn't know these people. I let them in.

I'm afraid I will bring people down if they are doing good. I had a friend who was on the honor roll, but I never heard of that before. I wasn't one of those kids, but I had something to offer. Her parents decided we couldn't be friends anymore, and that hurt. I decided I should only hang out with people like me, and then, I wouldn't disappoint anyone. There are lots of kids like me in school, but no one seems to care about us. I need to be with people where we can build each other up. If I am with kids like me in this facility, like foster homes and foster kids, we have more in common with one another. We aren't bad kids. People are so quick to judge us. We have talents. Even though we are in facilities, we can be honor roll students too. I am afraid if honor roll students know me, maybe I will bring them down. I just don't want to be friends with them even though I want to be friends with them. I get angry when I think about why certain people have privileges that I don't have and I never had. It's hard for me. They have their parents and I am happy for them, but I didn't and don't have that. I hear about these stories and I get angry. I had so many parents, but my mom had two parents. She lived such a different life than me. I wonder sometimes why my stories aren't like her. I wonder why my birth mom brought me into this world and why experienced all of this? That's the big question for me. I think my friends in honor roll are so lucky. I haven't had that. I think I get jealous sometimes. I am not adopted. One of my brothers is adopted. I want to know why someone doesn't want to adopt me. When you see this in the world

every day, people having families, and I don't have them, it's sad. It hurts. This is why I have barbed wire around my art. This is the reason I need to protect myself. I am not ready for the world. I am not ready to turn 18. I didn't have a childhood. I need to be a kid. My childhood was taken away from me. I am not sure people really understand.

Change is hard for me. I just want stability in my life. I need to have the same teachers. I need the same routine. I need to have structure in my life. I need to know I can count on people and know what happens. When we keep moving and moving, I am just an object moving. No one at school thinks about all of this. They are just passing judgment on them. As soon as someone says "foster," then it's over. We aren't supposed to say "mom" or "dad," because we aren't their kids. We are just moving objects. We are forced to move around and that isn't fair. I want a family who isn't going to give up on me. I need teachers who aren't going to give up on me. I need parents and teachers who love me and will be there for me when I make a mistake. I need a place I can call home. I need to bond with people. I need people to love me for who I am, for what I have experienced, and to believe in me and my future.

There is a need to for everyone to work together for the child. There needs to be a close bond. I didn't have parents who took care of me, but it was the county that was responsible for me. They were just there in name. They had no idea what was going on with me. I couldn't go to the movies, to the store or a friend's house, because the county had to give us permission, not our parents. I never had a place to call home. Teachers and principals need to know what we are going through. They need to care. We need a home. We need to feel closer to people. We need someone to really communicate with. We need someone to bond with. We need people who are going to show us they are in charge of us, not the county. That helps me realize I can go to those people. I want the people I live with to be my family, not the county. I need teachers and principals to know school should be a home for all kids, especially kids like me, who just want to be "normal" and have a place to call home with people who care about us.

A lot of people have raised me. I know most people had it good. I had so many people raise me. They told me so many different things. It's confusing. I had so many families. I experienced 29 foster homes and at least 10 facilities since I was just a kid. It's hard for me to say the least. I am still learning who I am and how my past has influenced me. This artmaking made it possible for me to bring this all together. It was a process that transformed who I am. I feel more free to say what has been on my mind, in my heart, and what I think will help people understand people like me better. We need to be loved.

YOU CAN'T GET IN MY SHOE

No matter what, teachers cannot give up on people like us. Teachers should not say things like, "I got my degree." Because a degree, isn't all that matters. What matters is what you do with what you know, how you treat the children, and what relationship you have with the children and their families. This isn't about making the "bad kids" feel worse about themselves. We need teachers who believe in us and have a bond with us. I am not sure how teachers are prepared, but they need to learn how to care and show the kids how much they want them to be successful. It's about being there. It's not about the paycheck. It's not about teachers saying, "I can't wait to go home," "I can't wait for break," "Only so m any days until summer," "That's not my job," or "I don't have time." We need people who go over and beyond. They are the ones who leave their problems at the door and focus on the kids. We need teachers and principals who do not give up on us no matter what. If I had those teachers in my life, maybe my life would have been different. It's something I think about. It's something I think about a lot.

The following is my art abstract. I walk you through my artmaking step by step:

> **Never.** I never did anything like this before. It's hard for me to trust people. I liked doing this, because I could tell you about who I am without having to share with you all of my words. My art is about walking in someone else's shoe. If you were to walk in my shoes, this is what it would be like. I had a lot of things done to me and a lot of things have happened in my life. My art let me share my life with you in ways I could not have done if I talked with you or just wrote about it. It took on a life of itself as I worked with Miss Christa. I started out thinking about my art in one way, and by the time we finished and talking through everything, it transformed into even something better than before. I realized in doing my art several things. One, I may not be as hard as I thought I was on the outside. I am growing. I'm still hard on the outside, but I am showing more of my soft side now. I am really proud of my art. I think it is something that really represents what I am thinking and feeling and how I am changing.

Hard on the Outside

My shoe is covered with rocks. I told Miss Christa I was hard on the outside. This was the hardest thing I could cover myself with. And then, that wasn't enough. I needed to show how I push people away. I keep them at a distance.

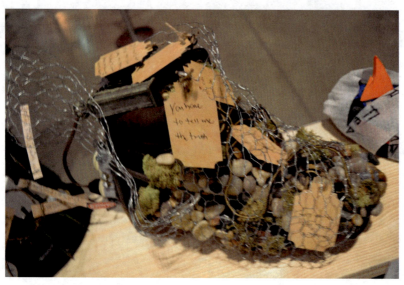

FIGURE 2.3 Hard as a rock

So, I wanted to cover my art with wire, just like barbed-wire. That was the look I was going for, so we used chicken wire. And that wasn't enough protection. So, I wanted the fence to be electric too. I have an outlet on the back with a cord and a plug, because it's now not just a barbed-wire fence, but an electric fence. I keep people out. Yes, on purpose. I am guarded. People tell me I come across hard on the outside, but on the inside, really deep, deep down, I want you to know I have a heart. Miss Christa saw this, and that's why I didn't cover my entire piece with rocks. Some of it doesn't have rocks on it, because I do take more risks, and other parts have moss on it to show my moments when I am soft. Do you see the keys? Well, I put the keys between the rocks. I decided to do this after talking with Miss Christa, because I realized there are things people can do if they want to really know me. If they care, there are things they can do, but you can see I put the keys between the rocks and glued them in. Why? Because it's not going to be easy for you to get in and know me. I have been hurt too many times. But if you can take the steps that lead up to the gate, and it's locked, well, then you have proven to me that you care. But let me remind you, it's not going to easy. I will be watching you very closely. I can't stand people who are fake. People need to be real to know me. I am very sweet, like candy, and have a lot of love in side of me. But, people just don't know this, because I don't show it. It's too scary to show it. My heart is way, way deep down, because of all the stuff I have been through. If you make it to the gate, collect the keys along the way, then you might just get in through the gate, but let me remind you, it will not be easy.

The Keys

One of the things I need from you is for people to teach me to love. I need to see it. I need to see it around me. I need it for others and I need it for me. If you can show that you care and walk your talk, you may get a couple of keys. These keys will lead you to my gate. Inside the gate, I wrote my story. But you can't get to it. It is sealed in bottles. This is for me to decide if I will share it with you. What's inside is what is going on with me. You will also see a sweeties inside. This is to symbolize what a sweet person I am on the inside. It's way deep down deep, but you can still see it if you look through the gate. So, you can see it sometimes, but you need to know it's hard for me to show this. Why? Because the more people I care about, the more I worry about them. I worry about people I care for.

I take online classes at school. Miss Christa asked me what it was like to take an online class. I told her, "I love it." She asked what I loved about it. I told her, "I like that I just do my work and turn it in." She asked me about my interactions with my teacher. I said, "My teacher doesn't know anything about me… and doesn't ask about me…or care about me….I just turn in my work and my teacher tells me everything I did wrong." Miss Christa asked me how I felt about that and I said, "I like it that way…it's just one less person to care about…" Miss Christa and I talked about what kind of relationship I would like with a teacher or the relationship I have with my teachers now. Some of my teachers are really strict and I think they care about me. I don't think my online teachers care

FIGURE 2.4 Symbolic of my life

about me, but it's better that way. They don't need to care about me. I just turn in my work. That's all they care about. It's just better that way. One less person to worry about.

Being Taken Advantage

I will tell you right now, I'm not going to be taken advantage of again. I was bullied in school, because of my weight. They would call me fat and ugly. I liked to handle the bullying on my own, and that's why I got kicked out of school. I lost control of my anger. It just kept building up inside of me and I let it out in all of the wrong ways. But, you know, I didn't want to be a snitch. Did you ever hear, "Snitches get stiches"? This means that if I said something to a teacher, then those people would try to beat me up. Yah, I'm not a snitch.

I didn't have anyone there for me. I had teachers at the school, but they were just teachers. They were not people I could trust or thought they cared about me or showed me they cared about me. I don't feel any of them would have cared about what was happening to me. Not one. Who could I go to? No one. Why? Because they just focused on themselves. They were there to teach and that's all. Well, I knew I could tell my mom, but I didn't want to tell her. My mom was already mad and disappointed in me, because of the choices I made. I didn't want to upset her any more. I get afraid of my mom sending me back into the foster care system. I get anxious and afraid. It's like this pressure to always do the right thing, like you can't make mistakes. Because if you make a mistake, you might not have a home. It's hard to live with that pressure. It's every day and it weighs on you. I don't ever want to disappoint my mom.

I have gotten kicked out of school and in fights before. It's not the first time. I think I spent most of my life fighting people and protecting myself. I never felt close to anyone except my mom. I took matters into my own hands, and I wanted to handle everything on my own. I wanted my hands, my fighting back to tell people at school "I'm not scared of you."

I fought people with my hands and my words. I did anything I could do to those girls who bullied me to stand down. I learned real quick, my friends took advantage of me and my kindness. They took my kindness for weakness. Many people do. They would say things about me on Facebook and say like, "Oh, she's fake," "Oh, I don't know her," "Oh, I don't like her," and then, when we got to school, they acted all different. I figured if I went to school and act all hard and stuff, then maybe I wouldn't be bullied.

People still tell me I come across as negative, rude, and disrespectful. I want you to know I can be funny and smart. I know I'm intelligent. I can

YOU CAN'T GET IN MY SHOE

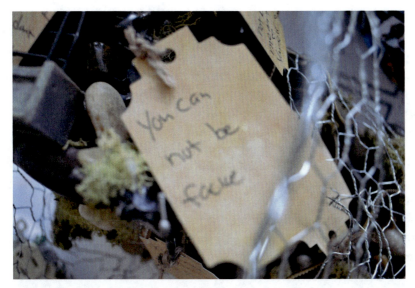

FIGURE 2.5 I can see you for who you really are

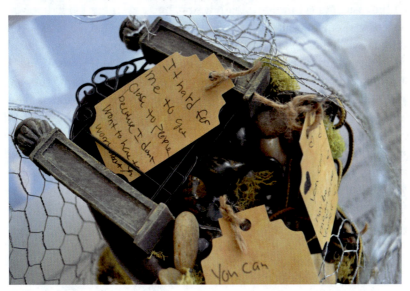

FIGURE 2.6 It's hard for me to get close

choose do the work teachers give me when I want, and I know I am capable. I just get tired of everything. I get tired. I get tired of fighting. I get tired fighting my past. I get tired of the rules. I'm not fighting here at this school. I'm working on myself so I can go to a public school where they don't focus on behavior. They focus on education. This means they help me focus on my work.

Inside the Gate

I know I can come across edgy, harsh, mean, rude, and disrespectful, but on the inside, it's really important you know I'm not those things. I am actually loving, caring, and respectful, but I keep it all on the inside. I have a gate protecting my heart. There is another key by the gate. You can see inside the gate, but you cannot see my story, but way down deep I have love inside. I feel safe inside there. I feel safe inside my locked gate. As I think about the outside shell and the inside me, I realize what I say or do on the outside is not always what's going on with the inside, but I need you to know it's important I protect myself. I think about what I used to be like and how far I have come. What I used to be like, well, if I saw someone's picture, I might have said something like, "Oh, that's ugly," but on the inside I would say, "That's cool." I can't let just anyone see the nice side, because then I might be seen as weak and then someone would hurt me again.

When you look at my art, you will see a lock and many keys. This symbolizes how hard it would be to get in. It would take a lot of work for someone to get on the inside, to get into my heart. If someone was interested in knowing me, in letting them in, well, they would need to be there when I least expected them to. They would need to be caring. Not just caring once in a while, but all the time. If you want to get close to me, then you need to love yourself and be respectful to others. I cannot be around people who do not love who they are, because I need to learn from you. They would need to tell me nice things about myself, like "nice shoes," and be nice to me to be respectful to themselves and others. I want to see what they say actually happen. I don't think this is asking too much, but most people can't do this. And most important of all, you need to show me how to love. Because I have been hurt, and terrible things have happened to me, I need people who are going to love me for who I am, and by loving me, you are showing me how to love.

My Final Thoughts

This chapter was wonderful for me to write, because again, I couldn't make any mistakes. This is my story. My art focuses on trust. That's really all we want. We know we have been through hell and back as well as my mom with me, but most important, we need teachers and principals like that. We need people who are going to be there for us no matter what. They need to believe in us. We need teachers who know we are missing. We need teachers to wonder, "What happened to you?" And to follow up with, "What happened? I was worried about you." We need a "classroom family." We are often left out, like we don't

YOU CAN'T GET IN MY SHOE 53

matter. But you need to remember, we can do anything. We just need someone to believe in us, because education is just too important.

I wanted people to understand the power of art. The way this process makes kids feel. It's powerful and changed my life. I have never been given an opportunity like this before. I think schools need to think about this. It gives you a chance to use your mind and think about what is important to you. This is a way to express themselves. As kids, we express ourselves with words and how we dress, but this is different. This is much more powerful, because kids have so much they want to say. They want to be good. They want to be nice. They want to be accepted. Many kids don't know how to do it. I went from feeling like I didn't have a voice to realizing I not only have a voice, but my voice is just as important as your voice. I have been told over and over what to do and how to do and faced so many consequences for which I am not proud. I walk on egg shells and wonder if and when I will be taken from my home. I am disempowered by a system because of my label. And that label has contributed to the way I see myself and how I behave and even what I think I could or could not become. Don't people see this? My art shows I not only have a purpose, but I am somebody and I became this somebody because of what I lived. I am not responsible for what happened to me, but I am responsible for taking it from here and so are you if you want to be in my life. Teachers need to know us for who we are instead of our files. We are so much more than those big words used at meetings about us. We are important and we need people to recognize this. I can only speak for myself when I say this, but I want people to treat people like me with kindness and understanding. My life matters too, you know. I may not be a straight A student or a goody-two-shoes, but I will mind my own business so you can go about your day.

This book can hopefully help teachers and principals understand we matter and our stories matter. I am not sure these people are trained, but I don't think they are trained to know how to work with kids like me or for that matter, care about kids like me. We need people to believe in us and to be there. I have been through so much, so learning is sometimes very hard for me. I have so much on my mind and I am dealing with things my teachers and principals could never have imagined. They never really understood kids like me. That hurts and it creates problems for us when we are trying to learn. If we don't think you care, because so many people in our lives have pushed us aside, then you don't stand a chance. Can you teach someone to love us? Can you teach someone to respect us? Can you teach someone to care? I am not sure if you can, because until now, I never met teachers or even a principal who did.

I was able to say things and think about things in my art that I could not say with my words. I learned things about myself in the process. That was pretty

amazing. I didn't realize I wasn't such a hardass as I had been for most of my life. I started to let people in when I started this artmaking. I am surprised by my own growth. I am proud of myself and what I accomplished. I bared my soul, but not all of it. I want you to learn from me. I want you to learn from my courage and my ability to make it through hell and back. Do you understand that? And I am still standing. Do you see that? You can't just read about this stuff in a class to be a teacher. I think that what I have shared with you should help you understand we have so much to learn. It doesn't stop. And if it does, then you should probably not be teaching kids like me.

No one ever thought I could do this, especially me. I never thought I would be in a museum. I never thought I would be an author. But look at me now. Look at me now! I am an artist. I am an author. I am an activist! And my story *does* matters. Does it matter to you? What will you do with what you learned? Did you learn anything at all?

CHAPTER 3

The Cage

N

I was kind a like, "Okay" when I knew my art would be in a museum. We watched a film about students needing champions. I learned everyone needs a champion. I decided to do this, because Christa said it was about telling my story, helping teachers and principals learn from us, and I thought it would be fun to do. I thought it was cool to put my story about me on a shoe. It was about "walking in my shoes," and I thought that was cool. I never thought someone, especially an adult, could or want to learn anything from me and my story. I had never done anything like that before. I did art before like painting and gluing, but I never did anything like this when you put all of this together. I liked the hot glue gun for the artmaking. I never used anything like that before, but I heard about them, but never knew what it was.

I never told my story before. I never told it out loud or put it on a shoe. I spoke with Christa about my story. She typed everything I said and then we looked at it together to make sure it said what I wanted it to say. It was interesting. I never told me story to a stranger before. It was exciting, but I was a little nervous. No one has ever asked me my story before. No teachers, no principals, and no one else ever asked. They only knew what I wanted to share. This was different. I was excited that I got to share my story. I was nervous, because I didn't know Christa. I was relieved afterwards. I had that inside of me for so long, and some of it came up and out of me. I wasn't surprised by anything I shared. I knew things were inside of me. I am not sure why no one has asked me my story. I am not sure teachers and principals should ask students, because I get the feeling they just think school is about coming here, learning, and then leaving. I never thought people, especially teachers or principals, had anything to learn from me.

I think it matters if teachers and principals know their students. To know their students means you have to actually care, not because it's your job, but because you really believe in the kids. You have to believe we are important, that we can learn, and that we do learn. You also have to understand we just don't live in a classroom with you. We have lives after school. And for so many of us, I learned our lives can be quite scary. Teachers don't seem to stop and think about that. I think they act like we about to start learning math and that's all we need to do. What they don't realize is that math isn't

always easy for us so we will do anything to get out of it. We don't want to fail. That's all we know. We only know we are failures. We need people to believe in us and to cheer us on. We need teachers to know we have so many things on our mind and it's difficult to focus on learning when we are trying so hard not to fail again. If teachers and even principals took time to get to know students, then it would be different for us. The students would learn to trust them. The students would know it's not just your job, but you actually want to teach them things and you can learn from them too. I never had anyone tell me they learned something from me. I didn't know I was a teacher. Christa surprised me when she said, "You taught me about courage." We talked about this. I taught her how to be strong, what strong looks like, and what it takes to let people in. That's my message. I came to understand I actually have something to offer. I didn't know that before. My story does count. My thoughts do matter. And in the end, we have something to learn from one another. Making this art the way we did taught me this important lesson.

Miss Christa and I did a lot of talking to get to what I wanted to do for my shoe [artmaking]. We talked about all sorts of things. I shared who my champions were and what it would be like not to have them. I know so many kids who don't have anyone. They are lost. I don't know if they will ever be found. And when you are lost, you are lonely. That's not a good place to be. It's not a good place to be for anyone, but for kids like me, it's really bad. We spend most of our time alone, afraid, and nervous. We feel like we always have to prove ourselves to teachers and to people in class. I am realizing working on this art that it's all a part of learning about myself. I never thought like this before. My brain hurts, just kidding. I joke a lot. When I laugh and make jokes, I feel better. I think this is one way I make it through the hard times, like the cage. That's the name of my art.

I am going to walk [no pun intended] you through what I did for my art. Originally, when working on my shoe [artmaking], I wanted to cover the end the shoe, but I decided to "close it or not really close it." I wanted to show people that I let people in, but I don't really let them in at the same time. I expected thought to go into everything I did. Every detail had a purpose.

I felt good after I completed my art. I felt like Phil Knight, because I made my own shoe with my own story. And my story mattered.

Here is my abstract:

> **I am full of love.** When Miss Christa and I talked, I told her right away that I was full of love and a good person. I wasn't always this way though. Now, I have people in my life who matter and people who have helped

me be that person. The person I want to talk about is my champion B. He passed away last year on September 14, 2014. He was shot in my neighborhood. B was at the wrong place at the wrong time. I knew him for four years. I met him at a basketball court in my neighborhood when I was 10. We played in my neighborhood, in elementary school, and we were on the middle school football team.

I thought B was funny, smart (he would always teach me something and I would learn something new), and kept me in class. He wouldn't let me cut class or roam the halls. He cared about me. B and I wanted the best for one another.

This is my third year at this school. I got here for being a "class clown" and a "nuisance." I was told I bother people a lot. My dad recommended me going to this school. I was having problems in school. I use to crack jokes in class. I didn't want to be there.

My dad thinks this school is helping me. He wants me to graduate from here and go to the public school. I got out once to go to public schools, but then, I came back. They had problems with transportation. I was disappointed. I had to learn to deal with it. It wasn't easy, but I dealt with the disappointment.

I like to laugh. I love to crack jokes on people and pull pranks. I knew I was funny when I was six, but in school sometimes, I was sneaky. And sometimes, I shared out loud, but I got my work done in school. I added cuss words and pulled pranks on people. The pranks ended up with me fighting. I was fighting kids who I made fun of, because they didn't like my pranks.

I live at home with my dad. I have a 17-year old brother. I also have a cousin and a grandmother. My dad takes care of my grandma. This is his mom. She is 92. I have a really good relationship with my grandma. She cracks on me. I get my humor from her. I never asked her how she felt about me having to come to this school for the last four years. I am afraid to hear her answer. I don't want to disappoint her, and I think I do disappoint her, because I go to this school. I think she wants me to do better, and wouldn't understand why I got here in the first place. She just wants the best for me.

My dad is more work, work, work. He is very serious. My grandma is caring. She does things for me that she wouldn't do for regular people. When I was little, she would be at home with me and take care of me. I would eat Cream of Wheat or oatmeal. She made sure I did my homework and kept me out of trouble. My grandma also made sure I went to practice on time. I never want her to be disappointed in me. I want her to be proud of me and when you love somebody that's what you do. I love her and she loves me.

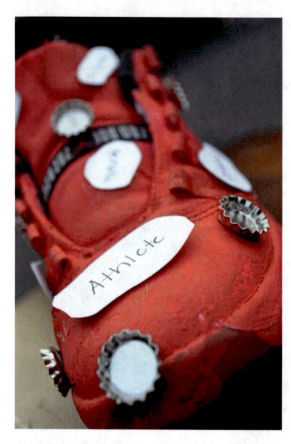

FIGURE 3.1
Walk in my shoe

Miss Christa and I talked about people in power and people who don't have power. We talked about how sometimes you have power because of the groups you belong to and how you sometimes don't have power for the same reasons. I belong on the inside most of the time. Those are the people who have power. I am educated and I am getting an education. I am straight, an American citizen, a boy, and speak English. I am on the outside of the dotted line, and live on the margins because there are times I don't feel like I have power. I am mixed or multiracial (Egyptian, Black, and Russian), Muslim, and behavioral issues that interfere with my learning. When I'm on the inside of the box, life is okay. I feel powerful and I have power and I can do things without people looking at me weird. When I'm on the outside, I don't want to be on the outside. It's not good, I am put down. I don't get to do what I want to do. Sometimes people tell us what we can and can't do when we are on the outside of the dotted line.

I made my shoe a bright red, because I have lots of love to share. I put all of the things that make me special on the outside of the shoe. I am a good friend to people. I also am an athlete. I am responsible and I am a gentle person.

THE CAGE

I have some sharp metal pieces on my shoe, because I still protect myself. I have been hurt by people and I am going to protect myself. I didn't cover my whole shoe, because I am a very gentle and loving person, but I will let you in when I feel comfortable. I will tell you what I feel you need to know. I put bars across the top of my shoe, because I want people to know I need to be loved. This is a jail cell. The real stuff is being held captive. What do I mean by the real stuff? What do you think I mean? It's all the stuff that makes me me. It's all the stuff that I remember, that I get sad about, that I get angry about, that scares me, that makes me laugh, that holds me back, that makes me think, that makes me who I am today. And it's held captive because I have been made to feel like I am bad kid for being me.

I need to be accepted by other people. I want people to know this by seeing through the bars. I didn't want it covered like its' a secret. You can't get to my heart and know everything about me though. You can look and I will let you know when I trust you. You can't see how you can through the bars and to my heart. I did this on purpose. I am the only person who knows where the key is, and in this case, it's on the bottom of my shoe. I did this, because I wanted it hidden from you. I will let you know if I trust you and can let you in. It's my decision and it is not something I take lightly.

I think teachers and principals need to know everyone has a story. We all want to be loved. We may not say those words, because it's scary, but deep down, that's all we really want. Even the toughest kid you can imagine just wants to be loved. I don't get why people don't see this. Are they blind? We

FIGURE 3.2 The cell

want people to see the good in us and realize there is good in us. We want them to know there are good things about us even if we sometimes make bad choices. They need to get to know us in order to help us. They need to want to find the keys that unlock the doors that might seem like there is no way in, but there is. You have to take the time to find the key. It's not just going to be given to you.

Final Thoughts

I think it is amazing over 600 people came to the show and saw my art. I am proud of myself for having the courage to share my story and to show them how I see my life and what I have to offer. I never met adults who thought I had any thoughts or something to offer until now. These strangers, well, they now know my story. And I am hoping that my story will help principals and teachers see that we need more stuff like this in school. We need to learn to express what we are thinking and we need teachers who actually care about us. If you want us to learn, then you will take what we are saying in our chapters seriously. I don't think teachers and principals ever take us seriously. If you took some time to know us, to actually show that you care, you might be amazed at how close you could get to the cage. But for now, you are only welcome if you are invited. If you could learn something from what I shared and what I lived, then you are off to good start to work with kids like me.

Although I am the same person I was before doing this project, I do feel different. I feel different, because I am happy, because my story has been told. I am not used to being happy or proud of myself. I can't think about the last time that happened so it might be the first time. I hope my story inspires people to be brave and to have courage. I want teachers to be brave and share their stories too. Maybe they need to think about what happened to them and how those things made a difference in their lives. I want teachers to be strong in life. When I was younger, I will tell you, I wasn't this way. I learned to become stronger. One of the secrets to becoming stronger is to not keep stuff locked away or hidden from other people. This is important, because when you keep things hidden, you become numb. When you let it out you feel. I felt relieved and happy. I wish this for all of you. And to do this, I found doing this art so freeing for me. I could feel myself feel bigger as I accomplished more and more. I felt proud. I sat up differently. I started asking more questions in class. I would say nice things to other students if they did something good. I did this because it felt good on the inside. In the past, I would have just thought about me. But now, I realized after talking with everyone, we are really sharing similar lives.

THE CAGE 61

I never really thought about that before or even cared, but I do now. I see how other kids have courage to share. I like their art too! Their stories are powerful!

I hope the students in my class learned the importance of trying to get know people, like students, teachers, colleagues, bosses, and employees. Are teachers really ready to work with kids like me? Do they even like kids like me? Do you meet kids like me before you decide to be a teacher? Why do you want to be a teacher? Why does it seem so hard for teachers to work with kids like me? I didn't think we were that difficult. Advice: Just get to know us and be yourself. Are you a caring person? How well do you know your students? How well do we know you? We need to make sure everyone trusts everybody. We aren't just trouble for being here. They need to know everyone has a story. And some stories are more difficult to know than others. The time it takes is worth it. You don't want people to feel they need to tell you lies about their story, because what they are really saying is they don't trust you. All teachers and principals when they are learning their job, they need to know that even if children are labeled "bad," why are they considered a "bad" kid? Because in the end, they aren't really bad. I believe it is their job to fix it. The kids are just looking for someone to help them and to learn. I feel I have that in my school right now. I never did before. This place is different. People care here. I feel comfortable with everybody. They help me whenever I need help, they tell me I can do things, and they let me do things on my own.

And they were interested in my shoe [artmaking]. They wanted to hear my story, what happened when I worked with Miss Christa, saw what I did every time, and just cared. It was so cool to do this. I got to say things and talk about things I never did before. And then to know teachers were going to learn from me, well hopefully. I don't think most adults even listen to kids especially kids like me. I think my art was interesting to people because most people don't think like that. It was like I was teaching them through my art and they could learn about my life and how I am who I am through my shoe [artmaking]. I wonder how many teachers want to actually learn how to get into the cage and release all of the stuff about me? Do they really want to know about me? Do they really want to learn how to teach me? Do they think they have anything to learn from kids like me or are just bad kids because we learn differently? Something to think about, don't you think?

CHAPTER 4

One of the Best (Because I Worked so Hard on This)

C

I am 12 ½ years old. I am in 7th grade. I might be moving soon. I am going to a group home closer to my family. I am not allowed to be with my family, because they really hurt me. I am going to move closer to them. I don't know if I will ever see them or if I can live with them again. I don't know if they will let me. I am far from my home and my family.

My shoe is the best thing I ever did in my life. And it's about my life. I worked so hard on this. I think it's the hardest thing I ever did and I had so much fun doing it. It was hard on me and so many times I was tired. I was tired because of how much I had to think. I never was asked to think like that before. It was cool. And there wasn't anything I said that scared Miss Christa. She was cool with everything I said. It wasn't about being wrong or right. Miss Christa told me it couldn't be wrong because it was about me and my life and what I could teach teachers. I never thought I could do that! But here I am. I wrote more for my shoe than I think I have in my whole life. I kept asking Miss Christa how many words I wrote. She would tell me and I was so happy. I had things to say and what I did would be in a book! A real book! I never thought I would do this kind of art or be allowed to and then I got to be in a book? That's cool!

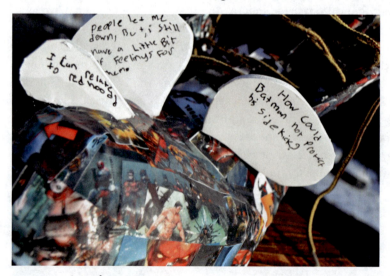

FIGURE 4.1 Art and comics

ONE OF THE BEST (BECAUSE I WORKED SO HARD ON THIS) 63

Like I said, I never did anything like this before. It was the first time I ever made art like this. I worked so hard on my art. It was important to me. I wasn't sure how to display it. Do I have anyone who put it on a table? Do I put it on a shelf? Do I put it on a desk? I never owned art before. I never had my own art. I got to put my favorite superheroes in my art. I LOVED doing this. I don't talk about what is going on inside of me, but I got to talk about what's on the inside in my shoe. We had the chance to make shoes into art. I thought it was weird at first, because I actually wanted a pair of boots. I picked the biggest, toughest boots I could find for my art. We did something called, "walking in my shoes." It's about learning what it is like to be me. And then, we got the chance to talk about what it is like to be us in school and what teachers could have done for us. Our lives might have been different if we had someone to talk to. I never had a teacher to talk to like this. We all need one. I have a teacher here now. She cares about me, but this was my first time with someone like this.

It's hard to trust people, because I have been hurt so much. The way I have been treated is not right. I didn't have a choice. This was my family. I didn't ask for this family. Me and my sister had to be with them. I was taken away, and I don't think it's right for me to have to leave. I don't have anyone. I am all alone.

I made up my champion. I don't have anyone who is my champion. I just don't want to share who could be my champion. This is why I like superheroes who are good and do evil. They are called anti-heroes. Some of my favorite anti-heroes are Redhood, Deathstroke, and Deadpool. If you are

FIGURE 4.2 I am deadpool

FIGURE 4.3 I can relate to deadpool's life

going to walk in my shoes, then you need to know I love Redhood, Deathstroke, and Deadpool. I covered my shoe with comics. And I put sayings on my boot, because I can relate to them.

Redhood is actually Robin from Batman. Robin got upset, because Batman couldn't do nothing to save him. Joker kept on hurting Robin, and Batman just stood there and looked at him. He didn't do anything to save him. Joker blew up the place. Robin died, and he was put in the pit of life. The pit of life brought Robin back to life. He became human again. But he changed. He became Redhood. When Robin saw Joker again, he knew Batman couldn't protect him. There was nothing Robin could do. He thought how could Batman not protect his sidekick? How could that be? The Joker stabs Batman, but Redhood risks his life to save Batman? Redhood went to save Batman even though he was hurt. He still cared about Batman. Redhood actually jumped in front and saved Batman. You know, I can relate to Redhood, because people let me down, but I still have a little feelings for them. I have been hurt so many times by people I loved and it changed me. I get so angry inside and even though I want to do good, sometimes I do bad things. I go back and forth just like them.

Sometimes the people who let me down are the kids here. They don't give me something, and then they let me down or they tell someone to do something for me, but they don't really mean it. I need people to really mean it, you know?

ONE OF THE BEST (BECAUSE I WORKED SO HARD ON THIS) 65

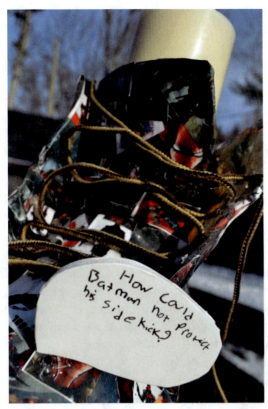

FIGURE 4.4
The candle symbolizes hope for me

I live here in a cottage. I have lived here for a little bit. I live here because I can't live with my family. They took me away from them.

I also like Deathstroke, who was a super soldier who could not live up to those responsibilities. Why? It was too hard for him. He couldn't control his anger at first, but then he could when he got older. He's a lot like me. Deathstroke was willing to work hard, just like me.

Deadpool had teleportation. He could go easily from one place to another. Deadpool has weapons. He also has a human factor. The human factor burned his face. Now, it's messed up. He is smart. He hurts, but he won't die. He's a survivor. Deadpool is always trying to protect himself, like me. Do you see this tear? He is not the man he used to be. He cried. His girlfriend kicked him out. It hurt him. I didn't realize this until now, but we have a lot in common. I am a survivor, because I am going through a lot.

I lived in another city in a different facility. Before that, I lived at home. I lived with my mom, dad, sister, and brother. My sister and brother are a lot older than me. I don't remember seeing them. My mom and dad still live in . I used to be real bad. I lied. I stole. I was mean. My parents never really did

anything for me even when I did have good days. They still said no to me about anything.

The only person who did things for me was my dad. He would get me little toys. I would open them up and put them together and play with them. My dad might get me two small halo figures, if I was good.

I always thought about saving money. My family was broke. I sometimes wondered if we would live on the streets. I worried about that. But my sister was different than me. She has disabilities, but she is smart still too. She can walk, but I forgot what he told me, but he said she can't work for some reason. My sister gives my parents her money so they can live.

I was always angry. I was kinda like...frustrated. I didn't really like anybody. No one would ever believe me about what was happening to me. I would always need help...personal help...but my parents were always mean to me. I needed a Batman. I needed a Robin.

My dad actually took me there to my first facility. My mom and dad were sick of me, so they took me to a facility. One time I had hundreds of sentences to write, and it took me 20 weeks to write a thousand sentences. When I got done, my parents said, "Good job..." and then they just threw it all away. It really upset me, because I took all this time to do this for them.

I was always scared at home, because my parents hurt me. I stole knives, because I was scared. I was afraid of being hurt by my mom. My mom says she doesn't regret hurting me. She cut me. She said she was struggling to get it from me, but that's not true. I was crying and I ran. She told me to come back or

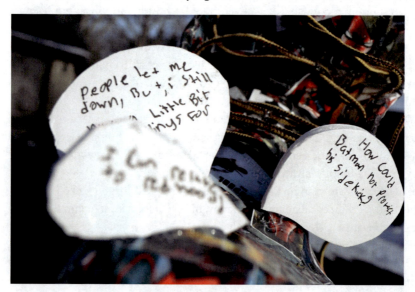

FIGURE 4.5 How could you leave me behind?

ONE OF THE BEST (BECAUSE I WORKED SO HARD ON THIS) 67

else I would get a worse consequence. I wouldn't go, because I knew what was coming. I was going to get hurt.

I got sick of it one day, and that was the day I said, "If my mom keeps hurting me, I will destroy this house" so I burned some of her stuff. I burned a chair, but I put it out. I would punch the picture frames and broke them. I told her, "Now you know how I feel." I always like to sharpen rocks and stuff, because I just wanted to protect myself. I still had my hands. She said she would cut them off.

When or if I go home, I am learning I need to walk away if I am angry. I am going to go to a foster home. I am not going home to my family. I really want someplace nice to go. I am happy now. I have learned that going back home is still dangerous. In my new family, I would like animals and a sibling my age so I can relate to them and they know what I mean. I want to someone to play with and I want to have some friends there. I want my foster parents to be nice, respectful, and caring. I want someone to ask me what my needs are. This is why I have a candle lit in my shoe. This is the hope I have for myself. I hope I will have a nice family and friends.

I think teachers need to listen to kids. They need to know that when we tell them something, they should listen and care about what we say. No one cared about what I was going through. That hurt. Teachers need to care. They just do. Only one teacher ever wished me a happy birthday. She made me a cake. I still remember that. No one ever made me a cake. When I say no one, I mean no one, not anyone. No one ever cared it was my birthday. I think teachers just wanted me to go away like my family. I was invisible. I am invisible. Do teachers really want to know us? What do they even know? I can't even listen to you if you don't hear me. I can't learn if I don't think you care. Do you know that? Some of us have a lot on our minds. I mean a lot. And we are going through things we don't even know how to talk about. You need to know we matter. We do. You have to take time to know us and maybe we will share more. It's not a promise, but it's a first step. At least it's a first step in the right direction. You need to show us you actually want us to learn and that you believe in us and you love us. If you can't do that, then you probably shouldn't be a teacher. Why would you want to be a teacher if you don't like us? It doesn't really make a lot of sense. We don't have families who care about us in the first place, so going to school and being lonely there too, well, it hurts.

I was able to tell people about my life in my shoe [artmaking]. I needed that. It's hard for me to talk. I am a quiet kid. I just keep to myself, but when I worked with Miss Christa, I could do what I wanted. She let me talk about what I wanted to talk about and typed everything I said. She would ask me to read it back to her to make sure she got it all, and she did. Then she would ask me to go through it and add more or take things away if I wanted. I liked it all.

I didn't know I could say so much. After we talked, I wanted to take the comic idea and put it in my shoe. We talked about the way the comics were like my life. I never thought about this and then I thought this is probably why I like them so much. They are me and I am them. I decided to make my shoe like a comic with bubbles. I put things in the bubbles that mattered to me. I worked so hard on this. I can't tell you. It was so much work and I am SO proud of myself! I wish other kids like me had a chance to do this stuff. I think they could learn so much about themselves and feel good for once. And I think their teachers need to learn about them. My teachers had no idea I thought like this or could do this art. They were amazed and said nice things to me.

So if you are a teacher or a principal, you might be doing all of this wrong. How many kids do you actually know in your school? Why do you want to be a teacher or a principal? Do you want to work with kids like me, because there are a lot of us out there. We are definitely invisible in most schools, but believe me, we watch you. We hear you. We know you, but do you know us? If you can't give us art and let us learn, what's the point? I did more this year than my whole life and no one thought it could happen, but it did. Do you want to know about us? How much do you listen? How much time do you spend telling kids what to do? If you don't listen or believe us, we will not talk to you anymore. And if that happens, you can't think we want to learn anything from you. I hope you understand. I worked hard. Teachers noticed here. They never noticed me in my other schools. Do you see me? Do you want to see me? Do you want me to learn? Do you want to learn from me?

CHAPTER 5

"Acception"

T

I would not say I have done anything like this before. It was off the charts. It was interesting and it made me have to think. I had to think about what I am talking about and wanting to imagine what this could actually be. When I learned I could be my own artist and my own author, I realize you can do this at any point in your life, but knowing the community would be a part of what I did was amazing. I wanted it to look good. I took pride in my work. I think everyone did. There was no way to make this bad. If anyone thought that, then no cookies or cake for them, because it was their story. It was their work. You can't judge us. I experienced this as a student, because I was different. People need to take the time to get to know us and understand us. We matter, but not everyone thinks so. This is why I made up my own word. I made up the word "acception," because we need to accept kids like me and it should not be the exception. Make sense? And so many of my teachers would never think that someone like me is actually smart because I am at this school and I have always been in special education or at least that's how it feels, but I want all of you to know that kids like me can learn and do learn. It amazes me how many teachers and principals think we can't do and push us aside. So many kids don't want to be our friends because we are different, but it shouldn't be that way. They have no idea how hard it is to be a kid like me. They have no idea what goes on in my head and what I used to go home to before my grandparents took me in. It can be very sad, but I am trying to help you with my art. You need to rethink some things because I don't see things changing any time soon. At least, I didn't see anything changing in any of my schools, but maybe it's different in your school, but I doubt it.

My art was cool. It was powerful. I kept wanting to add to it all the time. I had so much to say and I guess I really didn't want it to end. Maybe that's it. Maybe that is part of the art. It was the first time I could just be me and I was accepted as me. Miss Christa didn't make me be someone else. She was genuinely interested in everything I said. And they we talked about how to take what I wrote and put it into my boot I picked out.

This art was not complete until it had something more. I couldn't make it simple. It was important to add details. It was important to know I put thought into everything I did. This was not easy. I wanted people to understand there is a need to look at things from many angles. It isn't easy to know someone.

FIGURE 5.1
All should be welcome: Kids like me

I had to trust to let someone know my story. This takes time. When your kids, it might seem like it's easy to make friends, but it always isn't.

It helped that Miss Christa gave thought into what we were doing. She didn't just come in and say we needed to do this. She came in and took her time to tell us what was going on. Miss Christa explained it to us several times. I didn't know her, but then I got to know her, and that helped me. I was able to tell her my story and work with her once she and I got to know each other. I really liked seeing that she cared about me. I felt her care about me. She showed me that by coming to my classroom and talking with me. She didn't come in and tell us what to do which is what we are used to. She really cared about us. And when I felt that, I wanted to do more. The more I dived into this, the more I realized how smart I was. I think I am so used to feeling stupid that I stop trying. I don't want to make mistakes and I am very sensitive. So when I feel like I can't do something, I need people to be calm and understanding. I can do things, but I have to feel safe and know it's okay to make mistakes. We all do, but sometimes failure is really hard when a teacher is coming down on you or when you don't have any friends to talk to. Miss Christa was like a friend I wanted in

"ACCEPTION" 71

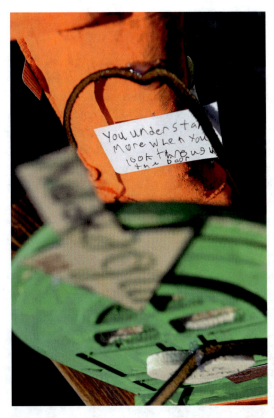

FIGURE 5.2
Reflecting and understanding me

my life. She made me laugh and she listened to me. The more we talked, the more I shared. The more I shared, the more I thought about my life. I never did anything like this before and it was hard to watch it end. I hope all kids get a chance to do this art. It's just amazing!

It was an interesting experience. This was a process. It had to develop organically. It became more than what was written down. It just happened over time and the more I thought about it and talked with Christa, the deeper I got. It was like I was living through my shoe [art]. It was about Christa getting to know me and me getting to know Christa. My art was about relationships and what I wanted and needed from people. And for the first time, I actually lived this through my art with Christa. I was able to talk through these things that I never did before. I usually don't talk about deep things, but this time it was different. I wanted to share my story. I wanted to share my story through my art. But in order to do that, I needed to trust her and it needed to be more than simplistic [art], because people are so much more than that. So, doing my art was complicated and took time. It was a give and take, like a dance sort of. And as I gave, I learned more about myself. And as I learned more about myself,

I opened up and was ready to share my art with people I didn't even know or even met.

I never thought something like that would have happened, but it did. And it was this not knowing that kept inspiring me to think deeper and figure out how to translate that into my shoe. I never knew what to expect and that was exciting. I usually like to know what I am getting into, but this was different. I was actually making a shoe [art] of what the world should be like for all kids, especially kids like me who don't have friends, are made fun of, and who are lonely because we just don't belong. But here, in my art, I belonged. I was important to the art. I was important to the message. And this was the first time anything like that ever happened to me in school. For the first time, I wasn't asked to be someone else. I was asked to be me. I am pretty weird sometimes, but I am very smart. Teachers treat me like I'm not, but I am. I know that, but sometimes my mind gets in the way or how I act is just too much for people. When I did my shoe [art], I was accepted for me. Christa told me there were no wrong answers. I never heard of such a thing, but she was telling me the truth. Everything I said was okay. She just asked me over and over again to share more or to explain something to her.

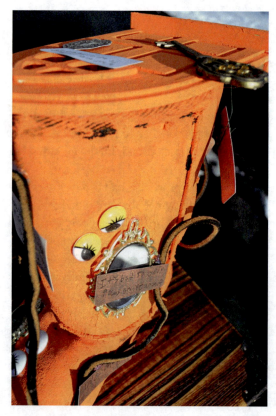

FIGURE 5.3
Learning and growing in my art

"ACCEPTION" 73

I kept seeing myself change every time I went to work on my shoe. It was pretty cool. I looked forward to what I was doing and I was excited to see what I would do next. That's just not like me, but it is now.

Overall, I feel my art was about not needing to change. When I say that, I mean, I am a beautiful person just the way I am. I think I am part of something that is so much bigger than me and kids like me get lost in it. I think that's what I want people to understand. It's about not changing the kids, but changing the schools and the way teachers think about us and the way kids think about us. I am who I am, so I hope that's enough.

I feel the sheer amount of people who came to the exhibit at the museum amazes me. I am so happy to hear people actually came to the exhibit and read my work and looked at my art. I hope they learned something and will do something about welcoming all kids in schools. I can't believe people actually did that and looked at their art for everyone. I can't believe people actually cared. This tells me there is hope. There is actually hope in the world. Maybe someday kids like me will have friends and feel good about going to school. That is a big thing to me.

It's almost interesting that so many people came to the show, because I thought people would be just like "whatever," but that didn't happen. People actually cared. I think anyone who cares about children like me should see this show. I think we can teach people so much more than any text book. Art is made to be shared. I am not sure everyone gets that. I am proud of everyone who did their art and shared their story. It took courage and we all had it in us to do it and to share it.

This is my art abstract:

> **I have always been different.** I really don't fit in most schools. I think the world needs to be a more accepting place. This is why I have a welcome mat and a welcome door on my art. It's the first thing you see. It's important that all kids are welcomed. Everyone should be accepted for who they are, but this doesn't happen in most schools.

I have someone who accepts me for who I am. My champion is Miss E. She worked at my old school. She was always there for me. She would help no matter what and was nice to me. She never yelled at me. She was so patient with me. Miss E would always help me when I was super upset. She even brought a friend in one time and got to the root of the problem. She got straight to the point.

I knew her for about six years. She knew me very well, of course. She wasn't too serious about things. She would joke with me. She was just nice to me no

FIGURE 5.4
What does it mean to be different?

FIGURE 5.5 People actually cared about my art

matter what. So many people don't let me finish, but she did. She was a good listener. She would always pay attention, but you might not think she was, but believe me, she was. Even if she was typing, she listened.

She also helped other kids. She would check in on me and talk. I had lunch bunch with her and we played a game. Once a week we would come to her. Actually, when it originated, I had troubles with other kids and Miss Blackbird made it for kids like me. And then, it was opened up to other kids and a lot of kids would come to her room and spend time with her.

Miss E. would make me listen to myself and think about what I was saying. Sometimes other kids weren't very nice and she would be there. She knew what to do. She was a second mom to me. You know, moms always know what to do. In the very rare instances I was hungry, she would give me a snack. She knew who I was.

There wasn't a student she didn't like. She knew me as a person. Miss E. even came to my house for a home visit. That meant a lot to me. I got choked up, especially with her card and everyone's card in general. They enjoyed that I was different and accepted me.

Most people don't always accept other kids. It's like that group of 50–100 compared to most people. They ALL ended up accepting me. I was the person who stood out the most, but they enjoyed ME.

At first, they thought I was annoying and then they liked me. They could see who I was and then they accepted me. If word gets out sometimes and people think you are annoying, then sometimes people just think that's how it is. That doesn't mean that's how it really is, but you know how people talk. What

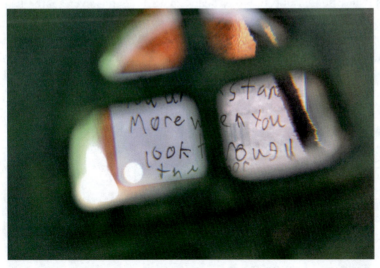

FIGURE 5.6 Looking through the window of my door and what do you see?

FIGURE 5.7 The door, the lock, and the key

people call 'normal' might be really strict, and they might only accept one or two kinds of kids who are 'different.'

I live with my grandma and grandpa. I have lived with them since I was 18 months old. They are my legal guardians. I am able to live with my Mom, but I am more comfortable with my grandparents. I don't think my Mom would be good for me. I have lived with my grandma and grandpa so long, so there is no point in changing it now. My grandparents are my Mom's mom and dad. My mom has issues. She has lots of issues I can't share. I did, however, share those with Miss Christa privately.

I go to Mom's sometimes, every other weekend. My mom has someone in her life. He is my stepdad. I don't know anything about him except that he is really good at math. My mom, dad, and grandma and grandpa told me about him. I have been at this school for 3–5 months. I came here because I have emotional outbursts. I am not dumb. I am smart. I have outbursts and sometimes that makes people think that I am stupid. I am usually in a pretty good mood. People talk about a topic and I am pretty good with continuing the conversation. You say one thing and it goes to another, making memories, and my thoughts just come out.

I am pretty good at keeping things in that are unnecessary or mean. My outbursts are random. Things are going on and I am learning to take care of myself. What's weird about it? You meet other kids and I have a hard time making friends. I have friends from X-box and they are nicer to me than other kids. I jump to help them and ask them if they are okay. Immediately, I feel the need to help others.

"ACCEPTION" 77

It's like I learned from my therapists-sometimes he would be upset and I would be like, "Come over and sit down here, Mister." And then it would go from there.

I talk to people, especially people who are in need. I crouch down so I can see their face. I talk to them directly. I try to help. I told the teacher I can't help helping others. It's just a part of me and it became the focus of my art.

I enjoy plants and stuff. I like to read. I love cats because they are calm. I feel like they are listening to me. They are my best friends. They lay with me and listen to me.

I spend most of the time in the basement alone. It's where I have my X-Box and the cats. It takes a while, but I am like them. They are relatable. They are smart in general. They just like me the way I am. I know that. They don't judge me like kids and teachers do.

When you look at my art, I would want most teachers to know that they think they know what children are feeling, but they don't. You still need to trust children even though they make bad choices. It's not what they are all about. They just made a mistake. The kids want to earn your trust. The more difficult the child, the more they want and need your love.

You can't control how kids are. The way they are is the way they should be accepted. Some of them need to be taken straight forward, but teachers need to be patient. Kicking kids out of the room is not the best thing. You want to keep kids in a group, but not if it's a fight. Kicking them out and making them feel like they don't belong will just upset them. It might be a 50/50 chance, but you want to meet the kids and really know them. I mean, really know them. If you don't know them, then you can't possibly help them.

Miss E really knew me, and that's why she could help me. Everyone is different and sometimes different consequences are needed for different kids. For example, not allowing me to finish my words. It's hard for me and for other kids, I would imagine. I might want to say it once. I might say something twice, but teachers need to learn how to listen.

On my shoe, I have a window right up front. If you look through the window, you will see an important message: You understand more when you look through the door. This means you need to take time and understand kids. You need to listen and look through the window. See people for who they really are. I also put mirrors on there, because people spend too much time thinking about themselves. I want people to reflect on this. I want people to think about how bad it is for people just to focus on themselves. We need to accept others, love and care for people, pay attention to what is really going on, learn to listen, embrace differences, and think about what we have to offer people. I think trust is the key, and if you have trust, then you realize differences are good things. I have been different my whole life. There should be no secrets

78 T

and I shared my life with you. You can open the door, because it's not locked. On the inside is part of my story in a bottle, but it's not sealed. I am like an open book. I want people to accept me for me and accept others for who they are. I chose orange for the door and the shoe because I think it is a friendly and exciting color, just like me.

I want teachers and principals to think about their kids and know what they really need. Remember, we are human beings. It might be hard to know what we need, but it's something we need to try to do. I am not trying to be mean when I say this, but I feel like some teachers and principals do not take the time to understand their students, because during the year, if you don't know them, then it comes across that you don't care. Each and every student matters, at least in small groups, try to understand them better. Know how they feel. I'm not trying to give teachers and principals homework, but this is not a paycheck. It's about knowing your children. If they get to know you, they will know you for the rest of their lives. You will be part of their memory. I knew someone who kept a letter from a teacher when he was in the military. When he graduated, he took out the letter and went right to her, because that's how important she was to him. Teachers and principals, take the time to understand your children.

Final Thoughts

Teachers and principals need to pay more attention to children like me. Things happen and people don't notice. Sometimes it's almost like people think "these kinds of things just happen in the world," but they don't. Kids like me go through so much and people just don't think we are capable of doing much of anything. No one thought I could do this art. No one thought I could write this much or say the things I said. I never did this much work in my life. I didn't know I could, but I did it. My art was deep. It got to me and I got through people in my art. I don't ever remember being given this chance before. I never did stuff like this with art. It was something all kids should be able to do. The key is you have to believe what kids say is important. You need to know we matter and actually believe it. You have to not pass judgment on us and think we are our bad choices. You have to know the art lets us be free. We get to do things we just aren't allowed to do. What are those things? We get to think on our own. We get to make choices of what we want to do. We get to tell you what's important and why. We get to actually make decisions and create art that people think is amazing, because it is.

It's important for you to know this: Teachers and principals cannot give up on us! We do try out best. Sometimes our best isn't enough for them. We are so

used to failing that we need to celebrate the baby steps, don't you think? There is something for us to be proud of. And it's sad when you don't see it. We need you to see it.

I think teachers and principals need to know we are not all the same, but there are things we should all be involved in. We should not be left out. Did you see my title for my chapter? I made up a word. It's the word "acception" because we need to "accept" one another and make each other welcome. We are part of team, but not everyone knows that or does that. It's not right, but it needs to be done. Bottom line: Pay attention to us! The smallest details matter. Don't overlook us. We notice when you do. We feel it too. The point of teaching is to help more than anything else. It's understanding us. We can learn. We are intelligent. We are standing right here. Notice us.

CHAPTER 6

Princess

A

I did art at my old school. I drew people and I colored it. I made animals and stuff. I never did anything about my life or my story before. I was happy to do it. I liked to tell my feelings and stuff. I don't really talk about my feelings and stuff, but I did this in my art. I was exhausted at first. I didn't really know Miss Christa. I wasn't sure if I could trust her. I started talking to her and it got easy. It got real easy. She thought I was creative and she believed I could do this and make a shoe. If you don't know about the shoe, it's my art. We are doing "walking in our shoes" so you can learn about us and learn how to teach us better. We are trying to tell people about us in our shoe [art].

The more I worked with Miss Christa, the more I told myself to talk. I just felt that talking was a good thing even though I didn't do that before. It felt good to let it out. I had things in my head. I kept them there a long time. If I could help a teacher be better, then I thought I could use my shoe to tell my story. Maybe, just maybe a teacher could learn from me and work better with kids like me. So, myself said, "Okay." I think I said "okay" to myself, because I wanted to get to know her. I want to know people, but I am shy. It takes time.

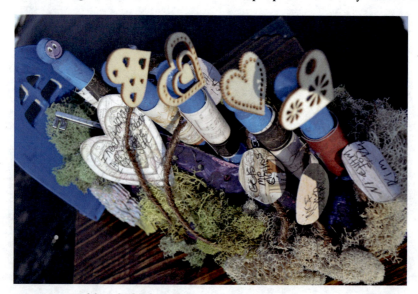

FIGURE 6.1 My life and school time line

I was happy when I worked on my shoe. I liked doing art. I liked doing the painting. I was excited. I love art stuff. I was happy to talk about K. I don't get chances to talk about my foster mom K. This was a chance for me to talk about her. I was scared at first to talk about her. I was scared to talk. I thought people might judge me, but that didn't happen. Everyone thought my art was "nice," "beautiful," "great job," and they were so "happy" I shared my feelings in my shoe.

When I finished, I was so happy and excited. I looked forward to doing the art. I like when people give me compliments. I worked hard. I put thought into my art when I was in the hospital. I had to share my feelings and stuff. I enjoyed doing this.

I think people must have liked what I did. It surprises me over 600 people came. I can't believe they wanted to do that. I never had anything like that happen to me before. I would like to do this again. I hope people learned that we are creative and that I am smart. I think teachers and principals need to know what I have been through. They need to know this so they don't do other kids like that. I don't want them to tell parents who are going to hurt them what they do in school. If they knew me, then they could have actually helped me. They would have known to believe me.

This is my abstract for my art:

My mom's name is K. She is my foster mom and she is my champion. My art is all about my mom and what she has done for me. I have been

FIGURE 6.2 All my feelings

FIGURE 6.3
Love

with K about a week and a half. She is nice. Her mind is nice. She gives kids chances. I like that about her. I live with my mom, my foster sister, and myself. My foster sister likes basketball, just like me. She is older than me. She is 17.

I painted the shoe purple, because K loves purple. I put bridges on my shoes. They are made out of wire and twine. Each of these bridges is about what K does for me and how she is moving closer to my heart. Each bridge has something on it. Each time she does these things, she gets closer to my heart and my sharing everything with her. Like, K takes me shopping. She gets me clothes. K takes me out to eat. I love eating at McDonald's. I get a hamburger and strawberry milkshake. K gives me a home. She listens to me.

I lived in my Mom's house before that. My mom was doing bad stuff to me. I had to leave there. I told people at different hospitals. No one believed me. I told my counselor at a hospital and she worked here. I would say I told five people before someone believed me. That counselor believed my story and then they took me out of my Mom's house. I have not seen my Mom ever since.

FIGURE 6.4 K's face is made of hearts

I never told anyone about what was going on. I don't have anyone to talk to about my Mom. I hold all of those feelings inside. It's hard to hold it all in. I would like to tell someone what I am thinking. When I am at my foster Mom's house, I feel safe. I haven't told her anything yet. It's too soon. Maybe someday I will tell her, but I don't know when. I put a blue door at the back of my shoe to let K know I want to let her in some day. She is also made out of blue. I put hearts on the door, because I want to let her into my heart. I want to love her. I know she loves me. If she wants to get there, then I need to know she really cares about me by showing me and I have to feel safe. I feel safe with my mom (K) and I will watch to see if she keeps loving me. This is why her face is made of hearts. She is showing me she loves me. I know she loves me. And someday I can love her.

It takes time to love someone, so at the bottom of my shoe is brown. As Kim shows me she loves me, the brown turns to light green and then the light green will turn to a dark green. In the dark green, I have flowers. This is my garden. All of this shows growth…turning from brown to green with flowers. I want to let K know everything about me. And at the very top, I put K there. She has a smiley face there. That is Kim. She is so happy, because now she is getting to know me. She is getting to know all of my secrets. This is my hope and that's why she's at the very top of my shoe.

My advice to teachers and principals is to help kids. I don't think my teachers and principal cared about me. My teachers would tell my mom what I said about what was happening at home, and then, when I got home, I got in

84

FIGURE 6.5
Show me you love me

FIGURE 6.6 K, my princess

trouble. I would get beat. I didn't tell my teachers what happened after that, because telling them only got me in more trouble. Instead of believing me, they kept telling my mom and then she kept beating me. My teachers were mean. They would yell at me. I don't remember what they yelled at me about. I didn't feel safe at school. I didn't want to learn from them. They were so mean and didn't care. I don't think they liked me or kids like me. I want teachers to be nice to all kids. This is important. And they need to listen and believe kids when they tell them something like this, because I didn't think they cared at all. They didn't help me.

Final Thoughts

In school, I am sorry for whatever I did that was wrong. Kids are sorry for what they do wrong, but teachers should know we are still good on the inside. We aren't bad kids. We might make mistakes, but we are good on the inside. Do you see that? Do you just see the bad? Teachers and even the principals I only saw if I was in trouble need to learn to believe kids.

I wasn't lying about what was happening at home. I was scared. No one believed me. I needed help. I didn't get help. I think teachers and principals should take a class on that. Don't you know how to get to know kids and why it's important? It's important. Just because I am me doesn't mean you can ignore me or put me down. Teachers and principals need to take a class on believing

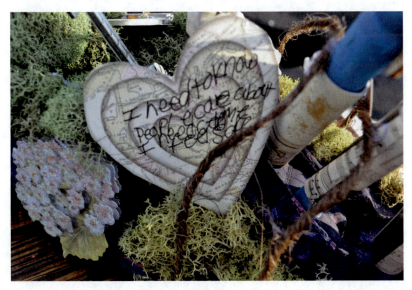

FIGURE 6.7 I need to feel safe and loved to learn

kids. I think they would learn good stuff like playing with kids and being nice to them. I think they can change and learn. We can, so why can't they? I think they would learn how to help kids in school. I needed that, but it didn't happen. It made me very sad inside.

Doing this art helped me. I was calm. I was relaxed. I did this for a long time and never complained. I really enjoyed talking and putting this all together. I liked my art. It said so much. I never could say anything like this without my shoe. My art said more than I think I have said in class or with K. I hope teachers can learn something from my shoe. I wonder if they would like to walk in my shoe. Would they feel the same way as me? Would they think like me too? Do they know what it's like to be a kid like me and go from foster home to foster home and be told you can't learn because you go to special teachers and in special classrooms? I get treated like I can't do anything, but as you can see, I can and it's beautiful and it's me. It's all me.

CHAPTER 7

The Flame of Anger

L

I am 13 and I am in 7th grade. I have never done anything like this before. This was my first experience doing art likwe this. I think I did art before but it would have been in art class. This was different. This was in all of my classes except for gym. I wish all kids like me had the chance to do this art. Not just art, but art like this. This was something else! I got to say things and think about things without getting in trouble. And then I would take what I talked about and think about how to put it on the shoe I picked out for my art. That was cool!

I have all kinds of anger balled up inside of me. This was a chance for me to get my anger out without getting in trouble. I always got in trouble with my anger. I let it get the best of me and the flames would just take over. Those flames ran deep. They ran real deep. The anger got harder and harder to deal with and I just blew up all the time. I got in so much trouble in school. They would kick me out, but that's really where I needed to be. The angrier I got, the more I was out of school. I am not sure how that helps kids like me 'cause we really can't learn at home when we are kicked out or we can't learn if we sitting in the hallway by ourselves. We can't teach ourselves. So many times, we just need someone to talk to or to be with or to just care and ask about our day. And people who encouraged me at this school were letting the flames out. They were letting the flames out because I thought they cared and they listened. The flames represent my anger, because I have a lot of anger inside.

I thought this art was pretty cool. I had the chance to let people know how artistic I am. They also learned people loved me and people who encouraged me to do the right thing mattered to me. I let them know about me and how much I am learning about myself. I need to let things out in a positive way. I learned this in doing my art. I am pretty sure I never said that before. That's a big deal! I realized that I need more of this than I let on almost all the time. I have a hard shell, you know. I come across as a badass, but on the inside I am mush. I want to just be me, but I am not letting anyone in until they prove to me they are good people. I watch closely, you need to know we all do. We need to know that what you say is what you do. I won't learn from you if I can't trust you. I won't learn from you if you truly do not care about me.

I think my art let people know kids like me have a lot of anger inside. We have not been treated with respect. So many of us have been made fun of

© KONINKLIJKE BRILL NV, LEIDEN, 2019 | DOI:10.1163/9789004383890_007

FIGURE 7.1
This girl is on fire

because of how we look, how we talk how we learn, or that we don't have any friends. We have a lot of problems outside of school. And when we are in school, it's even more frustrating. We need to let it out sometime. I hope you are learning kids like me need to learn how to let our anger out. We need to learn how to do this in positive way in schools like this. And it's important for us to learn to respect adults. I may not always want to do that, but I am learning I need to.

This art helped me think about things, learn about my anger, draw things that were important to me, get my anger out in a safe way, and create what it actually looks like to me. I never did anything like this before. It was the first time I let me anger out and I didn't get in trouble. I didn't get in trouble once. Miss Christa listened and asked me questions. She wrote down everything I said and I got to see if she did it right, and she did. I got to read what I said and I thought I did a good job telling people what's going on in my life and other kids. I never wanted to let my anger out. I wanted to keep it inside where it was safe. I didn't want to let my anger out on everyone, because it's just going to push everyone away. So, doing the art let me let my anger out without getting

THE FLAME OF ANGER

in trouble. I talked about my anger. I shared stories of times I was so angry and disappointed in my family. So many people have just left me or hurt me. I am wounded.

When I finished working on this, I felt relieved. I let it out. I couldn't take it anymore. I needed people to know what I was going through. I couldn't use words at that time. I was afraid to use words. I didn't want people to know what I was really thinking. I thought people could get offensive with me and beat me up if I told them. The art helped me tell people what was really going on with me. They could understand me.

I think it's pretty cool to know so many people came to the museum and got to see my art. They got to read my story. I hope they learned that everyone is angry at some time. I hope people understand we have problems that we need help with. We want to do right, but we need help. I need attention. People like me can't handle themselves very well. We get in trouble, go to jail, or get shot. So, when we are at schools like this, I am learning how to deal with people who tease me. I don't have time for this. When I do this, I feel relieved, because I tell the person how I felt versus not saying it and letting it build up.

This is my art abstract:

> **My shoe is on fire!** I have so much anger on the inside and the outside, so I decided to make fire all over my shoe. I also consider myself a glitter girl, so I combined the two and made glitter fire with Miss Christa. I may not have my family anymore, but I do have a champion. My shoe is covered

FIGURE 7.2 This girl is still on fire

with fire, because I have so much anger. I have the blue glitter shapes on my fire, because my champions are like the water to put out the fire. They help me calm down and put my anger out.

Miss K is my champion. I can talk to her and she understands what I have been going through. She will talk to me and give me good choice and gives hugs and stuff. I have been here for 3–4 weeks. I also could trust Ms. O and Ms. W who were people I could talk to at my old school.

I live here in the cottages. At my old school, I was fighting a lot. I was fighting a girl. She kept talking stuff and saying she could beat me up. That happened every day, but I didn't put my hands on her every day. I started fighting when I was in fourth grade in a different school. I fought boys and girls. I started fighting because they were hitting me and pulling my hair. I got suspended and they got suspended. The principal talked to us and said, "It's not good to fight. You have the right to defend yourself." The advice really didn't work. I didn't have anyone to go to talk about anything. They thought we were bugging them.

FIGURE 7.3

What I need and want to learn and grow

THE FLAME OF ANGER 91

I couldn't let my anger out by talking to someone, so I took out my anger on people. I kept it inside. That's not good, because then I explode.

When I was in 7th grade, I argued with my sisters. I was disobeying my mom and fighting at school, and then they took me to school and then my counselor came upstairs. My social workers came and told me I had to go somewhere. I didn't get to say good-bye to my mom. I was very sad and angry about that.

My mom came to visit me two days ago. It was the first time I saw her since I've been here. That's a really long time. I was happy, because I missed her. My mom said, "Hey baby, I missed you." I hugged her first and she gave me a kiss. We had to sit down and talk to a therapist. We had a couple hours together. She got me some shoes. I ended the conversation with a hug and kiss.

I talk to my mom almost every day. I have not seen my sisters since I've been here. They are older than me. They are 17 and 19. They both live at home.

I have been writing all of this down for a long time. I came back to talk with Miss Christa about my fire show. Did you know that while I was waiting, I just found out I won't be able to see my mom ever again. I am being taken from her forever. She did too many bad things to us and now the state is coming in and taking us. Now the state will tell me what do and when I make mistakes. I don't think I like the state being my parent. It doesn't even make sense really. All this means is that strangers are going to come into my life, tell me where to live, what to eat, when to sleep, who I can and can't talk to, where I go to school and just control my life. I don't have any ideas of my own. No one is going to listen to me. But when I do my art with Miss Christa, I get to say what I want and put my words down and she doesn't judge me or tell me what I can or can't do. I am my art. My art is me. And that's good enough. I am not used to that.

Like I said, when I do my art, I think. I have these memories running through my head. After hearing that horrible news about my mom, I realized I would never see the people who become important to me. I meet these people and start to get close to them and then they either leave on their own or I have to leave them. So many times I don't even get to say goodbye.

Some of the anger inside of me is because I just can't see my mom any more. They won't let me see her again. I mean never again. Can you imagine if you were taken away from your family? How angry would you be? Could you learn in school? Do you think you could do anything? Don't you think you might act made to people? And then you would get in trouble, wouldn't you? That's what happens to kids like me. We have nowhere to go and nowhere to put our anger. It's almost like teachers just think we should be able to control ourselves and keep it inside while we are in school. They are allowed to get angry, but we can't. We have to control all of our feelings. I would like to see them do that too

after being told what I was told. I am here and I am not going home anymore. My mom couldn't take it anymore. She didn't want me. She gave me up. I am nothing to her. I wasn't worth it.

How many teachers would have just seen me angry and dismissed it? How many teachers want to take the time to listen and support me? I just don't understand how this happens. How do people become parents? How do people become teachers? Isn't there some kind of test they can take to find out if they would be good parents? If they would be good teachers? If they would be good principals? Why don't kids get a say and decide if the teachers are good enough? Or if foster parents are good enough? It's like we are invisible. It's like I can move my mouth, but no sound comes out.

My Mom was doing crack and cocaine and stuff like that. She was always getting high. She doesn't know how to raise a child. My mom has no clue. She just thinks about herself. I went into foster care when I was five years old. We were all separated. I don't even know where my family is right now. I never went back home. I have been away for eight years.

FIGURE 7.4
Looking deep inside the flame

THE FLAME OF ANGER

What do I wish for? I want a family who will love me and support me. I want a real family. Do you know what a real family is? They would say nice things to me. They wouldn't do cocaine or crack. They would do homework with me. A real family would read to me. A real family would feed me. A real family would tell me I was important to them. I would matter. That is my hope. I think this is why I am so angry. It's really hard. It's exhausting moving from one place to the next. You never know when it's going to stop.

I have been in five foster homes in eight years. If you don't know what that is like, it's really scary. You are always wondering and worrying. Every time I went into a new foster home, it was hard. It was hard for me. Some of my foster families abused me. I didn't tell anyone. I didn't want anyone to know. If they knew, then I would have to go to another foster home. I just wanted to stay in one place even though they abused me. One day I told my social worker what was going in my last foster home, and then, things changed. I kept it all inside, because I just didn't want to leave another home. Do you understand that? I have to change schools and get made fun of again because I am in those special classes that everyone makes fun of you about. I am in those classes because I have anger issues. Why can't they understand why I am so angry?

It's important for you to know that kids like me, well, we get attached to people even though they did bad things. But, you know, I just couldn't take it anymore. I couldn't take the abuse. No one knew almost the whole time. I didn't tell anyone at any of my schools, because I was afraid they would tell my social worker and things would change. I didn't trust any of the teachers. I didn't trust

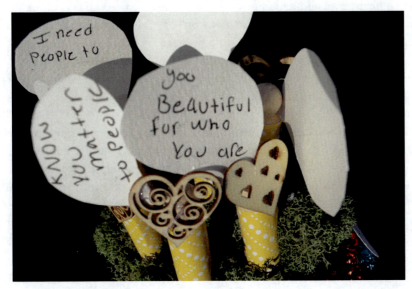

FIGURE 7.5 My heart wants this

anyone. I was alone. Because I didn't trust anyone at school, I could really only tell my social worker.

Every time I switched foster homes, I had to go to a new school. It was okay. No, I take that all back. Honestly, it was horrible. I had to try and make new friends and live with a new foster family. It is hard to get close to people when you are angry, scared, and you don't think anyone understands what you are going through, and you can't trust anyone because people hurt you and lie to you and do very bad things.

I know I keep saying this, but it keeps running in my head. I will never see my Mom again. She cannot be a Mom to me. My twin sister is dead. She died when she was four. My other sister is somewhere, but I don't know where. My brother is adopted somewhere else, but I don't know where. My other sister is with my uncle and aunt on my Mom's side. I don't see her. We are all over and I can't see them. Can you imagine? Would you be angry? Would you be able to keep all of this inside? It's sad. I am here and my mom is out there free. And me, I have to live here. The state wants me to go into another foster home and get to know a new foster family, but I don't have one yet. So, it looks like I will have to adjust again.

I hope my new foster family is nice and cares about me. These kind of families are hard to find. I think I would like to be adopted. I want a permanent family. But did you know the chances of me getting adopted are pretty much telling me it's not going to happen? No one wants a teenager. We are too much trouble and we have been through too much. If I could have a new foster family and maybe even an adopted family, I want to know people can accept me for who I am. Maybe that will or maybe that won't happen. I am so tired. This is so exhausting. I don't think about this stuff, because I get tired. My art is helping me get all of this out and I am not getting in trouble when I let it out. I try to let it go. I try to not focus on it, but I know it's there. And when I do my art, it comes back to my mind and I feel like I can talk about it and put it in my shoe [artmaking].

I am trying to work on not putting my hands on people and ignoring my anger. When I get angry, sometimes it just comes out and I feel like I don't have any control. I don't really get to talk about it or do anything with it if I am not doing my art. It's not like people want to listen to me or take time to do that. At home, my anger was up and down at home. It was good and it was bad. I didn't have any friends or anyone to talk to. I talked to my dogs about my anger. My dogs listened. They didn't judge me at all. They just loved me. I also talked with my mom sometimes. I don't think she understood. My dogs are B and B. They cuddled with me when I was feeling sad. I miss B and B. I am lonely. I don't have my Mom anymore and I don't have my dogs. I am all alone with my anger.

THE FLAME OF ANGER

I don't talk to my friends. They say they are my friends, but I really don't have any because I can't trust them. I just can't share anything personal with people. I don't know what they do or why they are my friends if I can't talk to them. I tend to hold everything in because I don't know how to express it in a good way.

Even though I don't trust anyone and don't really like people because they do bad things most of the time, if you look at the top of my shoe [artmaking], you will see a lot of people. This is what I need in my life. I need a lot of good people who are going to give me good advice. I gave all of these people in my shoe [artmaking] hearts for their faces, because they love me and this is why they are taking time to help me out. I put the green moss on the inside, because it's about me growing. I am growing because I am sharing for the first time and I am using my art. My art is really helping me. I don't talk much to people, but when I am talking to Miss Christa, I feel like I can talk to her through my art and she gets me. I need to learn how to control my anger. I think that if I can take their advice, which is written on the bubbles, then I would be happier and I could grow.

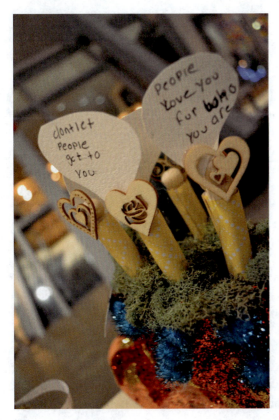

FIGURE 7.6
People who love me give me advice

96 L

This is exactly what teachers and principals need to do for all of their kids. They need to help them. They need to love every kid, especially the kids who need it most like me. We might be angry, but it's not because there is no reason. We are angry because there a lots of reasons. But teachers don't think that way. They just think we are bad kids because we yell, fight, and don't want to do our work. We do, but it's hard with everything we are going through. If we could have teachers who actually knew us, who came to visit us, who ate lunch with us, who played games with us, who spent time with us and got to know us, I think we would come across as good kids to them. They just can't see it. Miss Christa sees it though. And I hope people see I am a good kid in my art. I think it's me. I think it's beautiful. I never did anything like this and I put my heart in it. I know it took so much to do this, but it was worth it. I am a handful. I have a lot of anger on the inside, but I don't want to always be angry. We are not always easy to deal with, but all we want is for people to love us and help us. I just don't understand why it's so hard for people to love us. We aren't trying to be a problem. We may not always like all of the rules, but we need them. We need our champions to help put out the fires. How many teachers do you know would want to really do that?

Final Thoughts

I think teachers and principals need to know that I just want to be loved. I am a kid who has been through hell. Yes, hell. I have too much running in my head sometimes to think about school. I can do the work, but I need to know you will help me and still love me. Sometimes I just need to be able to work through some stuff. My art let me do that. I looked forward to that time every week. I knew I could talk and think and do my work. I knew someone cared about me because she always showed up. She showed me she listened and she got me whatever I needed for my art. I got to make decisions about my art. For once, I got to call the shots. Teachers need to know kids can do that. They can make decisions too.

In the end, I just want people to love me. Why is that so hard for people? I am not sure how you do this, I mean, love people. But all I know is that I do have a good heart. I think teachers and parents and principals need to have good hearts too. I think this should be a requirement. Can't we come up with a test or something to check for this? You know, a requirement before you can be a teacher and work with kids like me. Is that a requirement? Do they test teachers on that? What about principals? Do they love kids? I am not sure how we would do this, but I do know it's really important and it's not

THE FLAME OF ANGER 97

happening. And they need to know we can use art in everything we learn. It helped me think and feel things. Even though it was scary, I needed to do it. I knew I was not only helping myself, but I was helping people who wanted to be teachers and adults who wanted to be principals. Do you think they should be tested?

CHAPTER 8

I Want People to Listen

J

I am 12 years old and I am in 6th grade. I am not using my real name for this chapter. I am using a name that popped in my brain. I am choosing not use my real name, because I don't like it much. I don't like the people who gave me my name. I want to change it because I am not the same person anymore. I am J and I am starting to like J.

It was good when Miss Christa and I first met. What made it good? It was just awesome. I really liked it. I might have come across as having some problems with it because it was hard for me to do and I could be very quiet, but I had fun doing this. I never did anything like this before and I learned I could do this art and I did a great job! I don't think I ever gave myself a compliment before. I have had a lot of first times with Miss Christa and doing this art. None of my teachers thought I would do this. I don't think I thought I could either, but after I met with Miss Christa so much and she worked with me, I thought I could do anything. And I liked how I could take what we talked about and I got to think about how to make it art. I got to make my own shoe [artmaking]. And it was in a museum, I mean, a real art museum!

You need to know something important. After doing this art, I am not the same person I was. I am doing so good here after doing this. I am earning an overnight now. I'm going to use the stuff that I am learning in my foster home. I am going to go back with my Mom soon. I hope I will go back with her someday. I think that is the plan, but I have heard this before. I keep getting put in different schools and different homes. I get new teachers and I just get more and more quiet every time. I can't talk to people I don't trust. They are going to leave me or I am going to leave them. It's just how it is. Nothing stays the same-nothing.

Right now, I have a roof over my head. When I get grown up, I am going to have a good life. I got a new job. I shovel snow. I get $10 for a driveway and stairs. I am saving up for a phone and whatever I want and a way to pay for the phone. I am not going to let no police attack me or do something to me. I am not going to let nothing ever bother me. I am going to a man. I'm not playing around. I am tough. I am really getting along with my foster father. I want to be like him. I'm serious about my life. I have been serious since I have been with him.

© KONINKLIJKE BRILL NV, LEIDEN, 2019 | DOI:10.1163/9789004383890_008

I WANT PEOPLE TO LISTEN

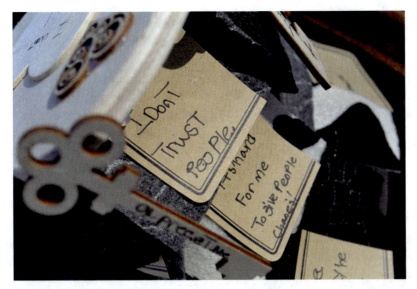

FIGURE 8.1 I put it all out there for people to see

When I met with Miss Christa, I will tell you, this art was hard work. I don't think I ever did anything this hard before. I wrote so many words. I was always thinking. Miss Christa typed everything I said. I would read it out loud and make sure she heard me right. She got it right. I knew she was listening. I don't think that happened before. When I knew she was listening and came when she said she would, I started to let her in.

At first, doing the art was hard at first, because I had to deal with stuff. I had to talk about my problems and my anger. The art helped me. It was like feeling good letting it go and talking and it was like a wound that was healing. The art gave me a hand in my writing because I was never a good writer. But Miss Christa didn't make me write everything which made it so much easier to write. Everything I said, she typed. She showed me everything, even all the times I stopped talking and I read it out loud to make sure I said that and then I worked on what I wanted it to say. It was amazing because I didn't think I had anything important to say, but everyone who read it either cried or got quiet or hugged me or told me I was brave or said what a great job I did sharing what was going on inside and sharing my story. I never even read out loud in class. I was too afraid, but I did read out loud now. I am a good reader and a good writer and a good artist. My work has power.

I talked about from the time I was 10 years old. I never shared my story before. I realized my art is part of my story. The art helped me, because it made me talk about things and work on things that were hard for me. At first, I wasn't going to share anything with anyone. But then, I started to feel more comfortable

sharing what I was doing. I went from hiding everything on the inside under my art to sharing some of it on the outside. I didn't share everything because I might scare some people with things that happened to me, but I needed people to know about my anger and where some of it comes from.

Miss Christa was so surprised when I decided to put things on the outside of the cloth. She said, "Oh my gosh, you are so brave!" I felt so courageous when she said that to me. I felt brave. I knew she cared about me. Miss Christa knew I was trying hard to share my story. Sometimes I sat in quiet. Other times I talked a lot. Sometimes I talked a little. Sometimes I didn't want to leave. I always wanted to go and work on it which I think surprised my teachers. They never saw me like that before. It was exciting, but it was hard. I never liked art class. I always felt like I made too many mistakes. I thought my art was no good, but I was good at this. I started going to art class without my teachers having to say anything to me. My art teacher couldn't believe it. I even talked in art class. That never happened. I was feeling good inside.

I really liked doing the art because it all made sense to me. I realized I was helping people who wanted to be teachers or anyone who wanted to work with kids like me. For the first time, I got to say what I wanted to say and no one interrupted me and no one told me what I was thinking was wrong. Miss Christa didn't get upset with me even when it was hard for me to share. She supported me. When I finished my art, I was happy. I was proud of myself. I made it. I shared my story for the first time. I finished. I didn't give up. I want to start things and work all the way through them.

I couldn't believe over 600 people saw my art. I wanted to see people give me love. Miss Christa worked with me all that time and it was a lot of time and all of those people came to the show. I can't believe all of those people came. I never had that happen before. So many people gave me attention. So many people gave me love. And that's what we all need, isn't it? Don't we all need love? Even if kids like me seem so angry, there is a reason for it. You have to figure that out because there are so many reasons we won't tell you what's going on. But if you can say no to giving up on us, I think you will be happy with the results.

I just want people to say "good job," "you're awesome," "I love you," "You're a good man," and "You have a good heart." I hope my art will help people. I need people to give me attention. I need people to show me they love me. I didn't have that before. I have that now.

After doing this art, I am a changed man. It's like I changed overnight. I am more brave and more courageous now. I talk a little more. I share a little more. I never did that before. I say nice things about myself. I go to class. I work in

class. I feel good more times now. I go to art class and I talk and I do my art. I want to thank myself for being the greatest dude ever.

This is my abstract:

> **I don't trust people.** I wanted to cover my shoe with hidden doors. I made them out of cloth. Some of my secrets are under the doors and other things I am thinking about are on the outside. This was not easy for me, but I decided which ones to put on the inside and which ones to put on the outside. My heart is on the top of my shoe. It is sealed, because it is not easy for me to trust you. I have been hurt many times. I want love! That's all I want! I put words on the keys so you know what you need to do to show me you love me.

My mother is my champion. She is my champion, plus she gives me hugs, kisses, and tells me I will be in her heart. My foster father is my champion. He gives me structure and love.

I am in a foster home right now. I have been in a foster home for 4 ½ months. I live with my foster dad. He is kinda not funny. I know he loves me. He is serious. He does tough love. That means he is cool, but he is tough to me, not joking.

I'm mad at my mom, because she has all those people in my home. I don't know who they are or why they are even there. I just want to be alone with her. I think they are trying to start something with me.

FIGURE 8.2　I want people to listen

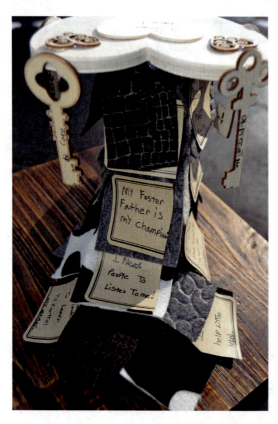

FIGURE 8.3
I am angry and I am loved

I have issues getting my anger out. I do tell lies. I don't like to tell the truth. I also don't always like to listen. I don't want to hurt my mom's feelings. My foster dad wants me to tell her how I really feel, but I don't want to hurt her. I don't think yelling at my own parent is right. I don't think it's right. I don't want to hurt her and her feelings.

I think I need this, because when I was around my mom, I was bad. That's how I ended up hear-disrespecting my teachers, throwing televisions. I would say it was anger. I was 10 when I started acting that way. Up until then, I was with my mom and my little sister, and my aunt, uncle and dad.

My sister was sent off to a foster home for babies. She is four. I miss her. I only see her on my visits. I have visits every weekend. I was happy, because it was her birthday yesterday. I would rather be with mom. My sister had to leave, but the 19 and 20 year olds are out there in the world.

My aunt and uncle are home with my mom, but my dad doesn't live there anymore. He comes over to visit.

I went to school with small classes. The police at school brought me home, because I kept getting suspended. I got beat up by bullying. I acted like I was

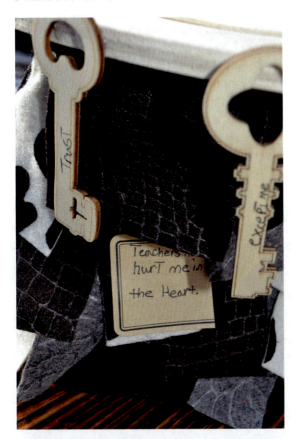

FIGURE 8.4
Don't hurt me

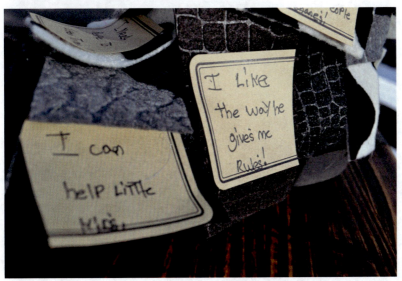

FIGURE 8.5 My likes

tough on the street, but I'm not. I had to keep them from bothering me at school and on my way back home. I would be alone. I told teachers, but all they tried to do was just keep what I tried to do to them as the same thing. They focused on what happened to them. I just want them to leave stuff alone.

A little it happens here. I go crazy sometimes. I count on myself. I can't count on no one else. It works to calm myself down. It works sometimes. I can calm my own self down. I take it easy. I just have to stop. It works. I sit down and be quiet. I need it to be quiet. I know that works. I would say you gotta get your minds off of the stuff we did, because at school, teachers, it's a new day, it's a new month.

I would say don't let the past come to the front. If you keep stuff, then it just upsets us. I think they need to let it go and just give us another chance. The kids also need to stop bullying and coming at other kids. You know, like they are grown. Staff can tell us what to do, but everyone needs to stop. Kids can't tell kids what to do. Only adults can tell us what to do.

I have felt like I wanted to share with someone, but I normally don't want to say anything. I just keep it all in. I don't trust people. I might trust someone

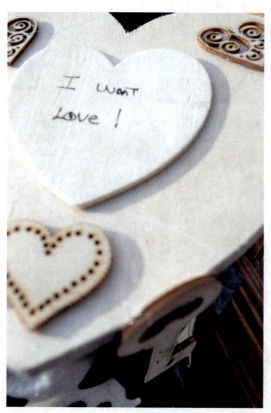

FIGURE 8.6
I want love!

I WANT PEOPLE TO LISTEN

someday. I have to learn to trust myself. I have to get trusted to and I want them to trust me.

Final Thoughts

Teachers and principals need to learn how to listen to kids. They need to know all kids need is love. They just want someone to pay attention to them, to give them compliments, and to help them. Some of us have a lot of anger inside, like me, because we have things on our mind. We have problems. We just want someone to listen and to show us they care.

And doing this art and working through my anger in my art was amazing to me. And showing it in a museum so people could learn about kids like me was the best thing ever! I never did anything like this in any school and EVERY kid should be able to do this art. I mean EVERY kid because you just don't know what's going on in our minds and the art lets you get a sneak peek. It's like a window and you get to look in and try to figure things out except we helped you because we wrote about our art and it was hanging right next to it.

If you can do this as a teacher or a principal and be good to kids and understand them and love them, then you might be let in and if you are let in, there is no telling what might happen. And when I say that, I mean good things, not bad things. Bad things might pop up, but we know you care because you are there. Maybe it's just easier not to care about kids and this is why teachers and principals just pretend it's about reading or math or science or being to class on time, because loving kids takes time and it takes having a heart. Do teachers who work with kids like me understand they need a heart? Do they even know what that means? And principals aren't off the hook. They need all of this too.

CHAPTER 9

Animal Land

L

I am 11 years old and in sixth grade. When I first heard about doing this I was excited. I was excited about making this. I love doing art. I get to draw and make stuff and paint. I like to make things, because I am focused and I get my energy out. I get out my feelings, most importantly. I was happy and nervous when I was doing this art and making my shoe. I didn't want to mess up. When I mess up in school, I feel like I am not doing it right. I feel bad on the inside. I also feel like I mess up outside of school. I sometimes do things wrong, like not riding the horse correctly. And sometimes I mess up in school with my anger. I get out of control sometimes. I am not sure where this comes from, but it has been around a long time. I think it has been around since I could remember. I can remember having anger inside of me way before I lived here. I don't live here anymore, but I remember feeling this way for a long time.

I chose to talk about my mom in my art, because she has always been there for me. I don't want to talk about my siblings. I was the only one who had to come here. They stayed home and went to school. I don't want to talk about why I had to come here. It had nothing to do with my anger. I have a lot of trust

FIGURE 9.1 The fence

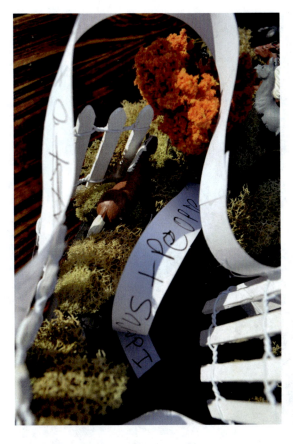

FIGURE 9.2
I do not trust people. I trust horses

issues. I am not sure why. Maybe it has to do with people saying things and then they don't do it.

My art is not just about horses. I used horses for my art, because they are my favorite animal and they calm me down. I love that horses are nice. They are my friends. I talk to them and play with them. I talk to them about my feelings. The horses don't tell anybody. I can trust them. They come by me when I am talking to them. No matter what I say to them, they treat me nice. I used horses to make sure you know animals are so much nicer than people sometimes, well, most of the time. They like me. I can't make mistakes with them. They like me for who I am. I am nervous to talk to adults, because, well, I don't want to talk about it. I am not ready. But I made a fence in my art to tell you I am not ready. I am not ready to let people in, but it's not like I don't want to tell you. I am not ready yet. I need to learn to trust. This will take time.

I hoped people would want to buy my art so it would go to a charity for animals. I wanted the money to go an animal shelter. I think it is awesome

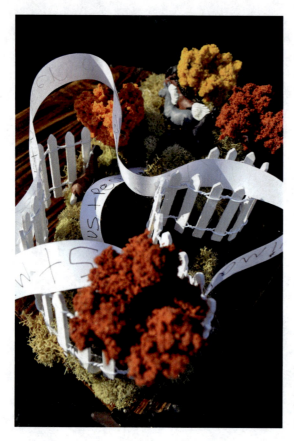

FIGURE 9.3
I am not ready to trust people.
I trust horses

over 600 people came to the show. I think people thought it was good. I hope people learned they need to learn more about kids. They need to know more about them, learn to listen, and know how to help them with them with their feelings and stuff. I feel like every kid is different and special in their own way. They would need to know kids by asking them questions and trying to be their friend. I can't learn from people who don't know me or like me.

Here is my abstract from my art:

> **I love horses. They took our horses away. And I don't like people.** My mom is my champion. She is the only person I like. She taught me how to ride a horse when I was one-year old. My mom likes to ride horses like me, but I like to train them to do tricks, jumps, and jumping through. I live with my mom's boyfriend, my mom, my two brothers (one is older at 13 and one younger at 5), and my little sister. I like my mom's boyfriend. He is nice. M plays with me. He plays "Call of Duty." We kill zombies together. I don't remember when my mom's boyfriend came to live with us.

I have been here since 6th grade. I was in a school like this. I live in town X [I can't tell you where I lived]. I went to a school like this. I never wanted to go to school in my town. They are stupid. All of my friends moved. I don't have any friends. I really never did. I don't have any friends here either. I am lonely. I like to spend time with myself, but I don't want to spend time with myself. I would like to have a friend here. I think this person would be nice to me. It has to be girl. We would play with one another. There aren't any games I like to play.

I'm not feeling good lately. I'm mad about talking. I can't handle noise. I need some peace and quiet. It calms me down. Doing this art can calm me down. It's quiet and no one is bothering me. Miss Christa hears what I am saying. She listens. I never did art like this.

I get so mad! This happens to me a lot at school. It happens to me at home too. I need peace and quiet. I don't feel comfortable sharing anything else with people. I don't like people. I don't like people at all. It's hard to trust them. I have been hurt too many times. This is why I don't like people. I talk to Ms. M who is my therapist. She is the only person I feel comfortable talking to. I put horses and green all around my shoe, because I love animals. I REALLY love horses. People came and took our horses away. I think they did it for no reason, but they came and animal welfare took them. I was very sad.

My Final Thoughts

It makes me sad to know it's hard to trust people, especially adults. I never really liked my teachers or my principal before. They didn't really care about

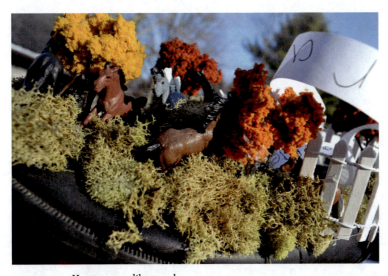

FIGURE 9.4 Horses mean like people

me. I could be there and I don't think anyone really ever noticed. It was like I was invisible. But when I was around my horses, they saw me. They knew it was me and wanted to spend time with me. They didn't tell me I was a bad kid. They actually loved me and got excited to see me. I don't know anyone who gets excited to see me.

I have so much anger inside, but I can't talk about it right now. It felt good to get it out when I worked on my art. I have to get out my feelings, because I don't like to talk. Sometimes, it is so much easier to talk through art. I love doing art. It is fun, but I get nervous sharing my feelings. I was able to share my feelings and I didn't feel like I was making any mistakes. That made me feel good inside. I don't have time to work on art most of the time in school. I never did anything like this. I wish teachers would talk to us more. I wish they would spend more time with us. I would like to talk to them more about my life and what's happening.

Teachers need to know it's hard to trust them. It's really hard. Kids like me don't want to trust you, but we do want to trust you. I hope that makes sense. If I do not trust you, then I will shut you out. Do you understand that? I have been hurt so many times in school. My teachers don't understand me. They don't want to know me. My principals didn't understand me and I don't think any of them even liked kids. I want to know them. I don't know how to ask. I hope they know how to ask. I want them to know who to ask me questions to show they care. They are grownups. Shouldn't they know how to do that?

I only feel comfortable talking to animals most of the time. They love me. They accept me. And my art shows this. It makes me smile to see it. I made that! It's beautiful and I think it's the most beautiful thing I ever made in my life.

CHAPTER 10

Helping Hands

M

I am 12 years old and in sixth grade. This was the first time I ever did anything like this. I can't believe I am writing a chapter for a book, made art, the art went in a museum, over 600 people saw what I did, and now I can try to help teachers and principals learn about kids like me. Wow! That's a lot! So many of my teachers thought I couldn't do anything like I was dumb or something.

I am thinking differently. I didn't know this until now. I never saw myself except for bad. I realize I am a helping hand. I didn't realize this when I did my art. I don't think I ever heard a teacher say I was helpful. I was talking about my mom and my family, but now I realize I am a helping hand. Why? We took in abandoned animals. My dog was three houses down. It was an abandoned house. I saw a pitbull in, because I could see his bones. It was roaming the back yard. The dog pound wanted to know if it was our dog. I knew it needed a home. I took care of it. I wanted to make sure it was fed and I put a leash on it. I named him K. This is my favorite dude from Motor Combat. It is a fighting game and K and S is his brother. I like the name Kano, because the dude I like is very strong. I wanted K to get strong too. He is one-year old now and he is very strong. We also have another dog. My mom rescued a Shitzu. We were walking back from the store. My mom picked it up and we brought it home. We gave it some food and it was pregnant when we found her. We took her to the vet for all of her shots. My mom wanted to make sure we took good care of her. She had puppies. Two of her puppies died, but we are keeping one. Her name is B J, but I want to name her C. The other puppies will go to my grandmother and my aunties. We are all taking care of the dogs.

It was lots of fun to the art. I liked what we did and it was really relaxing. It was cool. It was fun. I don't get to do this in school. I wish I could do this kind of art every day. In art classes, I am not sure why we don't do this kind of stuff. I didn't have to think about school. I didn't have to think about all the things I do wrong. I did a good job on my art and got to talk a lot. No one told me I couldn't talk. I got to talk about me. I got to talk about my project, which focused on my family. I don't talk about my family in school. My cousin is in this school too. He is the only one I would talk to about my family.

I think people liked my art. Every time I showed it to someone, they wanted to know more about it. It was cool! People asked me questions. Many people

FIGURE 10.1 My art is all about me

were surprised I could think. That hurt my feelings. I think all the time. I don't know why people say that. It's mean.

My art was about helping hands, how I am a helping hand, and I hope people liked my art. I can't wait to have it with me. I would like to sell my art and use the money for families who don't have money. I want to give my money away to people who don't have it. Or maybe, I could give the money to get someone a puppy or a dog so they have someone to take care of and someone to love them.

This is my art abstract:

> **My mom.** My champion is my mom. She helps me with my homework, even though we don't have homework here, I know she would help me, because she helped me in my other school. My mom also puts food in my stomach. She puts pizza in there, McDonald's, Poptarts, oatmeal, rice krispy treats, hot fries, and she gives me clothes. My grandma got me this shirt I'm wearing and my mom got me these pants and these shoes. My cousin gave me a basketball hoop that I can pull up on it. My mom buys me stuff for Christmas.

I have other people I put on my shoe. These are my helping hands. I have Grandpa J, Grandpa M, Grandma F, Mom, Grandma T, Step Dad, real Dad, and Grandma V. I wrote on each of the helping hands what each of them give to me. What I need more of is love from other people.

I talk to my mom about everything. The last time I told her about my feelings was yesterday. I told her I was feeling happy. I was happy that my pitbull had puppies on the guest bed. They are still limpy. We got a little crib for them. She had a lot of puppies. My other pitbull is having puppies to. We are going to sell some of them and then the other ones we will give away.

I put all of my champions on my shoe. I covered it in camouflage, because I want to be in the Army someday. I think it would be good for me. I put a red hand in the inside of my shoe, because it is reaching out. It is red for love. That is what I need. I put a heart on each finger, because all I want are for people to love me. I need people to understand me. I need people to accept me.

I have been at this school for a month. I was in Maple Heights. My anger got me from there to here. I haven't always been angry at school. I started to get angry when I was 11. I don't know what happened, but that's when I got in trouble.

I celebrated my birthday here. My teacher here baked me a cake! The frosting tasted like Kool-Aid. My fourth and sixth grade teacher was nice. Her name is Miss Rogers. She made math fun! She used to make raps up using math. Like this, "Fluency, fluency, can't you see, sometimes you just hypnotize me." I didn't get in trouble in her class. Health class was hard for me. I didn't like her. She was aggravating. She did stuff to me. She used to call me "T-MAC." This stood for "the most aggravating child." She called my brother that too. She also called him "Asian dude," because he looked Asian. That was my last period of school and I didn't like her. She used to eat things in front of us and

FIGURE 10.2 In my art I am more than aggravating

we couldn't have those things. That wasn't fair and it wasn't nice to brag about it in front of us.

At my other schools, I would punch people in their head if they went to their locker. I would also punch people if they got me really, really made. I act like this at home. My mom tells me to go in my room or chill out. I don't know what to do with myself. I got all this stuff going on and I just want to hit people. I get mad and I don't know why. I just get really mad.

I also live with my brother and sister. My sister is young is nine and my older brother is 13 and my stepdad, but we don't see him. He lives in XX. His name is S. I saw S recently, but we are going to move to XX with him. That's what I heard. He came into my life when I was 11. He was there on my birthday. He was my mom's best friend. She has known him since fourth grade. They are both 35.

I think teachers need to give kids positive attention. I acted good for my teachers when I was younger. They made learning fun. They liked me and cared about me. I know my teachers at my old schools didn't care about me. I didn't have anyone to tell my feelings and I am not sure I knew how to do that. This is something I am learning, but I need love. I think teachers need to know we have feelings too. Do they learn this in school? How do you become a teacher anyway? Do you have to show love? What if you are a mean person? Can you still be a teacher and work with kids like me?

My Final Thoughts

I want teachers to know we need love too. I don't think teachers even say those words or take time to really know us. It's sad. I need teachers to know about my family. My mom is the only one who has ever called me a helping hand. I never said nice things about myself. I thought I wasn't very smart because my teachers thought I was stupid. That's what I think because that's how they treated me like I couldn't do anything. How come my teachers don't see me as a helping hand? How come we don't get to do this art in school like this? It was so cool! This art really relaxed me. I was so calm and I did all my art. I don't think I ever wrote before. I don't like writing but I like how we did this writing. And I liked talking about everything and thinking about it. And then I got to put it into a shoe [artmaking]. I never did that before. I really liked doing this. I want to do this in the future, because I think this helps kids. It helped me. I go to class happy. I like to go and work on my art. I like the feeling I have inside. I like to know I am helping people who want to be teachers. I think they need to know what we think about so they know

how to ask questions or care about us. Maybe they don't know how and we can show them.

I can't wait to have my art with me after the museum. It helps people show me they care and want to learn about me. I hope teachers learn from my art and love kids. It's important. Do you see me? Do you just see bad? I am a helping hand. I wish you could see that.

CHAPTER 11

Treat Women Like Flowers – They Are Gentle

J

I am 14 years old and in 9th grade. I never did anything like this before. I was nervous at first, because I didn't know what I was doing or what to do. But I wanted to do this and I learned I didn't need to be afraid of making a mistake. I get in trouble a lot. I say bad words and get loud in class, but I do it because I have so much going on inside. Not everyone understands me. I have anger inside of me and I don't always know how to get it out. That's how I got here. I got here because I try to hurt people. I try to hurt people by yelling at them and hitting them. I can't always control it. I wish I knew how. I will tell you I don't get angry when I am with my dogs. I am a different person. My gentle side comes out. My dogs just love me for who I am. They get excited when they don't see me for a couple of minutes. I walk in the room and they are jumping on me and they are so happy to see me. No one else gets that excited. I don't have any friends who are people. I never really did. I think kids like me spend a lot of time by themselves. I asked if we could bring dogs into the school, but they said no. I don't understand why. I think that would help kids like me. It calms me down just like the art calmed me down.

I liked talking to someone. I liked making the art. I liked being able to tell someone what I was thinking. I thought someone was listening to me. I got to say what was on my mind for a long time. I needed that. I don't think teachers know what's on our mind. I don't think they care most of the time. They don't get it. They think it's easy doing work in school, but it's not. It's hard for me to be in school when I have so much else going on. I think teachers need to understand that. If we have dogs to pet and talk to or if we have art to do to tell our story or what we are thinking or what is important to us, I think it helps. I helped me. I wanted to do this art. It felt good to say what was important to me and tell teachers what they could do to help kids like me. I don't know if anyone will listen to me, but it felt good to share. I felt good to have some really listen to me. I got to make choices about what I wanted to say. I got to decide what I wanted to do for my art. I got to talk about my feelings and my heart. I couldn't make a mistake, because it was about me and what I thought. That just doesn't happen in my life. I hope you listen to what I am telling you.

© KONINKLIJKE BRILL NV, LEIDEN, 2019 | DOI:10.1163/9789004383890_011

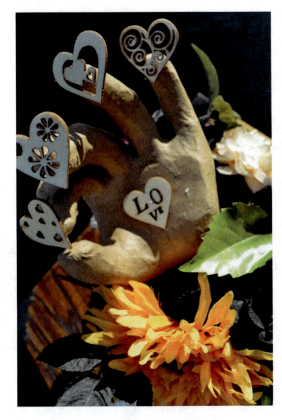

FIGURE 11.1
My art calmed me

This is my art abstract:

> When Miss Christa talked to us about every kid needing a champion, it made me stop and think. Did I have a champion? Who is there for me? I thought about it for a while. My mom is my champion. I love her. She takes care of me. She feeds me and emotionally she takes care of me. If I ever get mad or sad, she says, "It's okay, son. I love you."

When I was two months old, she became my champion. My "real" mom abandoned me. My mom adopted me. I also live with my dad. He is nice. I like him. He plays with me and supports me and protects me. He plays basketball with me or my little hoop in my room. Sometimes my dad wins and sometimes I win.

I also have two dogs. My dog C and my other dog. He is a black Yorkie. He is so cute. He has puppy eyes. When I give him love, he gives me puppy eyes.

My other dog is white and brown and her name is T. She is a Shih Tzus. She is loving, playful and careful.

FIGURE 11.2 My best friend

My best friend in the entire world is C. C was given to us by my mom's friend. T is a good dog too. She will stay with you, but C will go right up to people. Tonya is more about staying by me. She looks to me for permission first. C doesn't ask.

These are my friends and they calm me down. They are nice to me. They are not like kids. If anyone hurt them, I would protect them. They are small dogs. I like small dogs.

My dogs just want attention and when I don't give them attention, they nudge me and lick me. I love that. When I want attention, sometimes I do things just to do them, but my dogs are different. We both want love, but sometimes we ask for it in different ways. They nudge me and sometimes I say or do bad things to get attention, but we both want the same thing-we want to be loved.

When I am at home, my mom, dad, birds, and dogs are good to me. The food is good there. I have a better bed at home than I do here. I don't get yelled at home.

How did I lose my family? I got angry and hurt my family. I am in here for domestic violence. I have lived here a year. I get bullied here sometimes and I take it out on people, but I am learning to control myself. I used to get into restraints, but I stopped that now.

I play with other kids and sometimes they take over, and I feel like I need to protect some of them. I don't want people get hurt. Some of them are like brothers to me.

I get to see my family on Friday through Sunday, because I get to go home real soon. Sometimes I feel like I am on the outside of the world, because I am

FIGURE 11.3 I need a place to call home

on the outside actually. I am not part of my family when I don't live with them. They treat me different. I think they do it for fun. When I get mad, sometimes I strike out. Some things it upsets me are when people violate my personal space. I think it's like people might be dangerous to me.

I covered my shoe with flowers, because that's what I think about when I think about girls. I think girls should be given more respect than they get, especially from me, because they give birth and if it wasn't for a woman, then we wouldn't be here. Do you know what I mean? They are amazing and need to be respected. It's a big deal to give birth to a child. My shoe is covered with flowers, because it reminds me I need to be respectful to women. You should always respect a flower and treat it right, right? You can't just go up to one and take one out of the ground. You can't just pull them out of the ground just because you want to. Flowers need to grow and they need to be respected. They actually grow with respect. You have to take care of them and be gentle to them or else they won't get flowers. You have to know what you are doing with flowers. You can't just plant them whenever and you have to take care of them and make sure they have water and food and sun. I made some of my flowers black, because sometimes I forget women need to be treated with respect. The black represents when I don't make the best choices, but there are a lot of flowers, because I am making better choices, but I still make bad ones.

I put my dogs in my flowers, because they are my best friends. I don't have any friends. All I want is a friend. I don't know what it's like to have a friend, but

if it's like my dogs, then I know I can have fun with them, play with them, and talk to them. I hope someday I have friends.

I really don't have power sometimes. I feel like I don't always belong. I am lonely. I think about wanting to go home. I have a foster family. They love me. I want to be with them. I know that if I don't treat women with respect, then I don't feel good on the inside. And I don't get respect back. Like at home, how I behave at home. I go home every weekend and I feel good. I feel really good, because all I want is to be with them. I want to be with my family. When I'm not with my family, I feel bad. I love my family and I want to spend time with them.

On the inside of my shoe, I put a hand. This is the hand reaching out to me and reminding me what I need to do. All I want is to be loved by someone and to have a friend. This is why I put the hearts on the fingers. I need people to reach out to me. I need people to love me and I have to let them in. I have not been very good about letting people in, but I am learning to do this. I love my family and I want them to love me back. I have to do good now to get home. I think I am ready, but I need love...a lot of love.

Final Thoughts

I think if people wanted to be teachers, I would tell those people they need to love their kids. They can't just love the ones who act good. They need to love the ones who act bad too. I act bad, but that's not all of me. I don't just act bad just because. Other kids don't act bad just because. We act bad because we have things on our minds or we feel out of control. I had a lot of anger inside of me. I had A LOT OF ANGER inside of me. I am learning to control it. I think teachers need to take time and know the kids. I never had a teacher who cared about me. I think kids should be able to say a teacher is their champion, but I can't. My mom is my champion, because I know she really loves me. She shows me this. When will teachers show me this? When will principals show me this? If you can't, then you shouldn't be allowed to work with us. You can't be a REAL teacher.

CHAPTER 12

Magna Shoe

P

I am 11 years old and in sixth grade. I have never done anything like this before. I thought Miss Christa was a little crazy. I was thinking, "What? I am going to be doing a shoe?" I didn't understand what it meant to walk in someone else's shoe in depth. I understand it now that some people have it worse than me. I am learning about empathy. I never knew that word before. And I am learning people need to have empathy for me and I need to have empathy for them and I showed that in my shoe [artmaking]. I couldn't believe my art could show that, but it does.

I know now that I just need to help them and not make it worse for them. For this art, at first, I just went with it, which says a lot. I normally don't go with anything. I am pretty rigid. I like things a certain way and I need to be in control. The art was cool! I controlled everything I did. That was a first for me.

I just realized as I am writing this chapter that I can work through my anxiety, which is something I don't really know if I knew this before. I used my art to do that. Cool!

I like to talk, but sometimes I don't like to talk. It's hard to talk about things that hurt me or make me sad. I never really learned how to deal with my anger. I am learning how to do this, and my volcano really helped me. I hope it helps teachers and principals know they don't always know what is going on with kids on the inside. We might look like everything is okay, but on the inside, we might be volcanos ready to explode. I think we need teachers and principals to learn how to get to know kids, and not just kids like me, but all kids. Because what I learned from all of this is that I am not the only one. Every kid has a story. We don't always know what those stories are, but they have them.

I am sort of not the same person I was before doing this art. I changed. I am really hard on myself. I learned that. I also learned that I really can do things. I learned I can paint. I'm able to talk about my anger without exploding. I can share what I am feeling and let it out by trusting someone. I am not the only kid who is in a bad situation or has bad situations and that it was a really fun doing it because I was able to express myself. I really grew from this art. I am not sure why we aren't able to do this kind of stuff in school. I wonder about that. Why wouldn't we get to do this art in our other schools? It really doesn't make sense

© KONINKLIJKE BRILL NV, LEIDEN, 2019 | DOI:10.1163/9789004383890_012

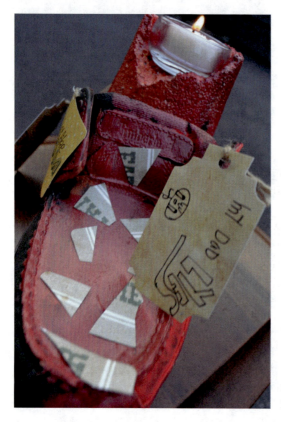

FIGURE 12.1
Magna: A first for me

because we all did it and look at us. There aren't as many fights. That's cool. I am actually making friends here, I think, because I show them my art and I tell them about it. No one told me I had to. It just happened. I wanted to share it. And I am in class more. I am not in the corner or in the circle. I mostly stay in class now. It's like I calmed down. It's like I know I can share what's on my mind and I look forward to going a working on it. I didn't even know how hard I was working, but I see it now. It's like I was doing all this work, but I had so much fun doing it. I never thought I would say this, but learning was fun this time. Don't tell anyone I said that.

In this art, I learned that I often express my feelings, but talking about my feelings in a way that people will listen is sometimes another story.

I realized it is a little easier now to talk about my feelings after making my volcano, than before. I think it was just making my art that helped me talk about my pity, my fear, my anxiety, my anger, and what was doing on. It was actually more than just talking about it. I think realizing it was a volcano helped too. I had to think of a metaphor. I didn't even know what a metaphor was, but I do now. I made my metaphor my art. That was cool.

MAGNA SHOE

I talked about everything in my art from the color to what I wanted to make to what I wanted on my shoe and why. This all helped me talk about my mom, my dad, my step mom, my sister, my family, our challenges, what hurts, and how I feel left out when it comes to my dad. I was able to talk about what matters in my art. It was much easier to do this than to just talk about it. I never exploded. I just talked about it and made it on my shoe. I usually have to have routines in my life with my anxiety, but I let it go. I just went with it during this art. I am proud of myself and surprised at the same time. I am happy I did it, and I was nervous, but I did it. I love what I did. My shoe looks great!

I am learning that I need to consider what it is like to walk in someone else's shoes, whether it's a kid or it's an animal. Animals and kids have so much in common. Animals and kids get abandoned. Sometimes kids get help, and for animals, they usually end up on the streets or in a shelter or in need of a family.

Even though my art didn't sell, I am realizing after the show, I don't need to feel bad about not selling my art for a charity. I felt bad at first, because I wanted the money I made from my art to go to animals that didn't have homes. But after the exhibit, I talked to Miss Christa about raising thousands of dollars. We talked about what I could do, but that I didn't need to bring in thousands of dollars. I am so excited about this, because my art is helping me focus on something positive.

I can relate to the animals, because I sometimes feel abandoned by my dad. This is part of why I am so angry. I realize now, I can take that anger and do something positive with it. My art has inspired me to make a difference for animals that are abandoned. I can't wait to do the research. I need to research on animals and how often they are abandoned. I need to take that information and choose a shelter. After I choose a shelter, and I need to find a no-kill shelter, I am going to call them. I am going to ask them what they need. Maybe they need kitty litter or leashes or food or treats or newspaper or blankets. When I know what they need, I am going to make a flyer. I am going to put on the flyer what I learned about the abandoned animals. I am going to tell them about some of the animals who need a home. I am going to tell them about myself and what happened. It will be something like this:

> *My name is T. I am 11 years old and in sixth grade. I was part of a Leading for Social Justice art exhibit. I made art for the show and wanted to make money for animals that were abandoned. My art didn't sell, but I am not giving up. I am learning that being 11 years old should not stop me from doing something positive for my community. I am going to make a difference for these animals, but I need your help. Will you be willing to buy at least one of*

the items on this list or donate any of these items to this shelter? Thank you for helping me save their lives.

This is my art abstract and what my volcano means to me:

> **I have so much anger inside.** I didn't want to do this at first, because it's hard for me to talk to people about real things. I get so angry. My entire shoe is a volcano. I painted it mostly red, because I am so angry inside. Most of me is angry. Part of the shoe is brown, because I am learning to calm down. I built a volcano in my shoe, because I am filled with anger. I can explode at any time. I don't share what's on my mind. I let it build on the inside. I don't talk about what makes me so angry. I wish I could, but I just don't know how. I get in trouble in school for my anger. That's why I am here. I need help. I am not always sure how to ask for it.

I do have a champion though. It's my uncle. He is my mom's sister's husband. He plays video games and he has a really cool man cave. He helps me with my server on Minecraft. He pays for it for us. He's okay with that. He lets me have Goldfish in his office. He is in college. He is older. He was putting firewalls on computers. He works for security and he deletes and defeats Malware. My uncle always wants to help me with plugins and downloading. He is sort of like a dad to me even though he is not my dad. I haven't talked to him in a month. I really miss him.

FIGURE 12.2 Volcano of anger

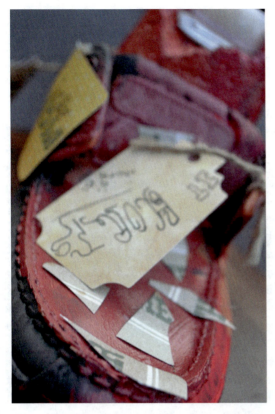

FIGURE 12.3
I miss him

My mom and dad are divorced. My dad makes me so angry. I want a relationship with him, but he makes me angry. I think I remember my mom running upstairs and crying. I remember being too young to know, but I noticed my dad picking up his crap and leaving.

I am comfortable at home. I have a sister, my mom, a dog, but we don't have a lot of money. We are comfortable. We have not been close to living on the streets. Half of her life is making us happy. Something stops me from helping her. I don't know what it is. My mom is very spiritual. My mom does Reike. It's spiritual touching. It's not a religion, but we are really good friends over that. It's a talent and I found a spirit animal.

I was in my mom's friend's class and there was a big, red dragon. It was a selenite. This rock is called selenite, and this is crystal...and that became my lion... I don't have a religion, but it helps me to feel like I have the power to change your energy. Did you know there is positive or negative energy? My mom is not crazy about it, but she shared it with me. I have seen my best friend's dad fall off a ladder and again in the hospital, but then after the first fall I had a feeling something would be worst and that's what I'm talking about.

I get angry. My dad is a jerk. I see him once a month for five hours. I don't want to see him. I see him for 2–3 days or for one month in the summer. My mom makes me go. My dad bullies me. He calls me names. My dad will say he doesn't do that, you know, call me names, but my mom makes me see him. I don't know why she makes me to this.

I get angry. I opened my mom's phone and I found out she is dating. I feel like my stepmom has a nicer car than we do, and so does he. I don't think my stepmother and him are not a good match. She is nice. He calls me names. I feel like he just doesn't like me. He is always starting conversations that I'm not comfortable with. He asked me if I was a homosexual. His brother is gay. He says some pretty mean things. He calls me a baby. I cried the whole night when I was told to sleep downstairs. My sister and I came up with a plan so I don't have to sleep downstairs.

I have a lot of anxieties. I have to be inside and be by myself. I use the house phone and I will call my mom. My mom talks to my dad, but my dad cannot accept that I have anxiety. Yes, sometimes people just don't understand me. When I stay with my grandparents, I'm out of my comfort zone. I'm afraid my dad might hit me, but he hasn't hit me. He takes my phone away at night, so I can't call my friends.

I think teachers and principals really need to listen to kids. I don't think they do. I am a thinker and rarely do they give me the time of day to talk about what's on my mind. I like to sit and think. I like to think about the world. I need time to think during the day. I can't just sit there and keep doing the same thing over and over again. I need to use my imagination. School is so boring. This was not. My art was cool and I worked so hard on it and all of the writing and on this chapter. I don't get why schools aren't doing this for kids. What are they afraid of? Is it because we get to do something that actually matters and they can't control it? Something to think about.

This art was important to me and the other kids. We said things in our art we never said to anyone before. It surprised us. And when we knew we were thinking about what it was like for us to be students in school, it makes me mad and sad. It's sad because I realize my teachers just really didn't show they cared about me. They knew nothing about me. They didn't know about my mom or my dad. They just didn't seem to care if I was there or missing. It was almost like they may have been happier if I wasn't there so there would be one less problem.

I have so much going on. I feel like I have to protect my mom. There isn't a man in the house except for my mom's boyfriends. I don't like them. I don't talk about it. I just get mad. And then I think I can't be a kid. I need to be a kid. I guess I am in the middle. I want my mom to be happy.

I get mad when I think about all of the bad things that go on in my family and at school. I don't have any friends. Do you know what that's like to be lonely? Teachers and principals seem to focus on themselves, but we have things going on in our lives. I don't know if I could trust them, but they need to know I have anxieties and how angry I am on the inside. If someone wants to work with kids like us, then they need to know we have anxieties. We get angry. We don't always understand but we act like we do because we are scared. We get pushed away by so many people and none of us have any friends. We need teachers and principals to actually care.

CHAPTER 13

Deep Blue

L

I am 15 years old and in ninth grade. When I first met Miss Christa, I thought, "I don't want to do this." I give people chances for me to do stuff with them. I gave her a chance. I think I didn't want to do it but I did want to do it. The part of me that didn't want to do it thought, "I am not good at this and I don't talk about things and I don't think that what I have to say is very important...." And then the other part of me, the bigger part, said, "You never did anything like this before. It might be cool to do it...." After we started it, I thought it was cool. I thought the project was cool and that people would see it. I wanted people to think that it was cool. I wanted them to know I feel depressed on the inside. I think teachers and principals should know how to work with kids like me. They need to know how not to push them over the edge, because kids just get more stressed. When they get more stressed, then they get more depressed. It's like it combines and just makes things worse. The teachers I had before this school had no idea how to work with me or kids like me. They knew I was depressed, but they didn't know how to talk with me or to work with me. I think that I am here, there are some teachers who know how to work with me a little better. I need more one-on-one help. I don't want them to see this, because I don't want to hurt their feelings. There might be some teachers I can tell and it won't hurt their feelings. I don't feel I can say anything. They need to see it without me saying anything. I don't want them to see it. I think it makes me look stupid if I ask for help. That's what people think about us anyway. I don't want people to think I am stupid.

I think it is cool that over 600 people came and read my stuff and looked at my art. I relieved some of my depression talking about it and stuff. It made me feel better about me and about my depression. It helped to talk about it. I don't smile. Every time I talk with Miss Christa I tell her I don't smile, and then I turn my head and I do. She likes that I am not a good liar.

My depression gets released and then it comes back. I need people to know this.

Here is my art abstract about my depression:

> **I don't smile.** Or at least that what I told Miss Christa when I first met her. I wasn't sure about this. I don't do art and I wasn't sure about talking.

FIGURE 13.1 I don't smile. I'm not a good liar

> I don't talk much. I keep to myself. I would say I am a loner. Most people really don't know me or what goes on inside of me. I tend to be depressed. It takes over me. Sometimes I think about hurting myself and I can't stop myself from feeling this way.

We talked about people who made a difference in our life. We talked about people being your champion. I never had a champion at school. The teachers never acted like they cared about me at all. I was just a person in their school, nothing special. You had to be a jock or super smart or one of the popular kids. That wasn't me.

This is what I want you to know. I have one champion in my life. My mom is my champion. She is a person who supports me by whatever I need. She stands up for me. If I do something bad, she is always there when I need it. She talks to me whenever I need her.

I have been at this school for four years. I was being bad at my other school. I would fight people. I just wanted a reason to fight. I don't know why, but it's what happened. I am angry inside. I am also very sad. It's very heavy on me. It weighs me down.

When I was in my other school, they kicked me. I haven't been in a real public school since 6th grade. I like it here though. I like how this school is relaxed and stuff. I'm not stressed out here. I can take my time and learn, and they know I am very sad. They understand me and let me be me.

Color and Texture

I don't think there are times when I feel like I have power. I would like to control stuff. I want to learn how to feel happy. I feel like my depression controls me. It's a heavy weight on me. That's why I painted my shoe a dark blue. The dark blue is the color of my sadness. It's dark and it's heavy on me. I put some silver prickly pieces on my shoe, because I tend to push people away. I don't like people getting close to me and knowing about me. I tend to be alone. I wish I had friends, but I don't. I don't have any friends or people I talk to about what's on my mind at school.

Smiley Faces

I put some smiley faces on my shoe, because when I was working with Miss Christa, I told her I never smile. After working with her, she noticed I smiled. I told her I didn't smile. She asked me to tell her that with a straight face, and I couldn't do it. I kept smiling every time. It felt good to smile, but I don't smile often. I asked her to get me smiley face stickers and I wanted to put some on my art. I wanted people to know I am trying to smile and I actually do sometimes.

I am guarded about sharing what's going on inside my head. I would like to be able to control myself more. I would like to control my thoughts more. I feel powerless all the time. I am sad and stuff. I'm always depressed. I can't think of a time I haven't been sad or depressed. This is why I have a fence around me with the wires going across the shoe. This represents being surrounded by sadness and it weighing me down no matter what. It controls me, but I hope someday I will control it.

Candle of Hope

I want to be able to rise up and be happy and be in control. That's where the candle comes in. I filled my shoe with rocks. These are not just rocks. Each rock symbolizes what I want-I want happy memories. I believe that if I could make happy memories, they would help me believe I can be happy. That's the purpose of the candle. The candle being lit is my sign of hope for myself. I can't have hope if I don't have happy memories. If the rocks are my happy memories, then they can hold the candle in place. They can make it stay lit and standing without falling. That's what I really want. I want to be happy, to have friends, and to be in control of my thoughts.

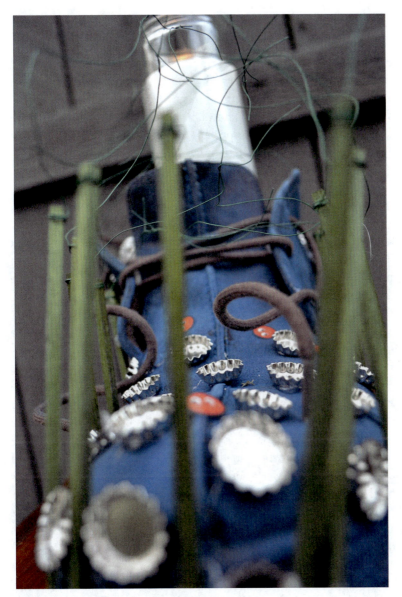

FIGURE 13.2 My candle of hope at the top

I think it would be great to have fun, but I don't know how to do that or to keep it inside of me. I want to be happy, not sad all the time. I want to have friends in my life. I want to have three friends, but these friends live in West Virginia and I know them from video games I play. I play with these friends virtually. I talk to them and play with them. I wish I had friends here. I had one friend, but we don't hang out.

What Teachers Need to Know

I think teachers need to know the quiet kids need attention too. They should pay attention to the kids who don't talk, and just because they don't talk, doesn't mean they don't have something to say. They hurt inside too. I wish teachers would realize they need to know kids if they want them to learn from them. And they should know it's important to know your kids. They need to be able to tell you what's going on in their lives. They need to know you care.

Final Thoughts

I don't know what I want to say about this. This art was so cool. I got to talk about things I just kept inside and I got to talk about things that have been on my mind. It's hard to learn in school when my head is heavy. When I made my volcano, it couldn't have turned out better. It was me. I was that volcano. I learned about myself. I got to think and it was quiet. For the first time, I wasn't going to be told I made mistakes. That just doesn't happen with this art. We are trying to not only learn about ourselves, but we are teaching other people what they need to do with kids like us. I think if we did art more often, school would be such a better place. It calmed us down. We actually talked to one another. We talked to other kids, staff, and teachers. I don't think we ever thought anything like this would happen for kids like us. We are usually the ones no one wants to talk to. But now, we are important to this book. We are making a difference and maybe someday someone will use this book to help teachers understand why art is important when we learn. And not just for kids like us, but I am thinking everyone should be able to do this.

I think teachers just can't give up. They give up so easily. If I sit there, it's not that I don't want to talk, I just don't know what to say or don't want to be stupid or say the wrong thing. They need to be patient. They need to listen. I need to be loved. I don't need them to say it, but I need them to show it. It would be nice to hear it, but I don't think teachers ever say those kinds of things. I am not sure why. They spend so much time with us you would think they would know us, but they don't. If they do this, it makes you feel better and it makes you learn. Don't you want me to learn?

CHAPTER 14

Barricade

A

I am 13 years old and in eighth grade. When I met Miss Christa, I thought this would be a very positive activity. I really enjoyed doing it. It was fun to work with her and expand on the entire project, you know, my art. I wanted to let everyone know my story. I have never done anything like this before. I have done other kinds of art like animated style drawing, drawing, and creative writing. I would talk about what I wanted my future to look like and some of my hardships. In my other art, I would talk about some of my other personalities. I am not just one person. There are many different parts to me. I am very kind and loving and on the outside I seem happy; however, on the inside I am angry and sad. I felt I was able to explain in this artmaking how my anger came about and why it built up. It was a lot to get off of my chest. I was glad I was able to. It was kind of scary, but I am glad I did it. I felt people might judge me and say, "Your struggles are honestly nothing." But what happened instead? I was praised. I was supported. And people listened to my story. I finally felt heard. When people looked at my art, I felt so good inside. I couldn't believe how many people wanted to support me. I have explained I wanted to be supported, but my art showed the reasons why I locked people out. They could see why I was hurting and why I built this barricade. They could see the barricade. It wasn't just talking about it. It was about seeing it as part of my story.

It felt good that my art caught people's eyes and they actually wanted to read what I had to say. I mattered. It was my first time at a museum. I felt accomplished and proud that I had a piece in the museum. When I walked in, I saw so many people. I was moved to see my teachers there. I couldn't believe it. I felt overwhelmed, but in a good way. Like, I felt flooded with joy and pride. I talked to one of my teachers. I showed him my full finished piece and he was very proud of me. Over 600 people came and my mom, godfather, and my little brother came to see it. My mom was crying. She was so proud of me. My mom knew my entire story and was so happy to see me share my story with the world. It takes courage to do this work. I didn't know I had it in me, but I do.

I had a chance to look at the other art. I got to read my peers' abstracts. I got to see their art. I have a much better understanding of why they feel the way they do. I also looked at the other art. I showed my mom my teacher's piece

© KONINKLIJKE BRILL NV, LEIDEN, 2019 | DOI:10.1163/9789004383890_014

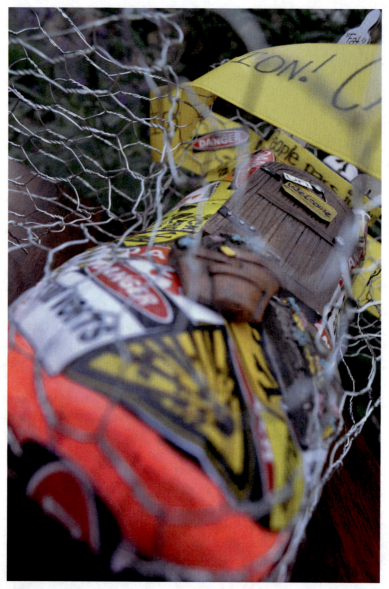

FIGURE 14.1 The barricade

about being the only Black man and how his champion helped him through the tough times. My godfather was silent. Not because he didn't have something to say, but he was also overwhelmed. He was so proud of me. My little brother might not have understood everything, but I think later in life, it will make a big impression. He was able to see me share my story and have the courage to do this work.

BARRICADE 135

When people came to the show, I hope they saw I went through a lot, but I won't let it ruin my life. I want them to learn I am a strong person. It's hard being a kid, and adults need to know that. I am a strong person. Kids need unconditional love, support, and praise. I hope they walked away knowing this.

I also hope everyone learned we are human. The world might be filled with hate, but it's important to love everyone. I tried to represent this in the caution tape and in the fence around my art. It is important to know yes, the caution tape and wired-fence are up, but they also can be taken down. You can take these down for me if I learn to trust myself. I need to learn not everyone in the world is out to hurt me.

I am still me personality wise, but mentally and behaviorally wise, I feel I have grown stronger. I have accomplished a lot in healing from my struggles. And now, I am working on the now. I am working on making sure my past does not keep me down. I notice that I talk to people more instead of bottling it up. My teachers have noticed a difference. One of my teachers noticed the improvement. My mom has been praising me every day for just being able to admit when I am wrong. I am more able to recover and move on instead of just holding on.

I think the artmaking and sharing my story and having my mom actually see my work through my perspective, it hit my mom in her heart. She wants to help me succeed in life. My art got to me. I didn't think I could do it, but I did. I was successful.

This is my art abstract:

> When Miss Christa came to see us, she showed us a video about a teacher saying every child needs a champion. Later, we talked about who our champion was and what all of our champions had in common, even if we didn't have a champion, it was what we wanted in one. Then, she came more times and we talked about people with power and people without power. We talked with Miss Christa and she wrote everything down that we said. She read it back to us to make sure our words were on the page. I took those words and made my art. I am very proud of my art. It represents me and my life. I will share this with you.

My champion is my partial hospitalization Miss L. She is kind and caring. Every time I am upset, she helps me. And when I get upset, she comforts me. I have known her since we started cheering in March. I get to see her twice a week. I like spending time with her.

I live with my mom. Sometimes it can be stressful, but most of the time we have a lot of good times together. I have been at this school since September

of last year. I came here for two reasons: (1) I was bullied and (2) for my own safety with my anger.

I was bullied at school. Kids would call me names, not talk to me, or push me. One of the girls said I got arrested for fighting my mom. I got arrested for fighting with my mom. She didn't need to tell people it really happened. I don't know how she found out.

Another girl was really mean to me. She used to be my friend. I was hurt by her several times and I was attacked by her mother. Her mother pinned me down and punched me. Her daughter and I fought and I got suspended from school. And then the next time, the girl's mom attacked me.

There was also stuff on the internet. I was doing inappropriate things on the internet. I was talking with people who I thought were teenage boys. I met them online. I didn't tell my mom and I didn't know what they were saying was wrong.

I was sent here in 7th grade by the school I went to. My mom is upset, and she doesn't think I belong here. She is realizing that my behavior is getting worse being here. And now, I get upset and I talk like a pirate, run my mouth and say stupid stuff. I am able to control my mouth. I am learning how to control it. I have a lot of anger inside of me.

I want to learn how to express my emotions appropriately. I want to learn how to express when I am not in a great mood and when I need a break. I told all of my teachers what was going on with the bullying, but no one did anything. No one was listening to me. If a child goes up to a teacher or a principal, they should take the time to find out what's going on.

I also feel like once health classes get started, I think teachers should talk about what is and what is not appropriate on the internet. I never had that talk with my mom. I had access and then I just started doing it. I saw a website to meet up with fans, and then this makeup artist did the same thing. I didn't think anything was wrong, because I thought these people were who they said they were.

I never really had any real friends. Well, I never had any friends. I was just looking for someone to be my friend. I didn't care who it was, I just wanted someone to talk to, to be friends with, and eventually, I wanted to get to know them. I found a friendship, but I realized in the end, the person didn't want a friendship. That person wanted something inappropriate. That person wanted something sexual.

I think schools need to do a better job helping kids make friends. Maybe they can give someone to write to. I want someone to be my friend who will not judge me. I think teachers need to help us be friends with other kids. In my old school, it just didn't work. I feel it's just the community. I live in a community

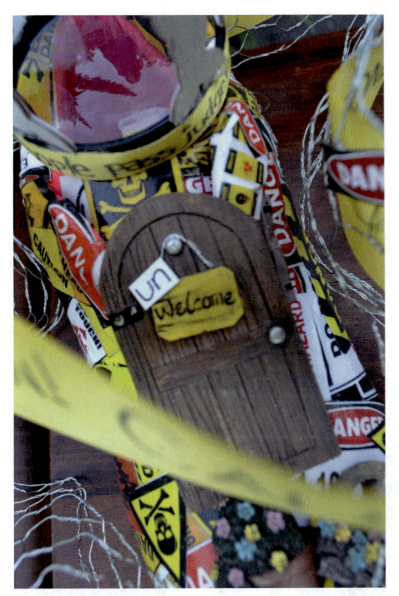

FIGURE 14.2 Unwelcomed in schools

where you have to rich or an athlete in order to be accepted, and, well, I'm not. I am not rich, my mom is single, and we are barely comfortable with money.

Kids have been mean to me, because I don't get live up to their expectations. I just don't fit in. This is why I have a magnifying glass on my art. I constantly feel examined by people in my community. This magnifying glass offered a view to the 'real' me on the inside. I wrote on the inside while looking into

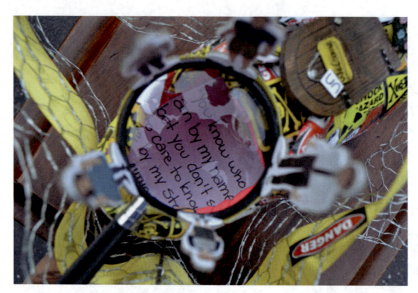

FIGURE 14.3 Magnifying the real me

the magnifying glass: You don't know me. You need to know my story. I glued people around the magnifying glass, because they represent the people who have passed judgment on me. They were all White people. These are the majority of people in my community. And on the back of each person, I wrote the words of what I have been called by White people. They are all surrounding the magnifying glass and making sure I am not part of their circle.

FIGURE 14.4 They surrounded kids like me

I wrote words like "fat" and "ugly" on the back of each person, because this is what people have said to me in my community. And the people who say bad things about me are all White people. Because I have been hurt so much, I put a fence around me as well as a caution sign. I have a lot of anger inside of me and I have to protect myself. I don't make it easy to get in and know me, because I have been hurt so many times.

I put caution tape up around my art. I made the caution tape. I wrote the word 'caution' because I might let you in, but I might just as easily push you away. I also put up the fence, which is the barricade. This is to make sure I keep people out I don't want in. I placed an unwelcome sign on the art, because it is hard to 'welcome' people in and getting to know you, but as soon as I let them in, I can't think of a time I regretted it.

Final Thoughts

Being an author of this chapter, being able to do this art, being able to share my story, and being able to give advice to teachers has been a wonderful experience. I have been able to share about myself. I am no longer a victim. I am on top. I am a survivor.

Teachers and principals need to know so many students get picked on every day in school. They need to learn how to listen and be supportive. They need to know they are able to do this, so the classes they take need to help them realize

FIGURE 14.5 Caution

this. I think teachers and principals need to do this art. They need to think about what it is like to be in someone else's shoes.

In order to work with kids like us, I think teachers and principals need to be in certain scenarios. They should be required to get to know children like us. They should have to build a relationship with us. And we should get a say if they pass or not. We would be working with professors and let them know if they can be teachers or not. No one has never asked that of me or anyone here, but I think that is something that has been on my mind.

Teachers need to know kids get ridiculed and you either don't know it or don't want to know or don't know what to look for. You need to be the change for the kids. If you see or hear about a child being put down in school or being hurt in their home or being ridiculed in their community, then YOU need to do something about it. Why? One day that child will look back and will either wish you would have helped or will be thankful you did. Who do you want to be? The helper or the one who should have helped?

CHAPTER 15

My Story

S

I am not using my real name for this chapter. I am choosing to use the name Scarlet, because she is one of the characters I made up. She is a superhero I created. She saved the earth from her enemy "The Glitch," who killed her parents. Scarlet and her younger sister Arcana worked together to protect the earth. Before "The Glitch" killed their parents, their parents sent them to earth. The sisters made a lava house and lived in the earth's core for 18,000 years. They found an empty lava tube. They climbed to the surface of the earth. They each have three hearts. Each heart gives them another chance to live, but they are only given three chances. So now, onto my chapter.

I am 12 years old and I am in sixth grade. I am a first-time author. I think it's awesome. Take a walk in my shoes. I picked out this shoe because I wanted to make sure there was a place for me to lock away the things that are still private to me, like my heart.

I thought this was an awesome experience. It was one of my favorite things to do. I have never told my story through art before. I don't really show people my feelings or share my story, because it's personal. It felt good to share it. My mom always told me not to be nervous telling my story. There is something wrong with them if they don't like my story. And that always makes me laugh.

There were a lot of people who saw my art. I was so surprised. I never thought people would like my story that way or that much. I thought they would think, "Oh, it's just another story" or "who cares" or "it's just like everyone else's story." I think they liked it. It was unique. I shared very personal things in my art. I was able to tell my story, not be judged, and tell people what teachers and principals should be doing.

I am a different person after doing this art. I share my feelings more. I noticed this about myself. I find myself talking more to my mom and my friends. It feels good to get stuff off my chest. I normally just draw them and throw them away. But this was different, because I made something, shared my feelings, and realize, I never used to do that. It feels good to share my feelings. I feel better about myself. I feel better about staying home with my real mom.

© KONINKLIJKE BRILL NV, LEIDEN, 2019 | DOI:10.1163/9789004383890_015

FIGURE 15.1 My story matters

My teachers don't really know any of this about me. They do now, because I shared my art with them. I wasn't sure if they cared or not because they didn't ask. I just decided to show them my shoe. They asked me some questions. It was the first time that ever happened to me with teachers. It felt weird inside, but a good weird.

This is my art abstract:

MY STORY 143

My Champions/My Family

If you know me, you know my champion is my mom's boyfriend R. I was 10 years old when I met him. At first, after a couple of months, when I felt like I could trust him, I called him "daddy." He was the father figure I wanted and needed in my life. Robert was everything I wanted. I wanted a father who was kind, knew what I was going through, and knew when I was doing wrong, like the song "Daddy's Hands" by the country singer Holly Dunn (see https://www.youtube.com/watch?v=nOAjAWToYMI). This song makes me think of me and R.

When I think about R as my champion, he is strong. R knows what it's like to be in jail. He doesn't want to put this on any other people. R is very kind. He also does a lot of nice things for people. R is very respectful. He always buys stuff for people even though they say they don't want it. This is why he is standing right next to me on my art. What I like most about R is that he helps me work out my problems. He talks to me and helps me feel better about myself.

My mom is also my champion. She is standing right next to me on my art. My mom is smart, kind, and respectful, just like Robert. She knows how to discipline kids without hurting them. She is a good mother. She is a good mother by feeding us, giving us the right portions, and knowing when to stop us when we are doing wrong.

Clock

I put my mom, Robert, and me together. We are a family. I enjoy spending time with my family and want to spend more time with them. I miss them. This is why there is a clock on my art. I want to spend more time with my family.

I don't have any other champions in my life. Right now, I live in a foster home. I have lived with Miss T. since February of 2015. The Tuesday after Valentine's Day I was sent to live with her. I will probably be discharged soon, and hopefully, I will be going home next week. I don't call Miss T. my mom, because she is not my mom. She is my foster home. If I don't get to go home soon, then I will stay with Miss T. through winter break.

I got to a foster home, because I was having trouble dealing with my emotions. That means, I went to a hospital's psychiatric ward for six months. I got there because I was just having trouble. I accidently hit someone. Well, it wasn't really an accident. I was mad, and I hit him in the stomach and broke his nose. I did this, because he kept touching me the wrong way. I got mad.

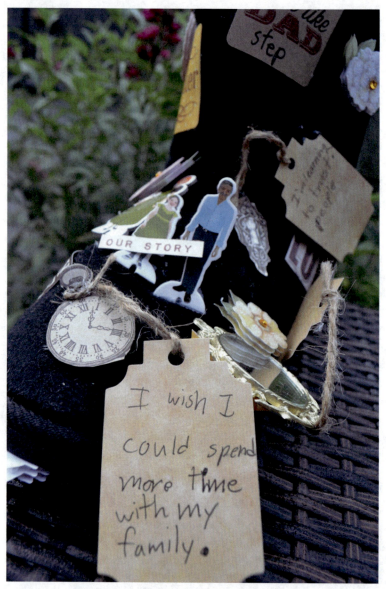

FIGURE 15.2 My teachers don't know what matters to me

They told me to go home and get rest, and recover. I don't know if I was really suspended or not. I don't remember. My mom took me to the hospital. After I got out, I moved in with my grandma and started visits home. But, I didn't feel ready to go home. I still wasn't listening. I would go around just saying my opinion. So, I came here to this school with my county worker. They asked me if I wanted to go here for school and live here.

MY STORY

I lived here for about seven months. Then, people asked me if I wanted to go to a foster home. I have been with Miss T. for 11 months. I am feeling like I am controlling my anger now. I am not getting into fights any more.

When all this started, I didn't feel like I could talk to anyone at school. I didn't feel safe talking with teachers. I thought, "No teachers...no principals...I can't even tell you who my principal was." I didn't have any friends. I felt depressed. I was lonely.

School was a lonely place for me. I think teachers and principals need to listen to children more. They need to learn how to really listen to them and know them even though they may not like certain children. Even though children may act bad, they still need to have someone listen to them. You never know if a good kid is really a bad kid and they just act good in front of the teachers, because kids who do bad things aren't always bad. They are just kids. They need to be loved just like everybody else. I think when teachers are learning to be teachers, they need to learn how to listen and love children-I mean learn to love all kids, no matter what.

I think the same thing for principals. When I was seven, I was at a school, and a girl lied on me saying I punched her, but that didn't happen. The principal didn't believe me, but she believed the bad kid. I was a good kid then. I just had a little bit of trouble. That girl was there longer than me, but the principal shouldn't do that. You know, just assume I lied, because the other girl was there longer. That wasn't fair. She just shut me out. She didn't listen. She just thought she knew what was going on, because I did a few bad things. But I was a good kid. I am a good kid. I am much better now, but still a good kid.

All I want is a friend. This is on my art. I don't have friends...I go to my family members...but I don't get to see them every day...it's hard for me...I talk to them by writing...or drawing or thinking in my head...it's lonely...I just want someone I can call my friend...I think schools should do a better job at helping us become friends...kids make fun of kids who are poor or just don't have friends...and that's not right...teachers don't do anything about that...I would like them to say something...to do something...to make it right...it hurts to have people make fun of you...all I want is a friend. I have learned to only trust certain people...and not trust everybody, because they may not be as to you... like my father...my real father...my father abused me...(I am going to keep what happened private)...I think what happened to me is related to my anger...and I kept it inside...I didn't feel good about myself...and now I am learning to feel better about himself...he is in jail for what happened to me...he will be in jail for a long time for hurting me...it's been there for three years...no one at school knew, because I didn't trust anyone...at school...I told my school, but they didn't believe me...it hurt so much to know they didn't believe me...I told my

teacher...she said, "Okay, I will look into it."...the leaders of the school didn't believe me either...she said, "Okay, I will look into it"...but no one said anything to me...so I told my mom after he abused me again, and this time my dad admitted to it...the police took him to jail...I left that school and we moved... I had to go to a different school...it was hard on my mom and me...the school never did anything to help me...I write a lot and it helps me...I write stories to

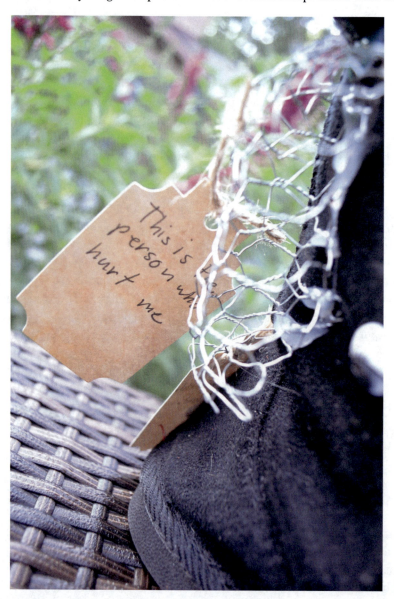

FIGURE 15.3 This is the person who hurt me

MY STORY

represent my feelings...I use a lot of blood and gore...I am really a soft person on the inside...I just don't always know when I can trust someone...but I just want a friend...I just want peace...I just want the world to be peaceful and not have any troubles...

My Final Thoughts

I think teachers should be made to listen to kids more, because you never know what's really going on. I would take them step by step and help them know how to listen and how to know if a child is telling the truth. They might be telling the truth, but if you think they are lying, you cannot help them. People, especially teachers, didn't listen to me about what my foster mom was saying about me and to me. Sometimes it's necessary to lie, because you don't think they can handle the truth or maybe the child is not ready to tell the truth or you don't want to hurt someone's feelings. I don't think teachers should work in schools if they don't know how to listen to kids. This is just so important. It gives people a sense that other people care. If kids feel they are cared about, the more support you feel, and the more you want to learn.

I think all kids should be able to this kind of work. Everyone has an artistic side inside of them. Everyone has a story to tell. Don't you? Do you want to hear it? Do you want to learn about me? So many teachers didn't think I could do this work. I can't tell you how many teachers think we don't think, can't write,

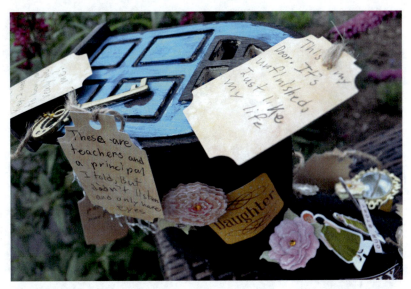

FIGURE 15.4 Teachers and principals need to listen and love us

and can't do much of anything. I think this is the most writing I ever did in my life. I liked how Miss Christa worked with us. She just looked at us and typed everything we said. Writing was easy. And then we would go back and read it to make sure it was what we wanted to say. And we didn't do everything in one day. We did things separately. It wasn't too much. It was just right. Why don't teachers get that? Don't they learn this in school? And why don't we have art in class? Art is special because you can share things you are thinking about that you cannot always do by talking or writing. It just comes out. It helps me think. It helps me learn.

I hope people learned in my artmaking that life isn't easy for a lot of kids like me. But if you have a support system, then you have a chance. You have a chance to make it.

CHAPTER 16

Freedom

V

First of all, I am a writer. I have written poems most of my life. I write to let my feelings out. Most of my poems are depressing. I talk about all of the horrible things I experienced. Most people don't want to read my poetry, because it's hard to read, but these things happened to me. They need to be said. This was the first time I ever did any kind of art like this. I was nervous and excited. I was nervous, because I wasn't sure what I should say or if I could say it. I asked my teacher if I could tell Miss Christa what I wanted to share with her. He told me I needed to decide that for myself. Over time, I became more and more comfortable sharing what happened to me and I decided it would be a good idea for teachers and principals to know this. I wanted them to learn from my life.

This artmaking was exciting for me. I learned about social justice. I never knew what it was and then I learned about a word I could relate to. I deal with this every day in my life. I don't have a family. I live in the cottages. I have been abused. I want friends. I want to go to a school and have a home where people love me. What I experienced in my life was an injustice. I am using my art to tell you about my life. My art was so much easier for me to share than to talk or

FIGURE 16.1 All I want is a family and home to call my own

just write about it. It took on a life of its own. Things started to happen when Miss Christa and I were talking and when I was putting it all together. I added somethings to my art, because I was feeling stronger inside. I was getting more confident in myself. I did an amazing job.

I came to school every day waiting to do this art. When Miss Christa worked with me, we talked about everything that mattered to me. It was the first time I was able to put my writing into my art. I never did that before. I kept telling her I was two people. I told her about the voices in my head. I made some very bad decisions in my life. The voices kept telling me over and over again to do very bad things. I knew I could make good choices, but sometimes the voices told me to do bad things. It is not easy to work through the voices. I do it. I would tell Miss Christa if the voices were talking to me. She would ask me what they were saying. I would tell her and then we would talk about it. I put the voices I heard in my art. I ended up writing my own country song, which went on the bottom of each shoe. I modpodged the words of my song on each shoe, because the voices told me different things. Miss Christa thought this was brilliant. I was so proud of myself. I love country music and I found a song I could relate to. It's the song by Chris Young. The song is called "Voices." I changed the lyrics to talk about what I was experiencing.

I have always felt like two people lived inside of me. When I kept saying that, Miss Christa asked if I wanted to cut my shoe into two halves. I started laughing. I asked, "Can we really do that?"? She said, "Yes, of course." I said, "That is me. That would look like I feel. I didn't know we could do anything

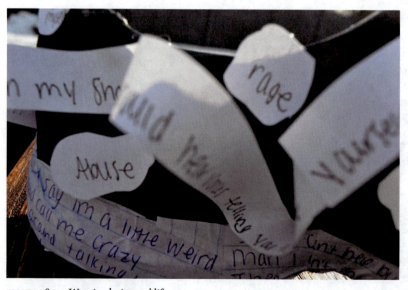

FIGURE 16.2 Weaving lyrics and life

FREEDOM 151

like that." Miss Christa said, "The sky is the limit. This is your story. This is your artmaking. You are going to take the justice issues you think are most important and translate it into artmaking." I couldn't believe it. This was the first time I ever thought I had so many choices to make. It was the first time I felt power like this. I had the power to make decisions about everything. I chose what I shared. I chose what I wrote about. I chose how to make my art. And I chose how everything would be put together. I never had this kind of freedom before. I am so used to people telling me what to do and not having any power to make my own decisions.

After Miss Christa and I talked, she would show me everything I said. I would tell her if it was correct or not. She listened to me and wrote everything down. Once we had everything down, she asked me how I would represent what was most important to me. I told her what I saw in my head. I told her how I imagined it. Mr. C, one of the teachers, literally ran to the high school and asked the woodshop teacher to cut the shoe I chose in half. It was amazing! I didn't think it could happen. They made it happen. I realized I could do anything. There wasn't a right or wrong way to do this. No one was passing judgment on me. My show was about me. It was about walking in my shoes for a day. And that is not easy, because I deal with a lot every day.

When we talked about objects representing my thoughts, Miss Christa and I went through every line of my abstract. I picked out what was most important and gave her a list of materials to purchase for me. I wanted paper with peace signs on them, a house, a bird with wings flying, people to be my family

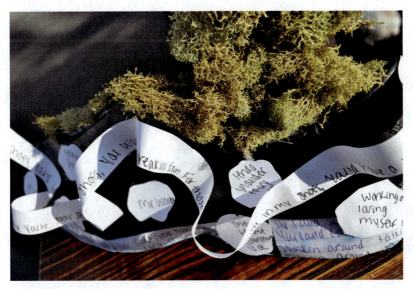

FIGURE 16.3 My story weave

and friends, trees and flowers and bushes, a table with food on it and ready for a family, and hearts. After we started to put it all together, I was inspired to rewrite the song "Voices." I spent all night writing it. We modpodged the lyrics on the soul of the shoes, because the voices are in my soul. They are a real part of me and they battle each other.

After I read what I wrote, I couldn't believe how much I had written. I never wrote that much before in my life. I mean, I wrote poems, but I kept asking Miss Christa, "How many words did I write?" She would smile and tell me. I was very proud of myself and so were my teachers. They were very proud of me for taking a risk and sharing my story. My story needs to be told, because there are other kids like me. There are kids who don't have a home. There are kids who have been abused. There are kids on meds. There are kids who hear voices. Teachers and principals need to know we are people too. They need to learn how to work with kids like us. I hoped my artmaking would help people see that we might look on the outside like everything is okay, but when you take time to listen and get to know kids, you realize there is a lot going on that you didn't know about. How can we be expected to learn when we are thinking about all of this other stuff? Teachers and principals need to understand this. I don't know if they are trained to listen and to care about us, but in my other schools, I never felt they did. I do here. I know there are teachers here who care about me. How do I know? Those teachers show me. They take time to know me. They know what works and what doesn't work. They know what bothers me. They know how to encourage me. They believe in me.

FIGURE 16.4 The family I want and need

FREEDOM 153

I wasn't sure if I would be able to do this, but I did. I not only shared my story, I shared personal things that are hard to talk about. And most important of all, I had my work in a real museum. My art is going to be in an art museum. I am very proud of myself. I think my art is powerful. I hope it helps teachers and principals learn how important it is to know kids. They aren't just there to teach about math or science or reading. They need to know me before I can learn from them. I don't trust most people, especially men. And if you don't understand why or understand this, you might not be able to work with me or help me learn. You might think I am not interested in learning, but I am. That couldn't be farther from the truth.

My artmaking helped me feel free. This is why I called my artmaking "Freedom." I want freedom in my life. I want to be like the bird in my art. I want to be free and spread my wings and fly.

This is my art abstract:

> **Two sides.** Miss Christa came to our school. She talked to us about children needing champions in their lives. We watched a video and talked about the people in our lives who were our champions. These are the people who help us when we have troubles. Some of us don't have champions, and others do. If you didn't have a champion, then you could talk about what you would want from someone who could be your champion, because you have to think about what you want from people. I have two champions in my life. My first champion is Ms. L. She helps me with my problems. Ms. L is understanding. She helps me with my voices that I hear. What does that mean? I hear voices inside of me. This is why I have two sides. I have good voices and I have bad voices. The good voices tell me to do good things, and the bad voices tell me to do bad things. Ms. L helps me to deal with things like this. You know, like my voices and my hallucinations. Mr. W is my second champion. He is my teacher. He is understanding and is always willing to have me in his room when I am frustrated. Sometimes I just need to take a break from my other classes. He talks to me and he understands me, cares about me, and accepts me for who I am.

I am 16 years old and a junior in high school. When I think about my life and what it's like to walk in my shoes, I think about my two sides. I hear voices in my head, because they help me deal with things. I was abused when I was younger and my voices come out, because I think they help me deal with what happened to me. I think it was too hard to deal with the abuse so my body made two people out of me. This way, it's a little easier to deal with it. I am learning to control my voices.

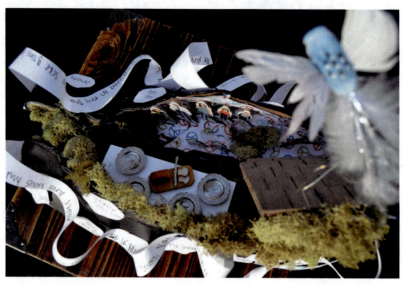

FIGURE 16.5 Two sides

If I think about my life, I realize how far I have come. I remember a field trip we took. I think about how far I have come. Right now, I live in a cottage full-time. I don't live with my family any more. They did horrible things to me. I am not going back there. They are looking for a foster or group home for me.

When I was younger, I lived with my mom, her friend, and my aunt and uncle. I didn't like that at all. It was a painful time for me. I'm not comfortable

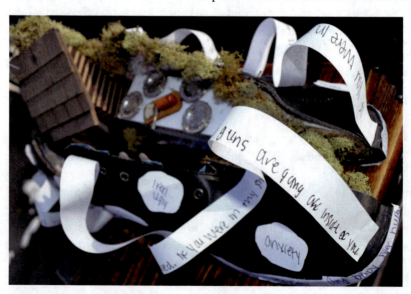

FIGURE 16.6 The outside is real

sharing why I am not at home with strangers. Please understand. I do want to share what happened, but I'm not comfortable sharing my life with people I don't know.

I am happy I am living here, but sad at the same time about moving from home to here. I don't like the decisions my mom is making. I cannot live with her, and that hurts to know it's not safe to live with your mom. I'm happy here, because I don't have to live in a house where people are being mean to me. It's kinda bad living here too sometimes. At first, I thought they were all nice, but then people can go off on you. It's not like it was at home, but I don't like people going off on me...I am talking about adults and children.

Knowing Me

Some of the teachers here understand I was abused when I was little. And some of them don't. It's sad to know some don't understand me, but I can't make them care about my past. Those people who don't seem to care just think

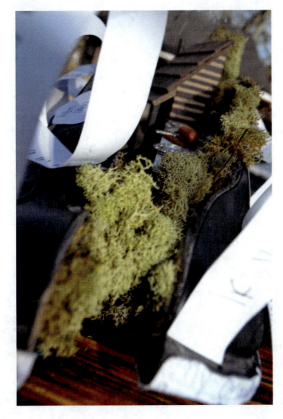

FIGURE 16.7
My two halves split down the middle

I am trying to get attention, but that's not it. They don't understand why I act out sometimes. I act out, because I am struggling. I am struggling with what happened to me and not being able to ever go home, because it's not safe. I don't know if they understand what it's like not to feel safe. Not even to feel safe inside my own body.

What have I learned? Although I felt and sometimes feel I have no power or control, I'm learning I have more control than I thought I did. I don't have to listen to my hallucinations. I don't have to listen to the bad voices. This is why you see two sides to my art. You have a good side with Mr. W and Ms. L, who are my champions, and the good voices telling me all the positives about myself. And then there is the other side. I call this the bad side. This side tells me things like hurting myself and hurting others. So, we cut my shoe in two. It makes sense, because I feel like I have two sides to me. And they are very different sides, but on the inside, it's all the same. I am looking for inner peace, a friend, a family, people to have dinner with, a family to love me for who I am, and to someday be as free as bird.

What I Need

I am looking for a family who cares about me and is understanding of my needs. I need people to know I need more attention at times. I struggle with my anger, because I have been through a lot and have spent a lot of time feeling like I am on my own. My family is not part of my life any more. Sometimes, I feel very alone. Lately, I've been getting negative attention, but I am learning how to get positive attention.

I put a home inside my shoe because all I want most of all is a place to call home. I want a place where I can eat with people at a dinner table. I want a place where people call one another family. I want a family too. I want a real family. I want a family who loves me for me and really understands what I need and is willing to be there for me.

I also want a friend. I haven't have people I can call my friend. I wonder what it would be like to have a real friend. I just want to have someone to hang out with and someone I can talk to about things. I think this is what friends do for each other.

I don't show to most people my negative side and I try to keep it in, but when I am at school, I let it out sometimes. I am learning when that happens. I am learning how to go and be more open to different people and learning styles.

Even though I am nervous telling you about me, at the same time, I want you know a little bit about me, so you can understand what some kids go through.

FREEDOM 157

Teachers at my other school never knew me. They didn't know what was going on in my life. I don't think most teachers care about the kids in their classrooms. They are there to teach, but they need to know how important it is to know your kids. If you know them, it makes such a difference. I need to feel safe and know people really love me for me and want to understand I have a story. My shoe is my story.

I feel weird talking to people who don't know me, because they might judge me by the cover. I hope you don't judge me. I am a good person. I just want a place I can call home. And I want a family. And I want a friend. I often assume people are judging me when they meet me. They might look at me weird or not really show they are listening to me. It seems like I don't always matter to people. They might be too busy, but it's important to know teachers need to take time to know their kids. All of them, not just the ones that act good or come to school and don't act like anything is wrong in their life.

When I worked with Miss Christa, I didn't feel she was judging me. I felt she cared about me, listened to me, and wanted to help me share my story, because she said my story mattered. I realize I feel more comfortable with females than males. I need people who are being open to what I have to say. I take redirection as a negative, because sometimes I feel like the way it's said is negative, but I don't feel like this when I am doing my shoe. I am not saying everything I want to say, because I don't want strangers at the art show to know all the details of my life. I don't know them. It wouldn't be appropriate, but I think they need to know just enough to get them to realize how important it is to be there for

FIGURE 16.8 I want a family to have dinner with

kids. You know, to really be there. But here, I feel like I can say what I want and need to say.

Sometimes, I feel like people just don't get it if I tell them I went through abuse. I don't think they understand how bad it was and what it did to me. I have hallucinations because of the abuse. I get them when I get nervous and sometimes when I am happy, but more when I am nervous. They tell me to do bad things, but I also have good hallucinations of my grandma. She tries to tell me to do the right thing.

Getting to Know Me

There is a song called "Burning House" and I think it describes me the most, because I had a house fire and it was up to me to get everyone out of the house. My mom had a panic attack and I got everyone out. There is another song Miss Christa told me about. I listened to it. It's by Chris Young. He is a country singer. It's called, "Voices" and after listening to it, I got it. It's about the voices he hears too. These voices are voices from his family and friends, his champions, who give him good advice. I really related to the song, because I hear voices too, and some day, I hope I only hear the good voices. I decided to rewrite Chris Young's song and put my songs on the bottom of my two halves of my shoes. On the good side, I put the lyrics to what the good voices tell me to do. They want me to believe in myself. On the bad side, I put lyrics to what the bad voices tell me to do. They put me down and tell me to hurt myself and others. I am learning how to be strong and tell the bad voices to be quiet. I want to drown them out with the good voices. I think if I can have what I want on the inside of my shoe, then the bad voices will go away. I want peace in myself. I want things to be quiet on the inside. At times it gets overwhelming because the voices are all talking at once. I want peace. I think if I can continue to learn how to have peace and love myself, then I will be ready for a family. I'm supposed to either have a foster family or a group home really soon. I am very excited, because I need that. I need a place I can call home so I can someday fly above it all and be as free as a bird.

Will you get to know me? Will you shut me out because I hear voices? Do you know anything about me? Why do I seem to scare you? Don't be scared. I just want a family. I just want friends. I never had either.

CHAPTER 17

The Cycle #Dark Side

W

I am 17 and a senior in high school. I am an author and an artist now. I chose not to use my real name, because I am finally in a place where I can help myself. I am a changed man. The old me was the person I was before my art. The new me is the person I have become. I am realizing so many things about myself and what I need and where I want to go now.

The only reason things got bad was because I let them get them get bad. I learned through this art that I cannot destroy myself. I am in more control and cannot get things get so bad for myself. To some degree I wanted things to get bad, because then I could get the help I needed. I didn't feel on the inside before. I just felt nothing. I think that is a horrible feeling. Sometimes, that is still at the core of me. But now, I decided to take a chance and try to be happy and enjoy my life. Even though that didn't work out, and it settled inside of myself, then I guess I was just going to run with it. I motivated myself in the past to run myself into the ground, and be miserable, but now, I realize there is more to this. I need to rise up and get my life together. My art talks about being on the ground, starting with nothing, and then making something out of it. All I ever felt was nothing, so now I think about what God made. God gave us earth and gave me life. Knowing this, and thinking about how ignorant I was, and not asking for help for this, I decided to focus on myself in my art. I know what I want and I know what I need from my teachers and my mom.

The main reason I did this art, knowing that I felt nothing inside, I knew I had to start to build something. I took a shoe and made something out of nothing, just like my life. I had a new mentality. I didn't realize this at first. I was destroying myself, screwing myself up completely, and now I am not going to keep myself in hell. I am building on myself. Imagine a guy who feels like absolutely nothing and now I took a chance and tried to build myself up by making something out of nothing. I was given a shoe and I made art out of it. What people need to understand is that from 8th grade until right now, I didn't try to help myself. I didn't have the wisdom or common sense or skills to know how to ask for help. By the time I realized this, it was too late to go back and determined to destroy myself. I was relentless. I needed to satisfy that part of myself. And this will be the first time I have not wanted to destroy myself. This has never happened before to me. I have goals from here on out and I am focusing

© KONINKLIJKE BRILL NV, LEIDEN, 2019 | DOI:10.1163/9789004383890_017

FIGURE 17.1 My art

on building my life. I don't need to put myself through hell. I can focus on what I really want.

My mom thinks I will end up on disability, but I don't think so. The thing is, I can make it. I don't have to destroy myself. What people need to really know is to let things go. I wasn't in a place to get help. I didn't think I needed it. Once I was ready, and I am ready now, then I could go forward. I had to hit my own rock bottom. I don't want teachers or principals telling me I get one chance or that "you have already tried to help me." I needed to take a fall in order to understand who I am and who I want to become. I think God is the only One who could do that for me. I needed to be ready for help and my art talks about the cycle I put myself through. They got as bad as they did, because I needed to do that, so I could be ready to actually help myself. I need them now. If they can't be there now, then they need to go away. I don't need to destroy myself anymore. All I need is someone who believes in me now. I might not have taken the paths they wanted to go. If you can't help me now, then I need you to stay away. I am not on your time and I don't want anyone giving me any lip about what will happen if I don't "get it together." I don't want to be homeless. I don't want to receive disability. I want to make it. I am in a place now to help myself, but I need people to support me.

I really enjoyed doing this art. It was fun and it expressed who I used to be. It really helped me focus on me. I never had this happened before. I never had a chance to do something like this. It opened up doors for me to understand my pain and suffering and hell I have been through. I did this art to help

THE CYCLE #DARK SIDE

myself build myself up. I did this art to say what was important to me and how I understand what matters. It's just nonsense to think this art wouldn't matter to someone. It gave me a space to get help when I needed it, not when people thought I needed help. Being miserable is not what I ever truly wanted. Who want's that for themselves? I need chances to prove that and for once in my life, I can willingly help myself. I used my art to share that story.

I am a changed man. My motivation is no longer self-destructive. It is self-helping. My artmaking was a way to express it. It helped me, because it led me to this. On the inside, I was feeling focused. I was motivated to do something positive. I never did anything like this before. Let me stress this. I don't have fear or anxiety when something I really care about is happening to me. This is why I didn't want to sell my art. I put it as the highest number I could find. I looked up numbers and found the highest numbers I could find. I put the price at \$99^{99}, which is duotrigintillion. And for children it was a little lower at \$99^{72}, which is treigintillion. This art was so important to me. It is a masterpiece, my story, what matters to me, and what I need from my teachers and people around me.

This is my abstract:

> **I'm very sad.** I don't have a champion in my life. This is why I have band aids on my art. I painted them red and blue. The red represents the pain I have inside my heart. The blue represents my deep sadness. Why band aids? I am healing. I have been hurt so many times in my life, and I need

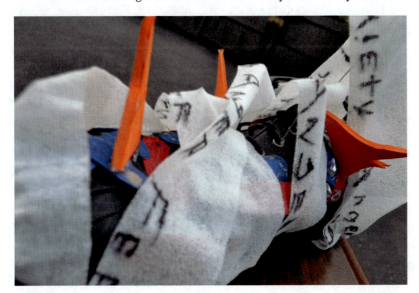

FIGURE 17.2 Telling my story through art

time to heal. And then there are the tear drops. I glued them on my shoe, because you need to know to walk in my shoes means you would be spending a lot of time alone and sad. This is why I painted my shoe with five coats of blue. The blue symbolizes how sad I am and how heavy it weighs on me.

If I need to pick someone, though, and say something, then I would say it's my mom. Okay, my champion is my mom. She is my champion, because she is the only person who takes care of me even though we do have issues. The main thing though is to know I only respect her spiritual knowledge or spiritual beliefs. That's about the only thing I can say that is positive about her.

I live with her. Between me and my mom, I don't care about our relationship. I have a relationship with God. That's a relationship I do have. He won't let anything happen to me, but it's hard for me because it's not like He talks back to me like a person. I need to put Him first in my life.

My art is about how hard it is to be a teenager. I want people to be in my life, but I don't think people want to be in mine. I have so many things to worry about. I don't talk to my mom about anything. I keep everything to myself, because I don't have any friends. This is why I have tacks on my art. The tacks are keeping people away from me. I get hurt so often. This shows my pain.

My mom has a way of really pissing me off. I don't talk to anyone. The main person I talk to is myself. I am the only one who understands myself. I talk to myself a lot. I am the only person who can talk to me. I put flames on my art, because I am so angry. I am angry at the people who didn't believe in me. I am angry at the people who keep trying to control my life. I am angry that people don't listen to me. I want them to listen to my words. I want my flames showing and shooting up, because they need to be seen. I want people to know how angry I am about what happened to me. I hope they doubt me, because if they do, I am going to shove it in their face. I will make it. I am determined. I don't blame teachers for being angry with me, because I am quite determined to destroy myself, but they need to know what has been going on inside of me. They need to know how to help me and to know not to push kids when they aren't ready. They will tell you when they are ready, but they just need to you to be there. You don't have to do anything, but listen.

As a teenager, the biggest problem I have is that I can't get a girlfriend. It starts a cycle to self-destruction. I don't believe in myself when people don't love me or give me a chance. I can do things, but people just don't believe in me. And then, I don't believe in myself. I destroy myself. As far as I can remember, I have always wanted a girlfriend. I have been exploring having a girlfriend when I turned 14. All I wanted was to have friends and a girlfriend.

THE CYCLE #DARK SIDE

When I was 16, I learned I didn't care about having friends. Nothing else really appealed to me except having a girlfriend. Friends were hard to make and they just seemed to use me.

Having a girlfriend? It used to be a strong passion to and now it's just an over-blown obsession. After years of looking for a girlfriend, I can't find anyone. I don't think a girl would ever like me. I mean, why should they? It just creates so much tension for me. I just want to be loved. I am scared about what is ahead for me.

I am not ready to have a job and it's the worst time for me. I am not sure I will make it in society. The thing about this is, it's kinda like this: there is a cycle. And this cycle is because it all begins with my anger. I wrapped my art in a wrap like a cycle, because it consumes me sometimes. It takes over me. It's like I can't breathe sometimes. There are some spaces to breathe, but most of the time, the cycle just takes over. If you want to help me, then you need to know how to help me break the cycle.

I can't function in society, because I have bad anger issues. This is what I have been told. This is why I have fire flames on my art. This represents my anger. I have so much anger inside because people don't love me or want me around or believe in me or support me. So many people have just given up on me. I threw temper tantrums when I was 12. Eventually, I grew out of them. They aren't as bad or as frequent as they used to be, but I am still angry. My anger is from anxiety, and my anxiety comes from not being able to have friends or a girlfriend.

In a lot of ways, I just don't appeal to girls. It makes sense though, that I don't appeal to anyone, because I don't even appeal to me. I can see why girls don't want to date me. I just think they want someone better than me. I mean, who wants a guy who is just a borderline mess?

I'm very negative. I'm deciding if what this is actually anger or hatred towards myself. And then, I get angry with myself for being angry, which makes me anxious. I just don't appeal to people, especially girls. And this brings me down.

I'm also impatient. It's like each one is tied into each other. It's overwhelming and confusing. One just leads to another. I am always constantly twisting my brain to figure this out. I feel like there isn't much I can do. I'm just me. It's all I got. People want to be something I'm not, and then I get angry.

I am getting anxious about turning 18. I'm not going to give up on this, because I just can't let it go. Inside my shoe is a mirror and glasses. I need to reflect on what I am doing. I have been through hell. I try to destroy myself. I want to be loved, but I don't always know how to let someone in. My heart wants this. My heart wants people to like me, especially girls. I imagine it would be hard to say what it might be like, because I never had a real friend or a girlfriend and

can't imagine anyone wanting me. I put a mirror on the inside of my art to show you I am reflecting and thinking about my life. I think about it often, but I need to think differently. I put the glasses on there, because I need to look at the world in a new way. What's happening now isn't really working for me.

I am in this job development program and I stopped going. Things have escalated to the point where I can't function in a work environment. It takes me over everywhere…going to school…dealing with not being wanted…everything going on inside. I am scared. I am afraid I won't make it out there.

I have anxiety all the time. I put the sharp-edged metal pieces on my art to show my fear. I sometimes push people away, because of how hurt I have been in the past. I don't do it all the time, so I didn't cover my art with them. But it happens enough for me to know I do it, and I do it, because I am scared. I just want friends and a girlfriend. I think my problems would all be solved if I just had someone I could count on. I need to let it come to me and slow down and then let it go. I need to learn how to do that.

My principal said all of this has to do with me being a teenager. I need to develop patience. I need to be patient with myself. I have all this anger inside

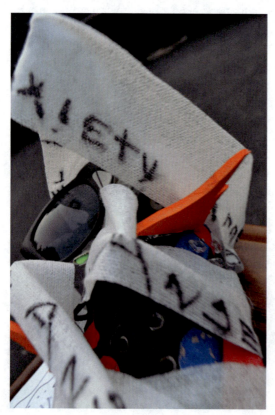

FIGURE 17.3

Anxiety surrounds me

THE CYCLE #DARK SIDE 165

and so much is from the fear I have. It's this cycle. It's a vicious cycle. This is why my art is covered in gauze with the words anger, fear, and anxiety. I am trying to heal. It just surrounds me and sometimes takes me over.

As I think about being 18, I think about asking myself, "What now?" I have been chasing this dream, this fantasy and I don't want to let it go. Maybe if I had a girlfriend sooner, maybe I wouldn't be in this place.

I am at this school, because of the cycle of anger I have with my anxiety. I want to get back to my anxiety and my fear. I fail, and I always end up learning I lost my girl to a White boy. I mean, it's the girl I am interested in, but she isn't interested in me. It's insulting and now it's just plain ridiculous.

I hate Black people. I hate the Black culture and everything about it. I don't like seeing what I see on television. And when I get out of here, every White person is just going to look at me like I'm Black. And they are going to assume I am like the Black people they see on television, but I'm not. I am nothing like those people on television. I am my own person, but all White people will see is that I am Black. I am very worried about this. I don't know what will happen to me when I leave here.

Most of my friends and when I try to date, I spend time with White people. Again, I don't like the Black culture. I don't like the ghetto or otherwise. I don't like any of that. It's not in me. It's not in any part of me. I KNOW I will be treated like every other Black person when I leave here, and that really upsets me. I will be treated differently than White people even though I don't think like my Black culture. I am not in a gang. I don't steal. I don't walk around and act like White people see on television. It upsets me. I connect better with White people than Black people. It's ironic, because I am Black and White guys get the girls, and I associate with White people better.

The problems are still there. My problems are more mellow now and I am trying to learn how to cope with all this. It just keeps going through my mind-a girl wants a guy who has a car, education, and money, but that is just stuff and women need more than that. Don't they? But I think this is what most teenage girls think about. They need to understand there is more to life and relationships than this and there is something better. I want someone in my life who is open-minded and reasonable. I just feel like a failure and don't want to feel like this forever.

I think it is important for teachers and principals to know we kids are kids. I have glasses inside my shoe, because I need to look at life through a different lens, you know, in a different way. I need to see the positives in my life. They are there, but I have a hard time seeing them and letting people inside. I put hearts on the inside of the shoe, because all I want is to be loved. All I want is to be accepted. I want to be accepted for me. I want to love myself. I don't want to destroy myself anymore. I need people, but I don't think they want me around.

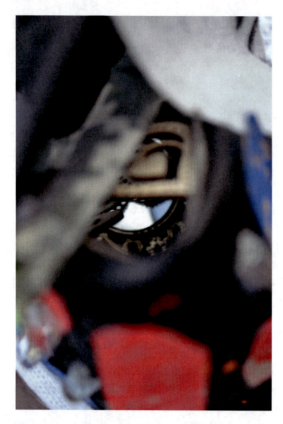

FIGURE 17.4
What is inside of me

I think teachers need to know we may not act like we want to talk, but we need people to listen. They need people to talk to about these things. You can't assume kids have someone at home. It's not like that for most kids. I think teachers just assume school should just be about school, but it's more than that. I needed people I could talk to and I never had that. I needed friends, and I have never had that. I need a champion, and I don't have one. But if I had to choose one, it would by my Mom because she is spiritual. I think kids need to know their teachers care about them outside of school and want to know what happens to them.

Final Thoughts

I need teachers and principals to know they need to give support to all kids. This is not just about me, but about all kids. I need teachers to be personal with kids. Not in an inappropriate way. And just because you are a teenager, doesn't mean you are grown or that you know better. If a teenager has to tell you that

THE CYCLE #DARK SIDE 167

you are grown, then that just tells you they aren't. Teenagers just act like they know everything, but as a teacher, you need to know we aren't adults. We are still kids. Becoming an adult takes time. We are still developing. I don't think you stop developing as an adult until you are in your late twenties. I will be 18 very soon. Age is just a number. Just because I am going to turn 18 and legally be an adult doesn't mean I know what I am doing. I am a legal teenager, but even though I will legally be an adult, teachers need to know we aren't. We are still kids. We still need support and guidance. We have real problems. Even though we are supposed to know better, we don't always know better. We are still kids to some degree. I realize the law says we are adults, but we aren't. Teachers and principals need to know we don't know everything. We are always not responsible enough. Not everything works for everybody. There are special things you need to do for kids like me. You can't be so harsh. We make mistakes. We have misunderstandings. Don't take advantage of us. We are just kids. Can you work with us and be nice? Can you care about what happens to us?

When I did my art, it really helped me say all of this. I wasn't scared. I used my art to say what was on my mind. I have a hard time doing that most of the time, but this made it easy. I let things out I have been keeping inside of me for my whole life. I just don't think teachers and principals think we can do this kind of stuff. It's like we aren't responsible enough to do this or they can't trust us. But we did it and we did a great job. I learned so much about other kids like me and they learned things about me. And then there were the teachers who started talking to me about my life. I always wanted people to know more about me, but I just didn't know how to say it. My art says it all. It is me. I didn't want to part with it for the museum because I worked so hard on it and it's me. It's all of me. I put myself out there for all of you to see and I hope you get it now. You need to know how to work with kids like us and my art tells you what I always wanted to tell my teachers. I just couldn't.

CHAPTER 18

I Look Fabulous

A

I am 13 years old and in 8th grade. I have done art like writing stories, made my mom a quilt, a glass necklace, and made a clay sculpture, but I never did anything like this. This was a sexy shoe. I wanted the money from selling my art to go to an animal shelter, but it didn't sell. I couldn't believe over 600 people saw my art and read what I wrote. I wonder if anyone laughed at it. I hope not. I like they complimented it, but I am quite surprised. I love it. I'm glad they didn't know it was me. I have never showed people my art like this. I was nervous about it, but I am glad I did it. I think they liked it. I felt so good on the inside to share me. I kept it hidden for so long.

I decided to pick a high heel, because I stole a pair of heels from my sister when I was two. I walked around the house with them. My sister was at dance, so she didn't know. She is good at dance. I looked fabulous! I looked at myself in a full-length mirror. I was at home with my mom and dad. They had no idea I was doing this. One day, I was walking around in those high heels, and my sister caught me. She was furious and yelled, "A! Give me my red high heels!" I said, "Never!" I ran away. I broke the heel. It popped off.

FIGURE 18.1 I like my art

I LOOK FABULOUS

When I wear heels, I love it! Don't judge me. I just don't want to care what people think. I don't do that anymore at home. I don't wear heels, but it has always been a memory for me. I made my shoe red and full of glitter, because that was the color of my heels when I was little. I begged my mom when I was two to buy me high heels. She wouldn't. My mom said, "No, those are girl shoes." I was mad. I never asked her again. That was the end of that. I wasn't allowed. So, I decided I would have that chance again. I wanted to choose heels, and red ones at that, because it made me happy on the inside. I asked Miss Christa if I could choose any of the shoes that were donated. She said, "Yes." I asked, "Even the high heels." She said, "Yes." She didn't judge me. I wanted the high heels. I picked them for my art. My mom couldn't tell me no this time, and my sister couldn't yell at me. I could just be me.

This is my artmaking abstract:

> **I look fabulous in high heels!** My champion is N. She is my sister. She is my older sister. She is 15. She is talented, nice, funny, but sadly she is going to stop. She is really good at tap dancing. She became my champion when she saved my life. I was riding my electric scooter and I fell off and she dragged me home and saved my life. She is an angel and the best sister a brother could ever have. I was 12 when this happened. It was so bad. I was going 12 miles an hour. It hurt. It was gushing. She took her shirt and put it on my head. She literally put me on the scooter and drove me home. I admire her bravery.

FIGURE 18.2 I did not fit in

I started this year at this school. I have been in 9 or 10 schools. I am here, because I couldn't focus and blamed it on brain damage. I know it's not true, but I wanted to blame it on by head. Really, I just didn't want to work. I live with my parents and my sister. I think I will be here one year. My other school said, "I didn't fit there" and hopefully will "fit there" meaning here. We are fixing that. I am getting extra help here.

I don't know why they took recess away from us at my old school. I like recess. It's fun. I swing. I get happy. I let me excitedness out! We have gym at my other school. I had friends at my other school. They were funny and annoying. I have friends here, but they are all of the grownups. I wish I had friends my own age.

I think teachers and principals need to know kids need more recess. It would not only give us more time to play, but time to make friends. I think having recess helps us get focus, because we get all of our energy out. I need to get my energy out. I think recess should be all the way through high school. The older you get, the harder the work, so you get stressed and need more recess.

I feel I look fabulous in high heels! I wanted to sparkle my shoes. I think they look fabulous!

Final Thoughts

I never wore heels again after that day. But sometimes, I feel like schools tell us what boys and girls should act like and dress like. It's almost like there is a certain way I have to act just because I am boy. I learned I am supposed to say things like "oh, hot girls!" or "I like Star Wars" or "I like Mindcraft." Boys are supposed to ask for certain kinds of toys, because "high heels" just aren't for boys. That's what I have been told. I feel like I fit the description of what it means to be boy, and sometimes I just don't fit. I like to wear heels, but I don't. Why? Because I am afraid of what people will say. I think teachers and principals should allow boys and girls to dress the way they want. If a boy wants to wear heels, then he should be allowed. I never heard a teacher say it was okay. If I did, I would feel I could fulfill a dream. This is why my art meant so much to me. It's who I really am, but I can't show it. I'm nervous. I'm afraid. I would like for all kids to be able to dress the way want and be who they are. I hope teachers understand what this means. They need to know that this was so much more than a shoe. It was more than an art project. That shoe is me. I never shared this before. I wish my teachers knew this about me, but they don't. They do now and so do you. What will you do if you met someone like me?

CHAPTER 19

Life Is Strange

M

People ask me if I am a boy? I do not identify as a boy. I mean, maybe I am in transition. I am not sure. I am young and don't really think about whether I am a boy or a girl. I do prefer the pronoun his. I wonder why I need to be one or the other. I am me. I know who I am. I have a deep voice and I dress the way I dress. My art was about what it meant to walk in my shoes. And this is one of the things I experience all the time. I mean all the time in school. People don't know if I am a boy or a girl. I have teachers looking at me. I have principals looking at me. I have students looking at me and talking about me. Why does it matter?

When I think about who matters in my life and how that person helps me think about myself today, I think about my champion. This is the person who has been there for me. I have a champion in my life. My brother S is my champion. He is funny, willing to help me, and he has always been there for me. When I was little, this bus driver made me cry, and my brother stuck up for me and made me laugh. After he went to basic training, he came back home. I missed him. Unfortunately, I was already in DH (it's like juvenile detention) for my anger issues with my parents and siblings. What did I do? I hit my mom and threatened my family. I was 11 years old. I was in a public school. I was mad and didn't know why. All I knew was that I couldn't do anything about it. I couldn't control it. No one seemed to understand me. No one.

I'm not for sure when my anger started. I actually can't remember a day I wasn't angry. Every day in school I was mad. I also had anxiety since I was little. When I think about it, maybe my anger could have been passed down to me from my birth mother or birth father. I was adopted when I was really little. I don't remember it. I don't remember anything. It's a closed adoption. What does that mean? It means that the parent doesn't want any contact with you. It means that the parent doesn't want you to know who she is, so don't bother her. I don't have any contact with either of them. All I know is this: My birth mom was 16 when she had me. She didn't want me to have a rough life. Her mother told her it was best to give me away, so she did. And so, I live my family now.

What I do know is this: My birth mother met my mom and dad. She chose them to be my parents. I don't know anything about my birth dad. And I have no contact with my birth mother, but I need to wait until I'm older. I want to

© KONINKLIJKE BRILL NV, LEIDEN, 2019 | DOI:10.1163/9789004383890_019

find her. I want to know about her. I've talked to my birth parents about it, but they want me to wait until I'm older. Sometimes I don't know if I want to meet them. When I say them, I mean my birth parents. I have anxiety when I think about it. My parents are okay with me wanting contact, but I don't know if I want it at this time.

I figured all this out a few days ago when I spoke with my mom. What I mean to say is that I was trying to figure out where my anxiety came from. She told me she thought I had anxiety. I used to cling to her when we were in church. She wouldn't get to go to the other aisle and leave me. I still do that today. I want to be around her. I want to know where she is, because that makes me feel safe.

Most people don't seem to understand anxiety. I have a lot of it. I had an issue with my friend. She didn't understand anything about anxiety. I got mad at her and her friends and then, of course, she got mad. I got weak and I got really soft. I don't like that, but I did it. My friend said, "Why do you act so weird?" I told her, "Well, I have anxiety." I told her if she wanted to know more about me, then I would share with her. I sent her some links about anxiety. I sent her the link and she listened to 50 seconds of it and then I explained it to her. She understood and now my friend feels like she can be there for me. I asked my mom how this happens [anxiety] and she said I had it when I was little. She never talked to me about it. I had to ask about it. I was really curious and cared about my friend. I was trying to figure it out. I heard teachers and friends talk about it, but my mom never talked to me. I started asking.

I get shy sometimes about asking about anxiety. I don't feel comfortable talking about it with my dad. When my dad's father died, he changed. My relationship with him went down from there. I started hating him from then. Sometimes we had fun, but most of the time we didn't and still don't. My relationship with him is better now, because I am trying to work my way around our issues, like I used to do when I was little.

I am not the only one adopted and asking questions about my past and what makes me who I am. All of my siblings are adopted too. I have two brothers. They are both older than me. I think they are adopted from another country. I am not sure. We don't really talk about it.

I live with my parents. I used to live in residential. I had to come because of my anger. I couldn't control it. I lived there for six months and earned my way back home. I have been at home now for…I actually don't know now that I think about it. But, I live at home now with my mom and dad. I am working through my issues. Some of my issues might have to do with all these questions about whether or not I am a boy or why am I getting all of this special attention from teachers or why I have anxiety.

LIFE IS STRANGE

FIGURE 19.1 Life is strange.

I had a chance to share my story in my artmaking (see Figure 1). It was very cool because I don't talk about this stuff normally. I keep it inside. I don't even know sometimes that things are on my mind and when I did this, I started to realize more and more. I made a shoe. It's about walking in someone else's shoe. It's about empathy. I don't think most people have empathy. They seemed so concerned about themselves. I think we need to have more empathy or we can't learn and help kids like me. My shoe is about my life.

My art shows in the end that my friends actually know more about me than I know myself. I don't share these things with my family. I am quiet and private. I share things with my friends. Some of the things I share are that I want to

meet my birth parents-who are they? Why did they give me up? What are they like now? Would they want to know me later on? What are they like? Am I like them? Do they think about the things I think about? I also have questions about my sexuality-am I a boy? I have a deep voice and dress like a boy and people think I am a boy...so, am I a boy? I have anxiety-will I have it forever? Why do I have it? Can I get rid of it? How? Will I be in special ed forever? Does this mean I can't learn like other kids? I am discovering things about myself. I want to be me, but I think I am afraid sometimes. I also have a deep anger inside of me. I don't want people to judge me because of my deep voice or how I dress. No one thinks I am a girl. They all say or think I am a boy. Strangers call me young man or a boy.

When I thought about my art, I had to think about what I wanted people to know if they walked in my shoes and they became me. I thought about what to put on the inside of my shoe. I have a picture frame. This is me thinking about myself. On the inside of the shoe is a mirror. I am reflecting on my life and learning more about myself. This artmaking really helped me do that. I got to think about myself and did it in a way that I didn't have to do something one way. It was about what I wanted to do and what worked for me. That was freeing.

In my shoe [artmaking], I wrote a narrative about my life on a long thin piece of paper and I put it inside the frame, because this is what I really think about, but I don't share it with people.

I hope everyone who reads this and looks at my art will understand kids go through a lot and don't really have anyone to talk to. It can be very lonely sometimes.

I think it's important for principals and teachers to know how many children have anxiety and why they have it. For many children, they can't control it. It's about anger outbursts. It comes out of nowhere, and so does depression. I have both. I don't think I mentioned that until now. I have anger issues and I am depressed. One moment I am happy and then another moment, I am sad. It's weird. I don't know what my triggers are. I know I have a lot on my mind, but I just don't know where all of this anger comes from and I want to make it better.

I think teachers and principals need to be sensitive about mental illness, especially if you have OCD and anxiety and sexuality questions. It's important for them to know *these* are the kids who get bullied in school. I know people called me gay. I dress like a boy and look like a boy. In the past, I would have responded negatively. I would give them a look that they didn't know anything about me.

When I think about my sexuality, I find myself going back and forth. My body has a gender and I experience being a boy even though I was born a girl. I feel

LIFE IS STRANGE

male on the inside and I think I know myself as male. The way I dress and the way I walk and the way my voices sounds, it sounds like my gender is male. Gender is how I see me and my sexual orientation is something about who I like or who I am attracted to...my artmaking was personal and my journey is personal.

Sometimes I go by bi, and some people I don't tell them anything, because I am afraid of what they will say. At my other school, I told a girl I liked her. I liked liked her. She gave me a look and walked off. I didn't tell her that I was bi. I really don't share this with people. I share it with my friends. That's all. And when I think about it, I am sharing this with everyone who is coming to the art exhibit. I never talked about this in school. I don't feel comfortable talking to anyone here. It's like a back and forth for me, but I am trying to figure out if I can trust them. I think they know, but I am choosing not to tell them. I have an urge not to tell them. Teachers need to make sure they understand what kids go through and listen to them and help them learn how to go through this stuff.

PART 2

Adult Voices

CHAPTER 20

Born for Bred

A

Note by the editor: A and I spent several months together at the school. I interviewed A and we used the interview as the foundation for his chapter. I want to begin noting his incredible compassion and empathy for children who are so often ostracized by their communities. When I came to the school this morning, Mr. A and another faculty member were attempting to work with a student who was crying to the point of having difficulty breathing. The students' eyes were puffy and her speech was difficult to understand. She seemed overwhelmed with her emotions. Mr. A and the other faculty member quickly utilized their phones and played a video from the Disney film Frozen. The student immediately stopped crying. She slowly caught up with her breathing and blurted out, "Let it flow!" along with Mr. A and the other faculty member. The two men and the female student sang in harmony.

I have spent most of my life serving children who are in special education. I was not trained for this position. I was made for this job. I have undergone trainings in the district, and I feel they helped me, because I needed to know how children think and how to de-esculation. But most importantly, I was made for this job. I worked in this district in the special education for years. I initially worked in a program as a classroom aide. I worked with children who ranged in differences from cerebral palsy to autism. I also worked in the summer offering opportunities for children in special education to attend a summer camp. In 2012, I was offered a chance to come to this school. I also worked part-time in a facility in which some children were dual-diagnosed and were chemically dependent. I have worked and am currently working with youth at the same facility. My life is dedicated to helping kids stay off the street and do right for themselves.

I don't think I chose this profession. I think it chose me. Growing up, I had a couple teachers who really cared about me. Elementary school was a breeze, but in middle school, I had some rough times. Transitioning for me was difficult at first. I had to go to summer school. I promised myself, "I will never put myself through that again." I remember my first grade teacher. Her name was Ms. M. She worked with the whole class. She was excellent. She was a mother figure who cared for everyone. One of my toughest teachers was in third grade.

© KONINKLIJKE BRILL NV, LEIDEN, 2019 | DOI:10.1163/9789004383890_020

Ms. G was someone pushing me. I received three Fs on my report card. I will always remember that day. When I saw those grades, it crushed me. I knew I was better than that. My mom talked with Ms. G, I saw a change in myself. I wanted to work harder.

I also had some who didn't care. I came from a large school district and transitioning from seven elementary schools to one middle to one high school. Bringing all of those people together was quite challenging. There was a huge learning curve for us. Teachers had to learn us and we had to learn them and each other. I don't really remember anyone who made a difference. Mr. W sticks out for me. He cared about us to the point that no matter what we did to make him angry, he never held a grudge. He would come right back and say, "Let's go and do this." And then, we would pick up where we left off. I recently got a chance to see him. I bumped into him. I thanked him for everything he did for me. Mr. W said, "Thank you." It was ironic I actually saw him. He told me he just retired. I wasn't terrible in school, but I had my moments. I was the class clown and telling jokes. I love to laugh and I love to make people laugh.

In high school, I got into sports. I played football and basketball. I was the wingback in football and guard in basketball. I really appreciated the coaches. Coach M, I was also in a class he taught in high school, was funny and a good guy. I actually had a chance to work with him in this district. I learned from him then, and I continued to learn from him now. Coach H, he was an overall great dude. He cared so much about the community and the school system. He was one of the most influential people I encountered in high school. In the summer time, he had a landscape company. He would offer to hire us and this kept us busy. I could talk to him about anything. Coach H was all about education. Ms. A is the ONE who helped me graduate from high school. You either got an A or an F in the class. She pushed me. She pushed me hard. Without her, I don't know I would have passed the proficiency test. I hate writing, but I loved math and science. I had her in 10th grade and 11th grade. I was determined to pass her class. I worked extensively hard in her class. Going into my senior year, I felt confident. I think it's sad, because some of the "smartest people in the world" who were on honor roll who did not pass the proficiency test. They had anxiety about test taking, and I just don't think that was fair. It was so much pressure. I passed, but I know so many who did not. They were smart, but they just could not pass that test. These teachers gave me the tools to be successful. They cared about me and made things happen for me.

Growing up in the neighborhood I grew up in, the teachers were going to make sure we made it through. There were options out there that weren't good for us. Some of those options included school or drugs...or school or gang activity. I would say it was mostly my family who helped me through all of

this. Even though the community I lived in was known for negative things, it is important to know there are a lot of positives. People outside of our community didn't know that. There was a neighbor up the street who would look out for us and a neighbor next door who wanted the best for you. Our families cared about each other. It wouldn't be uncommon for one of us to get it before word got to our parents. No matter whose house you went to, there was a place at the table for us. If I was over at my friend's house, their mom would say, "Hey, do you want to stay for dinner?" We always could count on each other for a place to call home. Now, it seems a little more difficult to do anything like this. Everyone seems to care about themselves and that doesn't work for kids, especially our kids. This could be due to the loss of economical funds and not being able to do what they once did. Because if you can't make ends meet and you are struggling, then I can't take care of company. You know what you have, and you know they might be hungry, but maybe they are struggling to take care of their own. If you think about it, if I am looking at other people, and I don't have a lot of stuff, but I want to socially accepted, then I might go out and do things to keep up with other people. It's not right, but it might contribute to this. Some kids think, "I gotta do what I can to eat, to have clothes, and smell good." It's like the kids here I work with. They don't have a lot of resources. They need us to provide for them, because their neighborhoods might be struggling too. We might not have been through the exact same things, but there is light at the end of the tunnel. I think we offer them that light. We need to make sure they know there is light and they can make it.

A lot of the teachers taught in the community I lived in. I am not sure they knew much about our families, but I know they took time to know the kids in the classroom. They tried their best to help them. I think teachers saw more potential in us than anything. One thing I can say is that it was the ones who pushed me who have left a lasting impression on me. People always told me, "You can be a leader. People listen to you." It seemed to come naturally to me. I always try to see the good in people, no matter what. We can all make mistakes. We all need second chances; actually, we need third and fourth chances. I have a soft spot for kids, especially little ones. I guess you can say it's how I was raised.

I was raised by my parents who worked hard. We were very family-oriented. No one's family is perfect, but we learned core values. We learned to stick together. I have three other brothers. We are super close. We are always there for each other. We have each other's back. I put my passion and love into everything I do. I believe anyone is capable of doing what they need to do to take care of business. You need to know how to push through adversity. It's easy to do the wrong thing. It's much more difficult to do the right thing.

In the middle of working together, a teacher approached Mr. A with a middle school-aged student. He held a red card in his hands and smiled from ear to ear. The teacher said, "Tell Mr. A what you want." The student replied with a smile and pointed to Mr. A, "Me you." Mr. A asked, "Me you?" The student noted again with more excitement, "Me you!" pointing back and forth between both of them. The student smiled. A asked, "Now?" And the student replied and smiled again, "Yes. You me make something!" The student immediately jumped straight into the air and quickly skipped to the other side of the room with his arms waving from side to side. The two of them went into the office. They came out with construction paper and scissors. A and the student went to a quiet area and worked together on the student's creation.

We give the children here the attention they deserve. There are smaller class sizes here, which is good for them. A lot of kids downplay what happened at the other schools, but when they are upset, they let it out. Students tell me how difficult things were for them at other schools. Many of them say they felt different and they talk about feeling isolated at home. It all depends on who you talk to. They tell us what it was like. I believe the children feel accepted here. I think they know we don't read a child's file and make assumptions. I get to know the child. That is half the battle. It's about building a positive rapport with the child.

I understood the artmaking as a place for them to tell their story, to let go of their emotions, and to start working on the positives. I saw how anxious they were to come and work on their artmaking. They were always ready to go. They seemed to really enjoy what they did and put everything into it. They would tell me that. For the most part, when they are here, depending on if they are in the cottage or coming from a home, they all have their moments, but for the most part, they are okay. The older kids seemed to be doing very well. There might be isolated incidents, but they end and then everything is okay.

I was impressed with their artmaking and the abstracts. They were touching. I was really impressed with how they expressed themselves, how they carried themselves, how proud they were of their work. I saw them go back through difficult times in their lives and made connections between what they did then and what they were doing now. They all had wonderful ideas. Their art moved me. I didn't know what to expect. I see art in a new way, especially with the kids here who are pushed out of school and by other kids just because they are different. One student doesn't stand out more than another. I noticed they made strides and improvement, but it is hard to decipher what was behind the improvement. I saw their artmaking as a building block for their growth. It was a step in their stride. I saw it put confident in themselves. They weren't ashamed of their stories. They were able to take pride in who they were.

CHAPTER 21

The Tension of Duality

B

Duality suggests choices, opportunities, and helping to empower those deemed "other" to see multiple viewpoints. Within each of us, there is the power to create a reality. I recognize it's not as simple as "trying harder" or "looking at the world through multiple lenses." For our children, their realities were chosen for them. They were born into families or into a world they did not choose. Our position is to provide our children with opportunities to look within and realize they can have a dual experience. In other words, you don't have to finish the way you started. And within this, there lies the tension. And this, is my life's work-navigating this tension.

I started working here twenty years ago. I moved from the residential facility to the district and then back to the school that serves the residential students. I feel like this is what I am supposed to be doing. I am supposed to be helping and consulting. I put a little time into thinking about this. Things just seemed to flow for me. I went with the flow, because I thought if things are flowing easy, then that's how it's supposed to be. It's like birds. They don't try to fly, they just do. My educational background is in psychology. I became a parent before I planned to, so I needed to work to provide for my family. I started working in residential treatment during the second shift. I feel somehow the information in my courses seemed to help me. I didn't finish my degree, but what I learned just made sense to me.

What I like most about working here is having an influence on the children's lives. I think I make a difference. I show them other ways of doing things. Sometimes my advice is different than what another adult may have suggested. I like to offer choices. I think when the kids feel they have choices, they respond. Sometimes the choices they are offered may not seem like the greatest choices, but they are given opportunities. I want them to understand it's okay to make mistakes and we can learn from them.

This makes sense to the children here. It's like my childhood. My parents gave me choices. If I screwed up, sometimes they didn't have to tell me, because the consequences told me enough. My parents were very clear about what the boundaries were, but very nurturing at the same time. And so, they were very clear about what I should or should not be doing. It was made clear to me what the boundaries were. They were not domineering within the structure.

They were nurturing. The values of giving back were a significant part of growing up. It was important to leave things in a better place than which we found them. Service was a strong value in my family. My father was a civil rights activist. Although this work was done before I was born, he focused his life on making things better for all people. He and his brother were the founders of a group regarding racial equality. I don't know if it's still in existence, but they founded the city's chapter. They organized the protests and demonstrations. My father's work focused on service. My mom was a nurse, and she gave a lot to her patients. She worked in nursing homes and hospitals. She did spend time with geriatric patients.

Some of my training has something to do with this. We had some extensive training with prominent psychologists and clinicians in the field. They taught us how to respond to kids in class and in group sessions. We were able to watch them and we practiced with them. It all seemed to make sense for me as a practitioner.

I believe these two worlds melded together. Sometimes it's hard to quantify how I understand this. When I look at the children I serve, I believe I understand some of their struggles. I am not saying I have lived their struggles, but I understand. For some, I am able to think about my personal experiences, which gives me an opportunity to share with them strategies they can use. But also, the understanding, things can change, a ray of hope. I experienced a very similar educational system. My first two years of high school were spent in a working class neighborhood and at some point, my parents decided to move to a predominantly upper-middle class community. That gave me a dual experience. I have known kids who had struggles financially with their families and then my parents moved to that neighborhood. It gave me another outlook. I met Black people who probably came during the great migration from the south. Most of my friend's families were not from the city. They were from the south. My grandmother did well for herself, but she was not from here and survived. My friends' families owned companies. And one of my friends' grandmothers bought them each a car. My grandmother didn't even have a car. There were different rules for different people.

The rules seem to change based on economics, but maybe not as much about race. More times disparities seem to be based on class more than race. In terms of our students here, economic opportunities seem to impact them. It impacts their homes, their communities, and the schools they attend. Because we are in a well-funded school district, they may have an opportunity to see things here they may not have in their own communities. For example, every child has a laptop or an Ipad. Some of our students would never have seen that in their school districts.

THE TENSION OF DUALITY

I thought the artmaking was a good opportunity with a third party not passing judgment on them. So many people pass judgement on our kids. I could not believe they did this. It was amazing and what it did for them was even more amazing. The students were engaging in dialogue about themselves and trying to figure out how they became the students they are and what they need to succeed. It was eye-opening for me. I can't tell you I didn't know our students, but what happened in their artmaking was new, exciting, and helped us learn so much more about them as they did themselves. They wanted to do this work and it wasn't for a grade. They were excited about their artmaking. It served as a calm for so many of them. They used their artmaking to talk about what was going on in their heads and their hearts. Again, this was not for a grade. Christa was not their probation officer. No one was making them engage in this work. Every student wanted to participate. And when the elementary students learned what the middle and high school students were doing, they wanted to know if they could do it next year.

The students shared with us in ways I have not seen before. Their artmaking took them to new places. I think I learned that many of them realize we care about them. And for many of our students, I was reminded how many did not care about them while they were in school and outside of school. With Christa, they were able to express things in a way they may not have felt comfortable sharing with us. It was as though the artmaking process gave them opportunities we may have not considered before in our curriculum. The process was deep and the students came back excited, proud, and accomplished every time.

When the students started to work on their artmaking, I didn't really see a change at first. What I did see was excitement, however. Maybe that level of excitement was a change, because for so many of our students, they feel defeated. To see them excited about learning, about sharing, about thinking at such a deeper level was invigorating for me. I realize none of them shared this with me, but I think the artmaking process seemed to free them. It seemed to allow them to uncover their true selves with no judgement being made. I know they felt safe saying whatever they needed to say, because they told me. I also got this impression because of their eagerness and willingness to spend time with Christa. They yearned for time like this and artmaking offered self-reflection, critical thought, and opportunities to explore.

When I think about the power of artmaking, there were many times our children experienced mood swings in the classroom, but even in the midst of their mood swings, students "switched" and left immediately with Christa to work on the artmaking. They were all engaged. I mean they were *all* engaged. I saw a change in each of them. When they were given opportunities to think, to be valued, to feel accomplished, to express themselves, well, their moods were

186 B

uplifted. The artmaking process and thinking about their lives and learning impacted them. They seemed more calm, motivated, and excited. Artmaking was a release. So many of our children are so guarded, but when they engaged in artmaking, they were not as guarded. The walls came down. They were transformed. The students would smile on their way out.

When it came time to showcase their artmaking for the public to see, I could tell how excited they were that people were going to not only see their art, but people would read their stories, learn something about them, and recognize the system doesn't always do people like them justice. Their artmaking allowed them to express themselves in new ways and this entire process was a HUGE step for them. Our children often feel judged and feel like they are "Other"; and yet, in this setting, when they engaged in their art, they not only took a risk and shared who they were, but their artmaking became them and they in turn became their artmaking.

I tried not to say too much to the students and their artmaking. I didn't want to interfere. After they completed their artmaking, they were proud of what they did. I thought their pieces were amazing. I saw them put thought into their work. The detail was amazing. The process and their artmaking meant something to them.

I think artmaking and incorporating this process into what we do with our children relates well to what we do here. We want to provide students with opportunities to feel proud of what they have done, to think about the world, and for them to understand their voice matters. They don't always feel up to it, but we want them to feel good about who they are. I saw them work hard. I saw them work very hard, but they completed something that represented who they are. For so many of the students, it was the first time they wrote that many words. They cared about what they did and realized it mattered. They found value in the process and realized it was hard work, but wanted to do it. Their artmaking was well-received, and I believe it was, because they put their whole selves into it. We were amazed at what the students made possible. When I think about this artmaking process and using it as a means of helping them make sense of what they are learning and connections among their lives, I realize we don't give them these opportunities. Sometimes we offer them opportunities to use poster board or mixed media, but we tend to rely on students' art therapy. It seems like teachers may think art therapy is the place for that type of work. I realize now that artmaking is not for the art teacher or art therapist. Artmaking can be integrated into everything we do, but we need to critically think about how we implement this across content areas.

After watching the students and Christa engage in this work, I am not sure if teachers are more comfortable or not with arts-based pedagogies. I know we

THE TENSION OF DUALITY 187

were not prepared to do that type of work as teachers. I am not sure why, but I can tell you we all saw the power of the process for our students. They were changed. And they were changed for the good. The process provided structure, but there was so much freedom they experienced. I am not sure they have ever experienced that type of freedom and exploration in their learning. Maybe that's the scary part. It's the unknown for the teacher.

I would like to see us continue to be diverse and use arts-based pedagogies to reach our children. We are expanding the ways we understand how to meet the needs of our children. I hope we will continue artmaking as sensemaking. I think this would be important for the children here, well really anywhere, because so many children are limited in their experiences and interactions with people and "new things," especially our kids. They are afraid of making mistakes. They have so much anxiety. School seems to be the place where many children learn they aren't as proficient in something as they may want to be. Art-based approaches seem to offer them spaces to understand themselves and allow themselves to just be. And that's a good thing, right? Our children, especially, need a space to just be. And not just be, but understand that "being" here, "being" present, and their "being" is of value.

CHAPTER 22

Diversity Is My Degree

C

I have worked in this facility for nine years. I moved from the residential side of things to the school in the last five years. I worked in the city at a corrections facility and the police department. I patrolled the city and was a supervisor for the corrections department. I went to school to be a police officer. I wanted to do this ever since I was a child. When I was growing up, the neighborhood I lived in, I saw a lot of crime from adults. The police didn't seem to know how to help my community, so I thought I would be of help to my community. I thought people were just adding to the cycle and I wanted to disrupt the cycle and actually help. For example, if someone was accused of domestic violence, the police would arrive. They would take the suspect in their car, but then, they would just drop them off on the street a few blocks down. The perpetrator would just go right back to the family and hurt the people who lived inside.

When I became a correctional officer, many of the people I knew growing up, were the people I worked with in the facility. My presence seemed to help them feel more comfortable, because they knew me and I knew where they came from. I wasn't judgmental. I provided soft spoken words. I helped them own up to what they were doing. I would talk to some of my friends and help them understand they needed to be accountable for what they were doing. Seeing some of the men and women I dealt with, well, I think they responded kind of easily to what was happening. Why? I knew them. I understood them. I was 25 years old, which was post-college and post-high school, and I knew the people who were known as "popular" in our neighborhood. When they saw me, you know, a John Doe trying to help them, it was humbling to them. Even though it might have seemed I was on top of them, because I was a police officer, I tried to understand them. I knew many of the people I met in the criminal justice system were football players and outstanding athletes in high school. I tried to make this uncomfortable situation as easy as possible for them. I thought, "Who was I to pass judgement on them?" I knew I came from the same neighborhood. I understood what was happening. I was here to help.

I realized early on in the corrections office and law enforcement, I saw things. I tried to understand why these behaviors were actually occurring and how we could be more proactive versus reactive. I wanted to make a difference in a child's life before the child would get him or herself in trouble. I lived in the

© KONINKLIJKE BRILL NV, LEIDEN, 2019 | DOI:10.1163/9789004383890_022

DIVERSITY IS MY DEGREE

189

same kind of neighborhoods as the kids here at this school. I share in some of the tragedies kids here have experienced. My family struggled. We didn't have it easy. We made it through the difficult times.

Everything that we have to give to the children isn't in a book. Many degrees come from living life. I share this with the kids I work with at this school. They might not have the best clothes, like the other kids in their schools, and then they become an outcast, but they need to know they are more than that. It's not easy, because this is how kids are judged. And when they are judged like this, then they are put down and this is when bullying and fights start. You stand out, because you are different. And then we have kids who are abused. If the kid's parents are abusing them, it is taboo in our community to speak of it. You look like less of man if you speak of it. This impact a man's education. It impacts his path. He is left thinking he is on his own and finds himself in survival mode. These young men just need to survive, but they can't look like they are barely surviving, because this is perceived as a weakness.

When our kids work with therapists, our kids sometimes have words go over their heads. Some of the people who work with them don't seem to understand what it is like to grow up in the projects. I do. I understand what they experienced in their neighborhoods. For example, it is important to know our kids didn't eat all day or that many of the kids lived on the streets. Our responsibility is to know them. Our job is not about meeting kids half way. Our job is about meeting kids all the way. Sometimes you have to go across the street, knock on the door, and get the kid out. You have to go directly to the kids. You have to consider what has gone on the inside of a child's bubble.

Our kids have been experienced being different in a negative way in their other schools. I remember this happening to kids in my own community. When I was in high school, I heard a teacher tell a child, "I get a check whether you learn or not." What the teacher was really saying is "I don't give a f*** if you learn or not." I knew going into this field, I could not be like that. I thought, "Who would I be if one of the children I worked with was homeless or was arrested?" I also wondered, "What did I do wrong? What did I miss?"

No one prepared me to work with children who have these kinds of challenges in their lives. I bring this knowledge and wisdom with me. I didn't learn how to do this work in my training as a correctional officer or as a police officer. I learned to be empathic and to be nurturing, because of my life. I learned how to be who I am today outside of my training. Knowing my actions could impact a child's life has been a major motivator for me.

I know how to be compassionate with children. I learned we have to break down our own barriers to help children. We also have to ask them if they want to come with us. Sometimes kids are willing to do this, and sometimes they

aren't. But if a child is not willing or able to come with us, then we need to wait. We need to consider the lives the kids have lived.

My job is to help kids understand what a value is and to value themselves and their lives. Their lives are not the same every day. We need to take time to understand where they came from, where they are today, and where they want to go. I am not sure they are always ready to do what we want them to do. We need to listen. We need to be patient. We need to walk alongside them. This is our responsibility.

One thing I want to mention is the gender thing, because we are hearing more and more of this from our kids after doing this artmaking. One of the things our kids do, well, is the gender thing. It is coming to play; you know, such as being gay. It is a difficult thing for Black men and Black boys to speak of this. Sometimes this is due to the tragedies they have faced as children. They need to know they can talk to us about anything. We have to be strong for them. We have to love kids for who they are. You have to teach them there are morals along the way. I tell kids all the time, "We are going to love you no matter what." Kids have been told for so long that their sexual orientation is wrong.

I have eight kids with my wife. They are all grown, and I am a grandfather now. I know that in all of my children, the children here are just like the children we raised in some ways. Each kid I work with has problems. They try to manipulate or have things on their mind or try splitting us or are resistant. The kids here are just like my children. I know as a father how kids work. If you understand children, then you know this. The children here may not be my biological kids, but they are my children. We have kids here who are just like the ones I raised and now they are grown and on their own. It's important to remember-these are children we work with. They have feelings. Kids are kids and they are a life cycle. It's up to us to help them talk about this cycle, what it means to grow up, and what all of this means to our kids.

Kids here often tell me, "You want to help me, but you don't know me." We have a tendency to tell children there is "only one way." How do we know this? Why aren't there other ways? We need to have diversity in our lives and stops you from helping the kids in a way that might work for them. We get so caught up in what we think is right and forget this is about the kids. This is something I learned growing up. There isn't just one way to think or one path to take.

My biggest fear-I don't want to see one of the kids we work with go to jail. I want to know I did everything in my power to help every kid. I think about when I was a football coach. I know of a football player who could have ended up in jail, because he didn't have a father at home. He didn't have that figure in his life to help him become a young man. Even though I was not his father, I was still be a father-figure to him. For me, it is important to know there are

DIVERSITY IS MY DEGREE 191

children out there who became adults, and I made a difference in their lives. I need to know a child who is now grown can still recognize me as an important person in their life. I think each of us need to know what role we play in every child's life here. It makes a difference. I take that responsibility to heart.

When I saw the children here working on their art, I was impressed. I thought it was amazing. I saw them take their lives and what mattered to them and put in their art. Their art was made of shoes. It was about walking in someone else's shoe and getting to know about them. I thought their art was a way to tell us what they needed-what they needed to open up, what they needed to trust, what they needed to learn. The students here took time out of their lives and let us know how they would let us in through their art.

I saw their art actually asking us to come into their lives. I couldn't believe it. I didn't know how some of the children felt. I was moved. Their art brought us to a new level. I didn't know some of the children needed what they needed or what they needed from us. I was taken back because so often all we see is what they show us or tell us. But their art took them to such a deep level and we were asked to go along the ride with them. They invited us. Their artmaking told us step by step what they needed, especially from the kids who have been abused sexually, physically, and emotionally. The kids told us they needed structure. They wanted to spend time with us. They told us that even though they might push us away, they still want me to be a father-figure to them and provide them with structure and consistency.

I noticed changes in their behavior when they worked on their artmaking. Some of the children let their barriers down. They started to allow some of us in. For those who were seeking safety, I saw them wanting more attention. I even saw myself being more compassionate with the children. I was learning about them and they were letting us in because I was reading their stories.

For those who were scared, I was able to talk to them about what they shared in their artmaking. I wanted them to know I was still there for them. The Black males here I saw a change in them. They were more accountable for their behaviors. It was like they let it out their lives in their art. I saw these changes in them, and I saw changes in me, because the kids were sharing more with me. They were telling me more about what was going on and how they were feeling. The more I knew about the children, the better I was able to help them. Some kids didn't want us to get too close to them, and that's understandable. Their artmaking told me where they were at, what they wanted, and what I needed to do to help them feel closer to people.

I think this artmaking helped them put their barriers down and then they could start learning in class. The kids were in class more. There was a solitude in the artmaking. They needed that, I think. They focused on themselves. They

took so much time and effort into what they were doing. It provided them with an outlet. They were able to focus on something that might be deep inside of them, but that's what interferes with what they need to do in the classroom. I think their art helped them focus on what they needed to do in class, because their art was a place they could tell their story and what mattered to them.

After the children completed their artmaking and prepared their art for the exhibit, I saw some of them talk to one another in new ways. They talked about being foster children. They talked about all the things on their shoes and what they represented. I heard two girls talk about the doorways they created with actual doors, because they wanted people to come in. I heard students talking to each other in a positive way. Before this artmaking, these two specific girls I am thinking of were enemies. There were a lot of erruptions between the two girls. They fought each other almost every day. After their artmaking, they were talking to each other. I saw it. Even though these girls come from very different backgrounds, like race and troubles in their lives, their artmaking helped them come together in a new way. It's not perfect, but it has definitely improved.

The children's artmaking was right on. It helped me help them in a way I would not have considered before. They want us to care about them. They want us to pay attention. You cannot work with children who have these needs and not know them. You cannot just check in and check out. It's not for a paycheck. If you think you can be in this line of work and not really know the kids, then this these are not children you can work with.

Being a father of daughters, it is important to know how to help kids feel comfortable, especially girls. Because of how things are today and the tragedies that have happened to girls with adult men in places like this, I would be very upset knowing a female student is uncomfortable with me. The diversity I bring to the table with my life and who I am is critical to working with our children. They will ask for me, because I provide children with safety. We are here to help them feel good about who they are, and most importantly, to make them feel safe. Their artmaking helped me learn how to do this and helped them break down their barriers to let us in.

CHAPTER 23

Adversity

D

I have been in this district for 11 years. I started out at an elementary school as a one-on-one aide for a child in a wheel chair. I have always been in this line of work. After one year of college, I got a job in a positive education program. We work with children receiving special education services. I was a paraprofessional and I went to school part-time. I went to school for education to become a high school teacher. And then, I got married and had kids. School had to be pushed to the wayside. I couldn't do it all. I became a paraprofessional in the public school in a first-ring suburb serving children in special education. I moved from that district to this district and I have been here ever since. My paraprofessional position was terminated, and because I had so much seniority, I moved from elementary to middle school to this residential facility. Because of my past experience with children in the system, I felt comfortable with the move. The only thing I needed to learn was how this system worked, because kids are kids.

I am satisfied helping children who are in need. I always hope I can get through at least one of them. I think they are in need guidance. To me, this means children need to know they can count on us and we have tools we can share with them to help them get through their day. Some of these tools are different coping skills such as listening to music, time alone, talking things through with an adult, learning to share their thoughts appropriately, and remind them they have the power to get them through their challenges. Sometimes I share my life experiences with them. I lost my parents years ago. I lost my mom, my dad, and my sister in a very short period of time. I could have taken different paths, and I let them know how I did it. After my father passed away, this was one of the reasons I left college. I went back to high school and started coaching. I needed to find a way to stay focused. I was able to stay on the right path by focusing on hanging out with positive people. Once my mom and sister passed away, I relied on my wife and my family. They kept me going.

Children here may not have their families to count on, so when I talk with them, I go back to helping them understand we are here for them. We may not be their family, but we are here to give them advice and support throughout the day. I realize there are children here I cannot reach. If I can't give the support a child's need, this is why we focus on our team. Each of us has something

to give. Sometimes we have to say good-bye to children who we know who aren't ready. This is sometimes due to lack of funding. We worry about our children. We worry about what happens to some of them when we know they aren't ready. We have a responsibility to prepare for the next child who comes through the door. We are committed to supporting them and helping them throughout this process.

Originally, I thought the artmaking was about giving shoes to those who are in need. Once I walked down there and saw what they were doing. I thought it was interesting. The kids seemed excited about it. They kept asking when they would be seen and would have the opportunity to work. It seemed therapeutic to them. Some kids can use art as a means of coping. I saw them use this experience that way. They expressed that to me. Some kids would say, "I'm feeling kind of anxious, can I see Miss Christa and work on my artmaking?" I heard this from several kids. I am not sure how often the kids actually share their stories, but I would guess they talk with their therapists. But in school, they focus on math, science and their studies.

I saw a change in their behavior. I saw kids focus. I saw them calm down. I saw them make it through their day without anxiety. They seemed to work through their anxiety with their peers or with academics. The artmaking seemed to really help them. When they finished, I thought their art was different for each of them. The experience seemed to bring something out in each of them. What I thought was interesting was how creative their art was. They each had their own style and way to work with the shoes. Each one told its own story.

I think this should be done again and again. I never experienced anything like this before. I think it will benefit the new kids as well as kids who have been here. I think it's important for people who want to work with our children to be good listeners and believe in them. This art showed us what they think about and how they make sense of their world. It helped us work with them and build even deeper relationships with them because they let us in and for many of them it was the first time to let people in like this. Having teachers and principals be present for them when doing their art or showing their art, well, this is something they have not had much of in their lives. Why? Well, because most of their families are no longer around. Their art gave us a window into their souls. That's the gift of this artmaking. We learned so much about our children and this helped us work with them in new ways. My hope for the children is that they are successful in whatever they do and know how to use the tools they have within to do good in the world.

CHAPTER 24

The Sky Is the Limit

E

I have been in this profession for 15 years. I have worked with children who have emotional behavior disorders. I always loved working with kids, babysat kids who received special education services, volunteered for the Special Olympics, and I always loved school. I enjoyed being in school, going to school, and learning. I don't even know what that means. I just loved to learn. It didn't matter which subject.

My band director made an impression on me. I liked the way he interacted with the kids. He was always going above and beyond the call of duty. He made it so we would want to do more for him. He pushed us to always do better. This helped remind me to be there to listen to the kids I work with and that relationships matter. It is important to build relationships. In fact, we are still friends today. He knows I am a teacher and he is impressed with the field I chose. When I told him he played a role in that, he was humble in receiving the compliment. He doesn't think he did anything special.

One of my most favorite teachers was my kindergarten teacher. I know kindergarten was different than it is now. She played the piano every day. There was so much music. She was calm and kind and had a soft, gentle voice. She made it fun, but you were still expected to learn. She made me think about my approach towards kids. Sometimes you might want to yell, but then, I think about what I learned from her and remember the importance of building a positive classroom community. I haven't seen her in long time. I didn't get to talk with her, but I think she would be humble about the impression she left on me. She had a positive and calming nature to her. I carry that with me as a teacher with the children I serve now.

I try to come to work with the purpose of giving them the best day I can provide. A good day looks like this: (1) When you see a student with whom you work is developing coping strategies and you see them doing this more independently, I feel proud and rewarded. I am happy for the student who feels they have power over their outcomes. (2) If we get through a day feel positive about their day, that makes me feel good. We talk all day about feelings. One of the students with who I work with has only been in school a few weeks, because he has been hospitalized. We talked about the song "Happy." I printed out the lyrics, we learned them together, and now it's a requested song. I know

© KONINKLIJKE BRILL NV, LEIDEN, 2019 | DOI:10.1163/9789004383890_024

196 E

now this music made a difference. When he starts to feel down, he asks for the song himself.

I don't use arts-based pedagogies in my classroom very often, because I am limited to what I can use. I will, however, use music. They write lyrics as a way to express themselves. They can color or draw to express themselves.

I wasn't familiar with what was going on with the artmaking. Once the kids talked about what they were doing, they couldn't wait to show me what they were doing, what it represented for them, and how they were making their own art with their own story. I heard things about their families and their experiences in life. They were able to express what was going on and to think about how to represent it in their art.

In regards to their behavior, I saw the students understood what it meant to be marginalized by sometimes being in the box and sometimes being outside of the box. My understanding of this was having the kids thinking about when they "fit in" and when the "didn't fit in" and who had the power and control based on a group they may or may not belong to. I knew their backgrounds. I was familiar with their lives and some really struggled in how and when they fit. It wasn't as easy as being "Black" or "White" or a "boy" or a "girl" or "Christian" or "Jewish." I think they struggled with sometimes thinking "they didn't need to be here" and it was hard for some of them to think about "why they were at this school." Some of the kids have not developmentally taken responsibility for their behaviors and for others, some of them have not been in control and had adults make decisions for them. I could see how they used their understandings of being marginalized to help them talk about how these realizations have impacted their current situations. I was able to talk with them about how their life choices influence their situations and how some situations may still be out of their control, but how do they work through them matters.

I saw them being reflective about what was going on. Sometimes I saw kids have a shift in their mood, like they were thinking about what happened in their lives. In many ways they might have pushed these memories down and then they get brought up in their art. When things were stirred up for them, we would talk about their coping skills. Some of them needed time to be on the computer. Some of the students wanted to work on their art outside of the time they were afforded. Some students listened to music while others read a book. And some wanted to focus in order to stop thinking about what they were doing.

After students completed their artmaking, they wanted to talk about it or share it. I saw students wanted to share with adults. I think this is because they have a relationship with the adults and need adult affirmation regarding what they were working on.

This art helped us develop deeper relationships with our children. I think our students need to have relationships with other kids, their teachers, their principals, and for everyone to know how important it is for adults to listen to them. Children at this school typically don't have a large population of adults who they can trust. They have past histories with teachers who focus on the curriculum versus focusing on what children need. In this school were are pretty limited with our circumstances. How do you teach social skills when all of the children are sharing similar struggles? We need to think about being more inclusive and providing them with opportunities with experiences to feel more successful in settings outside of this school. We took them to the library, engaged in a distance learning workshop, but if we want to help our children, we might want to think about ways to get them out of school and into the community.

CHAPTER 25

They Lived Their Art

F

I have worked in mental health for 10 years. I started out with psychoeducational therapies, which are anger management, circles (for children who were sexually abused), social skills, and basically activities focused on problem-solving and coping skills. Next, I entered direct care, which is working in residential treatment. I did art, activities, and overall care for the children. I did this for six years. I left residential treatment and worked as assistant in a classroom with children with multiple disabilities-wheel chairs, some were nonverbal, obsessive compulsive disorder, autism spectrum. I worked there for two years. I decided to work in the school district. I earned my teaching license and have been teaching art for the first time this year.

I like being able to work with children through art. Originally, because kids can build self-esteem from it. I have always particularly liked this population, because they are small group. I don't believe they are any different than any other group of children. They are learning how to work through their emotions. And we are using art to learn how to do that. For some children, they enjoy it and for others, they feel intimidated by it. For those who don't feel comfortable, they may not have had positive experiences with it or they may not feel they are good at it. What is different here is that I still need to follow the standards, and give them time to explore with the materials. I find some are really into other mediums and get excited about what they are doing. I try to find out what is meaningful to them. I base my lessons around that.

I discovered they like to do projects that are more personal or music or sports or some even like writing. We did graffiti. They enjoyed that. I also want to find something they can be successful at and you want them to be successful even though they are coming from different backgrounds and experiences. Right now, we are working on bags for the homeless. They are making duct tape bags and fill them for people who are homeless. We are doing this for intersession week. We are figuring out how they can give to others. Because the children enjoyed it so much, they are going to make bags for themselves or a wallet.

I am only part-time here and was not able to be here for the discussions with the children. I am working with preK-12. The first I heard was they were going to have art at an actual museum. Once they started working on their shoes, I didn't hear anything. It was as though it was really private to them. I didn't

© KONINKLIJKE BRILL NV, LEIDEN, 2019 | DOI:10.1163/9789004383890_025

THEY LIVED THEIR ART

push them. And some students didn't want to sell them. They were all proud of their work. I am with them for 45 minutes once a week. I am not sure if some who were reluctant to art, and now he is participating in art.

I felt the artmaking and showing their work at the Leading for Social Justice exhibit was a moving statement and a great way for the kids to connect with art. They connected with themselves and their emotions. This helped us work with them. I had a student who would not even come to art class because he thought he might make a mistake. He thought his art didn't have meaning. But after this experience, not only does he come to class, he participates. He tries new things. He doesn't seem afraid. This child has changed. And he is not the only one. The students used their art to tell their story and to help all of us learn how to work with them better. The fact they participated, well, this is huge with our kids.

Their artmaking made me think. Their work made me think about what I can be doing differently as an art teacher, the extent I can integrate art into their classes, and into their lives. I noticed that their art made teachers and staff think about how we work with our kids or kids in these situations. As I said earlier, their art also made me think about myself and how I work with them. Sometimes there is a hustle and bustle with the day. Maybe they aren't just being defiant for the purpose of being defiant.

CHAPTER 26

The Children Touch My Heart

G

Writing this chapter was quite emotional for me. I cried several times. Why? I try not to think about work, because of what the children have experienced. The children come in with so many layers of clothes. They have been through so much. Many of them have been abused, others have been homeless, and so many are hurting on the inside. To think about it, it's just so emotional. I'm going to cry. I see so many strengths in our children. I think they are strong, loving, and so smart. I think our children are often overlooked. It's like they are invisible. People don't see them. They are right there. They are playing, laughing, and learning just like every other child. They are children, but they have not always been allowed to be children. So many of our children have had to grow up so quickly. It is an amazing place to work here. I get to work with children who are just incredible people. It is emotionally challenging, because when the children come to this school initially, they are trying to work on their issues. We are here to help them, to guide them, to show them how much we love them, and for many children, we are their family. For some, we are parents trying to provide them with love, guidance, and support. It's emotional.

I don't talk about it. I mean, I don't talk about work. Instead, I walk and stay active. I feel comfortable talking to people here about my thoughts and experiences, but at home and outside of here, people just don't seem to understand. I think it's easier if people don't look at our children. I think it's easier for them to think our children need to "be put away," because they "just don't belong." This is a way for people with privileges to just dismiss our children, because they don't "have to" pay attention or care for our children. They can put them off and pretend they don't exist. I am not sure people actually care what happens to our children. As long as our children are not around their children, causing problems or causing their test scores to go down, then everything seems to be just fine. It's almost like people can feel better about themselves when looking at our children during the holidays, because then, our children are considered "charity." They give to our children without knowing them, and then they are done thinking about our children. People feel good about themselves. I am tired of hearing, "I don't know how you do that?" I reply, "Do what?" They say things like "I don't want those kids near my kids" or "I don't want those kids in my classroom," but that's not the norm.

© KONINKLIJKE BRILL NV, LEIDEN, 2019 | DOI:10.1163/9789004383890_026

THE CHILDREN TOUCH MY HEART 201

"Why do you want to work here?" was the question asked of me when I was looking to work at this school. I had been trying to work here for six years, and finally, I had an interview. I replied, "I don't know...it's something that I felt... there is something here drawing me here...I can't stop thinking about them... I see children laughing and playing on the playground...I want to be a part of this...." For years, worked in sales. I could make more money, but I wasn't happy. Once my children were in middle school, I felt it was okay to change my career and work with children receiving special education services. For my first position, I was trained while working in the school. I was offered a position in this district as a paraprofessional in an MH classroom. After that, I was in a cross-categorical classroom. Unfortunately, now, for the children in the cross-categorical classroom, the classroom was phased out. In traditional public schools, those classrooms don't exist anymore. Children need them, but I am not sure why they need to do without. The children need a place to walk, a private place to talk, and get their energy out.

I worked in schools. It wasn't about teaching them, but about providing them with tools to help them cope and work through their day. I love working here. We are a family. This is my first year at this school. I work with two fantastic people who love the children and provide them with nurturance. We provide the children with a "regular schedule," smooth transitions, and talk about the classroom like a basketball team. It works for the children we are serving. We talk about "changing our game plan," "respecting each other's space," "working as a team," "appreciating each other's gifts or talents," and "how to help one another bring out the best." We will say, "Sometimes you need to observe the game and learn" and "sometimes you are the guard" and "sometimes you are playing defense" and "remembering that it is not the person who shoots who is the winner...it's the team who helped the person shooting." The children we serve are all boys at this time, and they seem to respond well to the basketball metaphor.

We also incorporated yoga into our classroom. This really helps our students. They are more centered. I wish we could do this more often. We have a program, but we have to continue to make sure we switch things up for the children.

"Ahhhhh ahhhhh" moments throughout this process were incredible! The children were so expressive and yet, so humble about their growth. It was amazing to watch them grow and share and create. We were all taken back by the power of the art. Their ability to share their stories and think about how to tell their stories through art to help us become better at what we do was incredible. I think their art made them feel free to express themselves here. I mean, in their own way. As teachers, we don't hear their stories. We don't see

how they understand their lives. The art helped them do that and they wanted people to know them. They knew that if we knew them better, they would learn better. All of the children wanted relationships with their teachers and the staff. So many of them are struggling and if we can know them on a deeper level, we have already started to see the impact at this school.

I don't read their bios in their special education files. I could, but I don't. I don't want to "hear about the children." I want to get to know the children. I never want a child to feel like he/she cannot be themselves or need to be something the school wants them to be. Some of these "ahh ahh" moments include a child flipping over a chair and demonstrating rage to coming in the next morning and asking for a hug or a child who is so angry in the morning and then giving you a card at the end of the day that says "I love you." We had a child who couldn't take food on the bus, because of allergies, and the student cried and cried and was so angry with me. The next day, he was able to express understanding to me. It was an incredible experience to witness his growth. He moved from a child who was not able to see other perspectives to a child who understood the reasoning behind the rule of not bringing food on the bus. Or another child who would have anger outbursts and now he shows us a card indicating he needs a break. And after he shows us the card, he waits patiently for us to have time to give him a break. That is amazing!

I am asked if I want to go back to the traditional public schools. I just can't see it. I am so happy to have the opportunity to work here with this family. And being here with the kids is amazing. They are my family.

And being a part of this art was part of being a family. Everyone played an important role in supporting each other. Everyone shared in new ways. The children behaved differently toward each other and toward us. They put their guard down and let people in when they shared their art with us and told us what everything meant to them. The art brought us closer together and we worked differently with each other. We became a real family. And I noticed it impacted the adults just as much as the children. We were drawn into their art because it was real. Their art was raw and full of emotion and meaning. Each of us, even though we didn't do the art ourselves, grew from this experience.

CHAPTER 27

Raw: The Thread That Connects Us

H

There's a fine line between health and sickness
Happiness and sadness
Luck and disappointment
No one person is immune.
Circumstances are fluid
Life is dynamic
Things change.
It's a delicate balance,
This daily dance,
Especially when young lives appear ripe for fray.
But a good day
Feels almost triumph
Setting the pendulum in motion,
Yet again.

∵

These are my beliefs. We are a weave. We are closely woven with experiences that we live. I try to strive what I wrote and know I make mistakes. The children with whom I work help me want to be the best me I can be. No one person is better than another. We are a family.

I was involved in occupational therapy for three years. I worked at a rehab center in another state. I moved here about 15 years ago. I worked in a nursing home as a nursing assistant. I raised my children and when my youngest entered school, I started as a substitute teacher. I have been a substitute teacher for 10 years. I am here every day, but I am considered a long-term substitute. This is my first year full-time, but I have been at this school at least the last 3–4 years.

I am touched. I love working here. I enjoy being with the children. There is a need here. My heart is touched when I work here. I want to be a positive influence for children who unfortunately, have experienced such hurt. A little goes a long way here. I think little things mean more here. For example, sometimes

© KONINKLIJKE BRILL NV, LEIDEN, 2019 | DOI:10.1163/9789004383890_027

it's just a positive comment, a high-five, a break, playing cards or something we think is "small," but shows children we care about them. These "small" things matter. I think when a child has not had much comforting in their lives, then "small" things might carry more weight. Sometimes doing "too much" is too scary. They may have distrust issues and gestures can be overwhelming. It is important to understand our children and what works with them. It's about taking small steps and making small gestures. It is important for children to allow you into their lives.

I come back every day with the attitude that every child deserves a clean slate. I have so much to learn from the children. I have learned patience as well as "blanket acceptance." I cannot decide if I will accept them, I need to accept them. I have learned about inner strength and resilience. Their lives, the way they understand the world, and the gestures they make towards me help me appreciate the "smaller" things in life. I appreciate my life and my experiences when I think about the ways our children have to work through the world. Deep down I am the same person inside, but I have definitely grown. I believe I have been touched. My compassion is more enhanced. The way I understand children has been more enhanced.

I felt raw throughout this process. I don't want to know the past injustices to view how I relate and understand the children here. I want to accept children as they are. When I read their art abstracts and saw their art, it made it feel more "raw." I am learning more about them. I had a cushion between them and myself. Knowing the backgrounds of the children could impact me. I don't want to feel sympathy or pity on the children. Maybe I would be too easy on them or give them too many outs. If they got a bum rap in life, maybe I would be too easy. I don't want to become that-to be easier. I think children need to have boundaries and be fair in their life.

I think children want to be known. They want to be heard. It's part of healing. Ultimately, they want love. I think we all deserve this. I this must have been difficult for the children to engage in this artmaking and put themselves out there. I think they may have wanted to count, to matter, to be heard. I think this was a way for them to say, "I want to be seen," "I want to grow," and "I want people to know I matter." This is important to a child's academic growth, because it's like Maslow's hierarchy. Food, love, and shelter are on the bottom, but you need to get through the ugly mess in order to accept learning. I think the artmaking may have helped them get out their feelings, their experiences, and have people validate them. It's like reflecting. They are putting themselves out there and combining what they thought, what they wrote, and what they created provided them with spaces to think about what mattered to them.

Final Thoughts

After the fact of knowing so many people saw their art and read their abstracts, it shows people can care about our children. I am hoping they may have a curiosity and want to know more about our children. I hope they begin to understand what our children experience in their lives and how important it is to support our children in school. They want to learn, but sometimes we are not aware of what they are living. I hope for those who saw their art and read their abstracts that this was simply more than a "rubberneck" tendency. My hope-people will realize they need to be an extension of humanity. They need to play a role in our children's lives and actually show they care. I am not sure how people are moved or what moves them, but our children's lives should help them realize what we need to pay closer attention tom which is our children. People need to be moved. I hope those who look at their art and read their stories learn how express that. I want them to learn how to express themselves in a way that will make a difference in their lives and their learning.

I think their artmaking makes it all "real." They lived this. They experienced this. Their stories and advice for teachers and principals is "real." I think it's important for people to realize these are "real" children with "real" lives. They not invisible and they should not be forgotten.

I was thinking, maybe in the future, we can help attendees who view their art meet with people from organizations that work with our children and their families. Maybe the artmaking can be the bridge; yes, it is a bridge, connecting our children with communities and schools. And maybe this bridge can bring people together to continue this important conversation. People who view their art and read their abstracts can meet people who are part of these organizations.

Just for people to walk away and say "that's awful" or "I can't believe this happened to children," is just not enough. I want them to be moved and then do something. I want to know the people who read their work and saw their art were moved in some way. I want them to do something, to be engaged, and to be involved. There needs to be a connection between the attendees and the children and their organizations. This bridge is important to making their artmaking even more powerful.

For those who want to go into teaching or to be a principal, I want them to understand what our children need. I want them to be prepared to meet the needs of our children, not to judge, but to empower. I think those who want to work with our children need to be open-minded and understand that what happened to our children happened, but to *know* our children *are* good children. We need people in their lives, in schools, who truly understand them and accept them for who they are. Their artmaking made this clear.

CHAPTER 28

Confronting Anxieties on a Small Scale

I

This artmaking process was new to me. I have never engaged in this type of work throughout my career; and when thinking about relationship between this artmaking, my career, and what I know about working with our children, I am amazed at what I saw and learned about our children through this process. I want to begin this chapter sharing how my paths landed me at this school and how these experiences influence how I understand our children and what they need. I started my career as a psychology major intern through a local college at the residential facility. I worked in the after-school program. They focus on partial hospitalization after school. The program provided the children with learning experiences outside of traditional academics. We focused on their diagnosis. For example, I worked with children identified as developmentally delayed. I provided them with opportunities to catch up. We did more play therapy with the children; and since then, they do more intense therapies regarding appropriate behaviors.

They hired me at the residential facility after my six-month internship. I was hired to work at the school during the day through the residential treatment center. I did not work for the school district. I worked during the day in the school and with the children after school. Eventually, I was hired to work for the school district as a paraprofessional in the classroom. I have been here now for many years. The changes I have seen have been more at the state level, funding for the residential treatment center, and because of that, these policy changes have impacted what we do and what we can do with children. We still do good work, but we are asked to meet requirements such as the Common Core versus more independent work. It seems more academic now, but not because we did not offer that, but I felt the way we worked with children was more therapeutic versus content driven. Most of our work involved manipulatives, engaged in hands-on learning, and utilized games to provide meet the learning standards. We are more focused on books and I think it is across the board, kids seem to be growing up faster. We use to have children focus on play and learning, and it seems as though society seems to expect them to grow up faster. I believe this applies even to my own kids too.

The kids bring me to work every day. There are rough days. There are days it is difficult to get up, but I have to give 110% every day. When children come

© KONINKLIJKE BRILL NV, LEIDEN, 2019 | DOI:10.1163/9789004383890_028

CONFRONTING ANXIETIES ON A SMALL SCALE

in and trust I will take care of them and help them reach their goals, this is so meaningful to me. Working with them is so rewarding. It fills me up when children come back and let you know their experience here mattered. They know they can come back any time and know we still think about them and care for them. We have all made connections with our children. We not only make connections with the children, we make them with each other. This community is strong. It has to be. We are here for the children and we are here for one another. I believe if our staff populations wasn't so close-knit, I don't believe this would work for our children. I feel supported here and know I can do what I need to do to support our children. All of the children know we have their best interest in mind. They know we are here for them; there is someone here who can help them; and they know we will do whatever we need to do to meet their needs. This is critical to their development and progress here.

During my 19 years at this school, I never experienced artmaking as the children have at this school. Initially, and I am not trying to be rude, but I wasn't sure what was really going on. This was a very new concept to me. We came together and talked about the artmaking, but when you haven't done something like this, you just don't know what to expect. I assumed this would be a cookie-cutter program. I thought the kids would be told what they needed to do and how to engage in their artmaking. That wasn't the process at all. I was shocked. I was taken back by the authenticity, effort, and time taken to provide the children with this opportunity. They had a voice, one-on-one time, and an opportunity to create art that represented who they were, their journeys, and giving teachers advice about what we should be doing for our children.

I will have to tell you, I think some of our children were initially intimidated by the process. Again, this was something new. Christa was new to us and our children have difficulty forming relationships with new people and with transitions. But what happened throughout this process was interesting. It was quite incredible. I wasn't sold on the idea at first, but now I see the power of doing this art and the need for me to learn how to do this for my kids in what we do every day.

Christa asked students if they wanted to participate. The children wanted to work with her. She met with them one-on-one, and I know they felt heard, because she typed everything they said and wanted to share what they said with us. They were proud of their writing. They were not hesitant to go and talk about what they wanted to do or to create the art. It took several months to complete their art, but they did it and without hesitation. They were excited to work on their artmaking and looked forward to the experience. They seemed to feel relieved and calm after working on their artmaking. I noticed this when

they returned to class. Their behaviors changed, and as they changed, so did we. We were able to know them differently. It was a different level of knowing them as students, as people. They interacted with one another in new ways. They shared and worked together. They took more risks. The kids were proud of themselves and wanted to participate more in class.

It was interesting as someone on the outside looking in at this process. Again, I didn't realize the children were leading Christa. This was so interesting to me. Usually, teachers lead the students, but Christa made sure they were the experts. The children led her and this book is a perfect example. This entire process was led by the children, their voices, our voices, and we all came together in the end to send a message. It took such a long time to do this work, but it was important to the process. As teachers, I think we are often put in positions to rush through and to use our voice and expertise, but this artmaking process was so much more than art. It was a process. It was a process like nothing I ever experienced or the other teachers.

I was under the impression because of my experience with other art activities that this was something assigned to the students, but that was not the case. Our students volunteered and wanted to work on their artmaking. I noticed immediately when children had a chance to express themselves the very first time by sharing their champions and schooling experiences, they seemed to relax. They seemed relieved every time they came back to class. They were excited about learning. And that excitement came right back to us in the classrooms.

As time went on, I respected more and more of what was going on, because I saw the children's responses to this artmaking process. I had no idea the time that is what went into supporting each child. I was impressed by the time taken to allow the children to lead the way, to really engage in their learning, and to use art to help them understand themselves and think about the world. When I saw the hours devoted to each child and how each responded with excitement and pride, I knew this was a meaningful experience for them. When I saw this kind of work being done, I respected the process and the artmaking. Our children need more opportunities like this. It was an incredible experience for all of us.

When children engaged in their artmaking, I don't remember a lot of the children speaking about what happened when they spent time on their work. It was as though this was their private time. Everything was secretive at first. They seemed to need this time to reflect on their lives and what impact all of this has had on who they are today. The children shared their work as larger sections were being completed. For example, sometimes the children would want me to read their art abstracts or they would show me their artmaking

CONFRONTING ANXIETIES ON A SMALL SCALE

when it was close to completion. They examined every piece of their art and told me what it meant to them and their story. It was amazing!

I noticed right away the calming affect this process had on our children. They just seemed relieved when they returned to class. It was as though a weight had been lifted from their shoulders. The children never came back disappointed. They seemed to feel good about themselves. They sat differently in their chairs. They sat up straighter. They spoke up in class. They asked more questions. The children wanted to work together and share. I wondered if this calmness and pride was due to the one-on-one undivided attention they received, feeling heard, or getting the chance to express themselves through the art, or maybe, just maybe, all of it. And now that I think about it, I think it was the entire process. This artmaking involved the children. They had a chance to be heard, think about what all of this meant to them, and then created something that was real. It was real for each of them.

The children didn't seem to feel stifled. It's like they knew anything was possible and it was up to them to make all of these decisions. I know from working in this field that for many of the children here, they don't get to make as many decisions at one time as they may have been given during their artmaking. They seemed to thrive in making decisions about their art, their stories, and giving sound advice to teachers and principals about working with children like them. I don't know for sure, because I wasn't there, but I am guessing none the less.

Children trusted that what Christa said would get done. They saw her come to the school for a year listening to each of them, working with them, and going out and getting any materials they needed for their artmaking. The children seemed to know they could engage with this artmaking without judgment being passed on them. For some students, I am not sure how many were open enough to the process to let go, but I can tell you they all seemed to feel better about themselves. I don't think all children were at the same point in their lives and understanding how to let go and share it all, but from what I read, and from what they shared, for those who did, they opened up in new ways. They felt better about themselves. For the children in our classroom, they seemed more positive about themselves and used less negative self-talk. That is a big deal for our kids.

When I think about specific students, one student in particular went from being more dependent to more independent by the time their artmaking came to completion. She seemed more focused and confident in doing what she needed to do for herself. In the past, she often tried to "out-do" other kids in class and believing "more is better." But when she did her artmaking, she seemed to change. She began focusing on her needs versus comparing herself

to others. Her artmaking focused on what she needed for herself and what she ultimately wanted-love and a family. For this child, being more independent was critical to her success here. She took care of what needed to be done. I believe the artmaking provided valued, more self-worth, and a sense of independence.

I believe all aspects of art, music, and self-expression are critical to student learning. I think the arts provide children with more opportunities to express themselves, provides more opportunities to go farther with what they are learning, helps them think about what they are learning, and encourages them to apply what they are learning to their lives. For our children, their art became a bridge to what they were learning. They experienced something, reflected on it, moved forward, and seemed to be more open to the next experience. I think the artmaking process is comprised of small steps leading to something so much larger. It's like asking a student to present a small speech in front of the teacher; next, sharing that same speech with the class; and then eventually, talking with the school.

Their artmaking was sacred to them. And although some of them may have been weary of what was happening, because this was new, they all decided to use their courage and engage in it. For so many of our kids, this can be overwhelming; however, the children chose to take a risk, make themselves vulnerable, and share their lives with all of us. I believe this artmaking process is important for our children. So many of them live with anxiety due to what they have lived. And I believe, for many of the children, although this was not overtly stated, this artmaking was a way the children confronted their anxieties, without judgement, on a small scale.

CHAPTER 29

Leading through Artmaking: Recognizing the Power of Arts-Based Approaches

J

Numerous reasons come to mind when sharing why I wanted to accept a position as the principal of a public school serving children with emotional and social learning differences. Simple things like looking for a new challenge and wanting to make a difference for all kids comes to mind. The purpose of this chapter is to provide some insight regarding artmaking and how often as school leaders, even as educators, we often overlook the power of arts-based approaches, especially when considering how to reach vulnerable populations. And in this case, I am referring to children who are not only receiving special education services, but who are dependent on the state and their school community to protect them, to guide them, and to nurture them.

Upon arriving in my new position several years ago, clearly a new challenge was ahead of me. Wanting to provide an A+ education for the most challenged kids was soon one of my main goals of my work. I have often been asked how I manage all the sadness and anger in the kids. Providing our students with that A+ program is how I manage the serious needs of our student population.

My biggest struggles are understanding how adults can put their children in harm's way and not keep them safe. Professionals in the field sometimes refer to our children in this program as "bad." This kind of thinking is dangerous and unproductive. Our students did not ask to be abused, neglected and/or rejected. Understanding the big picture like mental health needs, trauma, conduct and special education needs will help our students. And then there is compassion and empathy...very difficult to teach to those who think the children are at fault.

Our students' greatest challenges are managing their mental health, behavioral and emotional regulation and building trusting relationships with adults. I am frequently asked why students find trusting adults such a difficult task. The answer is easy-adults in their lives have not properly fed their children, clothed their children and consistently put a roof over their heads. Above all those reasons-adults have not surrounded their children with love or care from safe individuals. That alone has led to serious neglect and physical and sexual abuse. For most of our students, school staff provides the boundaries,

© KONINKLIJKE BRILL NV, LEIDEN, 2019 | DOI:10.1163/9789004383890_029

212 J

compassion, structure and guidance that all children need to have to be successful in school and life.

The most disappointing work happens when our students leave us. Few have successful experiences in the big world, many are challenged as they move on to foster care, group homes, other residential facilities or back home. Some return to us several months after they leave for another period of stabilization.

Many of our children have never experienced playing on a sports team, singing in a choir, acting in a drama production or simply having dinner each night at the table with family. Holidays and birthdays go by without any celebration outside of their cottage staff. Some children have not one person who stays connected with them throughout their life. Some have family members who are incarcerated for long periods of time.

Most of our children know no other way of life, abuse, yelling, alcohol and drug use, prison, police, hunger, and chaos; and unfortunately, arriving into residential care for most kids is a relief.

And even more disturbing, most responsible adults know nothing of our work, and when asked what I do for a living, I explain. They seem horrified, and never ask again.

Artmaking Process

When this project came to us, I thought this would be a wonderful opportunity for our children. I wanted to see us take their histories and make the most of it. I watched the children respond to this. I had never experienced this before. At the completion of the project, I had an appreciation and understanding of the artmaking.

When we met in the gymnasium to begin this artmaking, we talked with the children about their champions. I was facilitator for one of the small group discussions. We were talking about champions with all of the children in this school. I wasn't sure how they would manage this. They were excellent listeners. They were intrigued by the process. I thought they did a fantastic job. I wasn't sure how they would have responded, but I was surprised at the powerful impact these arts-based approaches were having on our children. I was also initially surprised by their interactions with Christa and X. I thought they might have been shy, but then again, all of them being in therapy as much as they are, they did a great job critically thinking about the work they were about to experience. Every child was engaged. I was surprised. They are wonderful resilient to be able to talk about what happened to them. I am amazed at what children say. And I remember one child who said, "I don't have a

LEADING THROUGH ARTMAKING

champion." I thought he was brave to share that. I wasn't sure if the other children understood. I didn't know if the children thought it couldn't get worse. It appeared at that moment, they said, "Oh, okay." One student said, "Oh yeah, the student said the other student didn't have a champion." I facilitated a conversation about how each of us could be a champion of the student. They didn't seem to think about others and have a difficult time being empathic. Students might say, "My county workers don't care about me...my social worker doesn't care about me." I am not always sure how to respond. We want them to know there are people who are here who care about them. But if they don't know what empathy is, then how can we expect this of them? Trying to help them understand one another and what they have lived might not always be realistic for them.

The children seemed to want to be accepted and supported from their champions. And although other children may have this type of structure at home, our kids don't have this. They don't always have someone to call their own or if it's even possible or if they are deserving. There are so many broken promises. They are told where to go and when they are going to leave. The transitions our children go through are overwhelming to us and we have difficulty imagining what it must be like for them. Our children want stability.

In regards to all of our children, the common themes emerged. The same child started to write about his champion was a superhero. He didn't have a real-life champion. He needed validation. He knew he was "good" at being "bad," and needed some type of validation. There seemed to be a theme of struggle. You don't want your children to struggle, but our children struggle so much it is exhausting. So many of our children look beyond their age. I don't know if children know how to put words to that. I am not sure they have problematized what happy is and what it might feel like to engage in this. We had a child who never celebrated a birthday. He is so little and he had an ice cream at a table. Eating the ice cream was the child's "best birthday" he ever had. We had another child who brought his belongings from home and asked to live in the cottages. And knowing how many family members don't want to visit their children and want their children to prolong their stay.

Our children want to be someone. We support our children as much as we can. Our children need the right champion to get them through this system. They just want to be somebody. They want to be recognized. They want to be singers, writers, and teachers, but they just need the support and resources to make this happen.

At the beginning, I said, "Hmmm...interesting." I asked Christa, "Did you ever have an issue with any of them?" I never saw this happen. I saw children engaged, and proud of themselves, and for them you could see the pieces of

their life come together and you could see what happened to them. This is how they viewed their life. Some kids may think they had little bumps, but our children do not. These were reflective pieces at such a young age. For most of us, there was a lack of events and mostly positive. But for our children, they don't forget and put their lives on display for others to learn from.

We worry about our children and their tendency to share their lives and be vulnerable. However, they were vulnerable and need to learn how to be safe in the community. Our children need to learn what it means to be unsafe in the community, but they were remarkably open. I found it ironic when they shared their lives and willingness to be in the open was amazing in a good way, because I hear therapists saying their children won't talk.

When I first saw the artmaking, I saw vibrant colors and sparkles and looked pretty "happy" to me. I found their writings the opposite of what they actually made. Their art drew you in and drew your eyes in. They were able to share this by drawing you in. I expected something to see very different. I see kids what they do and in therapy and it's depressing. However, overall, it was a way for children to look at me and read my story. This was deep and heavy stuff. Their pieces were survival based and yet they were intriguing and attractive.

I was simply amazed at this complex and thoughtful work. What our children are capable of doing, their potential, and where they want to go. When we teach children about analogies, they put these together when we think about what they have gone through. Our children put so much thought into what they did.

When one of the students shared his artmaking with me, I realized the extent his life was immersed in his art. I have known this child for a long time, since elementary school. Being accepted has been an issue with this student. He has been ostracized by students. No matter what program we try, it is almost like it makes it worse. We cannot force friendships, but as this child said in his abstract, we can create environments that are welcoming to everyone. That is not as easy as it may sound. He created an ideal situation in his art and helps us remember what really matters. What really matters is genuinely caring about each child and helping children appreciate what it is that they bring with them to school. This student gets so upset when adults cannot create a space for him to be accepted, to like him, or to be his friend. It seems difficult for this child to understand why the world behaves the way it does. In many cases, I am not sure I understand myself. I don't know why it is difficult for some people to be accepting of other students. It's as though being different is a bad thing sometimes. And for this student, he is different from his peers, but he has so much to offer.

This student holds onto happiness. He just wants to find one friend who will accept him. For those of us who have friends or make friends easily, this

LEADING THROUGH ARTMAKING 215

may not make a lot of sense to us. But for this student, and other students we serve here, this is the norm for them. They come here and have been told over and over again they just don't belong. But here, they do belong. They feel safe and secure. And for the student I mentioned earlier who just wants one friend, well, he hasn't given up that dream.

His artmaking makes me anxious for him, because if making one friend doesn't happen for him, I wonder, "What will happen for him?" This idea that schools do a great job of pairing up our children, well, it just doesn't work. It actually can make things worse for some children, because there might be a sense of resentment or pity on children who come to this school or who need special education services. We can't make these things happen. Now, he is transitioning at the middle school, and he is having difficulty managing himself at the school, and being so angry at the adults. His grandparents are supportive of him. They are aware of the side effects of the medication, but he needs relationships with people his age. He made this so apparent in his artmaking. However, we don't really make this a priority in how we understand what it means to educate children. We are aware of how often we are left off a list, an email, field trip, an assembly, and it seems as though the school is similar to the children we serve. We have needs and are not included, just as our children. When we think about giving back, our children are aware of why this is important. We have our children give back, because it's an important value. We want our children to learn they are important and do matter in the world.

We can't make children be compassionate toward one another. That student will tell you right away after being a part of these programs, "Well, that didn't work either." He becomes sad and frustrated. And who wouldn't? We worry about him socially. And the day he doesn't have his grandparents in his life, the day he doesn't have family around to support him, I often worry and wonder, "What will happen to him?"

We need to have people who understand our children and what they need. This commitment is pertinent to our children and their development. If they are not in emotionally stable environments where their basic needs are met, then we don't stand a chance. We have to begin by understanding where our children come from, what they have experienced, and spend time knowing our children. Not saying we "know" our children, but taking time to listen, to love, and to support them through yet another transition.

I am interested in having this artmaking process come back and support our children. We have a therapeutic piece and we do well with our curriculum, but we obviously have other pieces to explore. I am not convinced we are trained to know how to do this for our children in our preparation programs. When are we introduced to critical reflection or sensemaking or artmaking? Never.

216 J

And when we don't have opportunities to learn what these experiences can mean for ourselves or our kids, the we miss the boat. We often times fall back on negative thoughts about our kids and may not believe they are capable or sometimes even worthy. The reality is this: We see our children in so many unfortunate situations. Our children need a creative outlet to think about what all of this means to their development. They are children with so many insights and they understand privilege and the power of identity. And I realize reading, math, and science may not provide our students with opportunities to use their insights to help them grow. It's a space in which all of it comes together. This is an opportunity for children to learn how to express their thoughts, insights, and the way they understand the world in a nonthreatening way; and then, we learn so much about them and this allows us to help them in new ways. It's the right thing to do for kids.

This artmaking got at the heart of what it meant to be human. And when we think about what it means to be human, understanding the world around us or how we are connected to the world is critical to this process. No one ever talked about feelings in school. I don't remember any of this. I don't even remember having this done when I was a kid or when I was learning to be a teacher or when I was working with students. It's almost like we learn on the job. If we can reach our children, then we are going to help our children be successful. People don't seem to want to talk about culture in a school or a district, but it's the key to success. Why not? What are we afraid of? Or is it that those who are in positions of power do not feel there is a need to discuss anything? We need a culture of acceptance, not tolerance. I was recently in a training and we were part of a positive behavior program plan. I asked, "How do you promote this?" The reply was, "You just make them do it." There was no response.

The artmaking provides choice for our children. They chose everything from what they said, what they shared, how they understood the world, how they decided on their themes, how they chose their materials, and how they represented themselves. There are not opportunities for our children to engage in that type of work. I think there is often a lack of trust for children in special education, because they have been labeled bad. And yet, this is a misconception, because we have children who can be trusted. We sometimes assume children who receive special education services just cannot do, but we prove everyone wrong. Our children can manage technology, their learning, and whatever we put in front of them, including field trips, and we have success with our children. And yet, we have the same challenges as other children in educational settings. There is a gate here, and for some, they may think it's like jail, but we learn from this. We need to continue to provide our students with

opportunities to learn, to grow, and to trust. And not just trust themselves, but for us to trust them. And the artmaking created that space.

When we think about what children deserve, our children deserve the best. And the artmaking provides them with this opportunity. We have to talk about providing our students with opportunities to grow. Lunch in the cafeteria, eating with one another, going on field trips, use technology, and that our children deserve to have access to what every other children have in schools outside of here. This is part of what we do and what we believe. Access is critical for our children to grow, and the artmaking did and does that. I cannot begin to tell you the transformations I witnessed in our children and the transformation our children experienced with themselves. I saw children with confidence. I saw children make themselves vulnerable. I witnessed children muster courage to help teachers and school administrators think about what we do in school matters, especially with children who receive special education services. We often overlook the children who are placed in special education, and this process not only helped them make sense of their experiences in school and home, but in life itself, and for the purpose of educating future and currently practicing educators.

CHAPTER 30

Developing My Approach to Working with Children

K

I have been doing this job for many, many years. In other words, I started as a school secretary. I took time off to raise my children and take care of my aunt. I received a call from one of the teachers here. She said, "Hey, there is a job opening for a teacher's aide." The principal invited me for an interview. I met the teacher I would work with and I was hired. It took about a year to get to better understand how to work with the children. More importantly, it takes time to learn how to work with adults. And in this case, I was learning how to work with the teacher and to make a good team for our children.

I learned what it meant to develop "my approach" to working with children. I had to find my own way to walk, to talk, and to work with children. I had to find my own style. I describe this style of working with children as a listener, a tactile teacher, nurturing, and I am not offended by language. I don't take any of this personally. I don't pass judgment on children. I afford them with spaces to say what they need to say. I learned how to do this. And now, I am more comfortable with my style of working with the children.

The students bring me here every day. My partner teacher, especially, inspires me to come every day. With the teacher I work with now, it was an immediate match. We finish each other's sentences. She values what I think and what I do. I am not sure that always happens in schools, but it happens with me and my partner teacher.

The children here are called "throwaways." For those who go home, they usually go home to families who have many needs. Families are overwhelmed with their responsibilities. For the children who don't go home, let me be clear; this means two different things. Students who go to the cottages, there is a sense of hopelessness. They are often wards of the state. It is difficult to reach them, because they have been passes around from one place to another and then to another. No matter where a child here calls "home," there are issues and challenges they face. The commonality is being passed on if they are foster children; and "being let go" if they are with a family and being strong living with families who are overwhelmed with the experiences they are living. Overall, children need stability. They need to be loved. We offer stability here at this school. We love all of our children.

When all of this took place in our school, and when I say this, I mean the artmaking, watching and hearing the story of our colleague was helpful. I never

DEVELOPING MY APPROACH TO WORKING WITH CHILDREN 219

experienced anything like this before, not in my training or preparation or with the students. We watched a video regarding champions and it was helpful. The video set the stage and helped our kids think about the role champions play in our lives. Every child needs a champion, but I am not sure our kids felt that way. The artmaking process began with discussions about who we are, what's a champion, and the extent we have champions in our lives. So many of our children do not have champions outside of this school.

When I think about the artmaking and the power behind it, it was hard to comprehend something I had not experienced, but knowing one of your colleagues had done this work and had the courage to share his artmaking and his story on the first day, well, it was really helpful. I knew some of what my colleagues shared, but his artmaking gave me more insight into his experiences. It was enlightening. His final piece mirrored his teaching. He is calm, understanding, and empathic. My colleague's artmaking was what he was as a teacher. His art was him and he was his art. It was powerful. It represented his values, attitude, and actions. His artmaking, in many ways, was actually a teaching moment. Leroy took a risk. He made himself vulnerable and so many times, we don't do this as teachers or leaders. We aren't asked to engage in this type of work or even introduced to it for that matter. Initially, Leroy's artmaking seemed fragmented. He presented all of these art pieces that looked like puzzle pieces. Initially, I had no idea how it all worked together. And then, it all made sense. Each piece of the puzzle was a moment in which the experiences he lived influenced how he thought of himself. And he continued to explain how those thoughts then impacted how he responded to the world around him. This was interesting to me. It was as though the process allowed Leroy to view his life as a puzzle and how seamless his journey was once he started to understand how he became the man and teacher he became.

And that was my hope for the children. Would they engage in this process at that deep level? And the surprising answer was, "Yes." And in the end, it was so much more than I ever imagined it would be. The students became their art. The art became the students. They made these incredibly moving pieces and their narratives brought many people to tears. When the kids brought their artmaking, I could simply look at the art and begin to deepen my understanding of what it meant to walk in that child's shoes. I have worked with the children for years and I can tell you what happened with this artmaking never happened with our children before. They talked about their art. They showed their art to everyone. They were vulnerable and were proud of the work they did. And believe me, it was difficult work. They were emotionally exhausted. So many times, it was like a weight was lifted off of them. They also expressed themselves in ways I didn't know they could or desired to, and I think they

surprised themselves also. I think they did because their faces would light up when they were talking about social justices most important to them. They were transformed, and so was I. The process is much more than creating art. It's not a class. It's a process. It's a way to help children think deeply about whatever they are learning, and in this case, they were learning about themselves and what the system needed to consider when working with children with special needs. Every teacher should experience this and learn how to make this happen for the children in their classrooms.

CHAPTER 31

The "Red R" Kid: Disrupting My Deficit-Laden Label

B

I have spent my life emotionally charged, but being told to "stay calm." I never demonstrated anything to show I was reckless, but my lived experiences are emotional. And being asked not to express my emotions and how difficult this journey has been for me has impacted who I am. My emotions are connected with my responses to discriminatory and unethical practices and policies I have navigated for most of my life. I feel as though I have been expected to contain myself. I have heard over the years, "Oh there he goes as the angry Black guy" or "there he is again on his soapbox." It's like a trap. It's like they bait me. Growing up, experiencing what I experienced would be difficult to prove, because the majority rules. When people like me face obstacles, they often go unheard. They are simply thrown away, just like any child with emotional and behavioral differences I would serve as a teacher. They too, are simply passed by and perceived as invisible by society. And throughout my life, it's as though I have often been ignored, passed over, and invisible. Other times, however, when it seems as though the majority is trying to make specific parts of me visible, I find myself tip-toeing through these complicated waters. I am asked to defend myself, support my claims, and yet, for those who engage in unethical practices, who are usually members of the majority, they have not been held accountable to the same standards. Interesting, huh? And the more I think about this, the more I realize the majority cannot choose when and when not to make me visible. I am here. And when I am visible, when "they" actually "see" and "experience me," they will see I have more education and experience than the most teachers. And for some reason, even though I have to be two to three times better than my peers, my experiences do not seem to "count" and is often "questioned." Because I do not "fit" the negative stereotypes of being a Black man, there is an underlying discomfort or fear that is perceived as a threat; therefore, minimizing my successes is a way to keep me in my place, invisible. I am not sure why fear seems to stand between me and others. This fear seems to prohibit people from working, listening, and supporting me throughout my lived experiences, especially in education.

This is the first chapter I have ever written. When asked if I wanted to share my journey about engaging in this artmaking process, initially, I was excited

© KONINKLIJKE BRILL NV, LEIDEN, 2019 | DOI:10.1163/9789004383890_031

about the opportunity. Later, I was a little intimidated. And now, after spending time reflecting on my life, I realize the power of this artmaking process, not only for the children I serve, but for myself as a teacher. As I drew meaning from my experiences and tried to make sense of what it meant to be a young Black male being educated in and working within a predominantly White society and educational system, I realized my race, class, and abilities were under question. And today, they are still under scrutiny. I have not found many people who are willing or able to step in and interrupt the system. I know there are people out there with similar first-tellings, and they are in need of spaces to reflect on the influence of their lived experiences in how they understand the world. I live in a society that does not seem to offer understanding, empathy, or time it takes to pull someone alongside them in order to succeed. I hope my chapter inspires anyone who feels marginalized, especially those who have been shut out from the educational system, who are known and treated like a "throwaway," to utilize this book, this artmaking process to disrupt the negativities in their lives, the deficit-laden messages, and break free, celebrating who they are.

This process was an emotional journey for me. Writing this chapter wasn't easy, because thinking about what this means to me, I had to reflect back and think about my childhood. For now, I will focus on what is happening now, and then I will take you back to my roots. I was a graduate student at a university. It was a relief to be in a course focused on social justice-oriented work in schools. Why? It was the first time issues of social justice were shared with me and wasn't told I was the one being "paranoid." This course focused on not only learning about the issues were terms based in "doing something," in social action. For me, social justice issues were something I lived with and continue face every day. The term "social justice" immediately took me to back to the lack of support those who live on the margins face in their everyday life; in other words, there is not an equal playing field for disenfranchised populations. These groups include students who identify as People of Color or by class or religion or sexual orientation or any other way of identifying as different.

In this chapter, first, I begin by describing my definition of social justice. Second, I discuss my professional career and how it led me to my graduate work in promoting justice in schools, especially for disenfranchised populations. Next, I share the artmaking process and its impact on my development as a leader. Finally, I address the impact artmaking to promote social justice had on the children with whom I serve in a school focusing on behavioral and emotional issues.

THE "RED R" KID: DISRUPTING MY DEFICIT-LADEN LABEL

Defining Social Justice

I can't tell you when I definitely understood what was meant by social justice, but I can tell you it is a feeling. It was a feeling I felt all of my life, and taking the course contextualized it for me. Taking the course named it. I realized this course was about me. There were terms and ways of thinking of what it meant to be Other that helped me understand I was not alone. I had feelings, but I didn't have the words to help me understand what all of this meant to my development, not just as a student, but as a young Black male. There was free and reduced lunch. What did people think about me when I received those meals? What messages were being sent to my teachers about my capacity to learn? What were they willing to do for me to be successful? Or were they? Did receiving free and reduced meals tell them I wasn't capable? I would only go so far?

In elementary school, I had two red "R's" next to two subjects in school- reading and math. I attended a private elementary school, and in that school, special education services were not available. Although I didn't have a label, the red "R's" meant I "needed additional support." When it was time to go out- side and meet with specialists, I thought it was "cool," but what was really hap- pening was providing me with extra support. After years of going through this, I looked up what was meant by these "red Rs." The teacher told me it meant "remedial." I just knew something wasn't right. I looked up what everything meant and realized I was being told "I wasn't smart." As a child, I saw those red R's and thought to myself, "You are dumb." Those red "Rs" followed me throughout my entire academic career. With my every turn, I doubted my abil- ity. I doubted my capacity to learn. I doubted my ability to reach my goals. I was "remedial." I wasn't me. I was a label. I remember crying about this. And I am crying right now thinking about this as I am writing this chapter. I told my mom at 11, "I won't be stupid." We both cried. She had so much pressure facing her, because she had a child who was labeled as "stupid." I wanted to be more than that to my mom. And I remember promising her "you will not have a child who is stupid...I promise you, mom." I knew at that time, at the age of 11, I was just "a little Black boy" attending a "good school" so "I could have a better life" and they were doing the best they could. I wanted to do my best to make my mom proud of me and not to worry about me. And now, I just realized those experiences were probably the foundation of why I am so committed to this social justice-oriented work.

I never discussed my thoughts with anyone at home. My only conversation was when I was 11 years old and made that promise to my mom. I suppressed

those thoughts and continued to navigate my way through life by myself. I learned this made life more difficult, but my challenges inspired me to do good in this world. No one in my family ever pursued a degree in higher education. I am a first-generation college student. I didn't want my brother and sister to fall victim of the discrimination I faced. I am the oldest. I felt a responsibility to look out for them and to watch over them. I didn't have anyone to ask for help, because I was the first to experience most things related to higher education. Everything I experienced was something I needed to figure out from welfare to food stamps to filling out forms to receiving assistance to special education to moving from school to school to learning how to balance academics and athletics, and then, figuring out who I was as a young Black male. I hung out with the people who were marginalized, not just because they were People of Color, but because people I knew were in drama, theater, music, or interested in something other than athletics. I remember pushing these boundaries when I invited my peers on the football team to watch me perform in a play. It was eye-opening to them. I became an ally and I was a bridge. I was a young Black man who was told "you won't be anything" or "you can be an athlete" or "you can't be in drama unless you are gay" or "you won't amount to anything because you are Black and poor" or "you can't defend 'those' kids 'cause then you are one of them." When I look back at my childhood, I have been doing this work for quite some time; but unfortunately, there was no one there to help me navigate these dangerous waters.

The course I took and the artmaking we did was a powerful experience for me. My passion, or maybe as I think about it, it was uncovering my passion, was central to this artmaking experience and reflecting on how I became the man I am today. Social justice work is not just something you do, it is something you are. It is something you become. I didn't have the terminology, but I had the experience. I had these feelings. It was part and IS who I am. If you have a problem with me, then it's your problem, because I am the man I am. I always knew people had a problem with me being "open minded." The more experiences I had, the more I realized I was doing right by myself and those deemed Other, but the course, and the artmaking, helped me understand this in a safe space. I was free to think about my life and make connections among my experiences, sense of who I am, and engaging in this social justice-oriented work.

Over time, I came into contact with people who shared similar thoughts as me. Most seemed to suppress their thoughts due to pressures by institutions, community, or peers. But I couldn't do that. I felt something may have been wrong with me, but I held true to my spirit. This oppressive system, one that is so much larger than me, was created to make divisions in myself and

THE "RED R" KID: DISRUPTING MY DEFICIT-LADEN LABEL 225

those I held dear to my heart who were deemed Other. The system wants me to doubt who I am and what I believe I can become. It is fear-based. And it can be quite intimidating, but over time, I came to realize this work has a name. It's social justice and equity-oriented work.

My Professional and Academic Career

I remember the tipping point in which I seriously thought about being a teacher. I was in a college communication course giving a speech about artificial intelligence. My professor asked me, "Did you ever consider being a teacher?" I replied, "No, that never crossed my mind." During that time, I was just a second semester freshman. Actually, I wanted to be an astrophysicist. I wanted to study space, the stars, and the universe. But, that self-doubt I talked about early, coming from the larger system, persuaded me to change my dreams. I felt I was in limbo. I realized it would take me even longer to graduate and pursue this career, and with the self-doubt hovering above me like a dark cloud, I didn't know what I wanted to do.

I started to reflect on my past. All I was asked in high school, "What are you interested in?" And then, I was placed in certain classes, but no one ever talked me or prepared me for the realities I would face. So once I stepped foot on campus, concerns were no longer focused on what I wanted to learn, rather, about when would I graduate. High school faculty seemed to make decisions for me regarding my course work and athletics; and once I graduated from high school, I felt like I was on my own. It was a hit-and-miss kind of game. I didn't feel prepared. So many students were much more advanced than I was, because even though we may have taken the same high school courses, they obviously, had very different high school experiences. I moved from astrophysics to behavior science to technology to eventually, teaching.

If it wasn't for my communication's teacher paying attention to me and my talents, I don't know where I would have been today. He saw in me something I didn't see in myself. When I spoke, he saw people listen to me. He saw people respond to me. My professor thought I had what it would take to be a teacher. He and I had several conversations about being a college athlete and an educator. He believed I could make a difference. Now that I look back on this, he was the first professor to help me talk about social justice issues without using the term. We examined stereotypes of athletes being individuals who "cannot speak eloquently" or "people who were not smart" or "people who cannot do." And with this, I realize now, we were not just talking about "athletes." We were talking about issues of race, class, gender, and much more, which were

about social justice-oriented. Maybe he was afraid to discuss this with me; you know, being direct about what we were really talking about. He wanted me to know I could be "so much more." My professor was implying, "You are not just a Black athlete...not just an athlete...you don't 'fit' the stereotype, so move forward and do something." He suggested, "Why don't you check out the education program?" This was the first time someone acknowledge me as a person, not just an athlete, not just a football player. And because I trusted him and took time to know me, then I took his advice seriously. It amazed me someone took interest in me. That had not happened to me before. I am not saying people didn't take interest in me, but they took interest in me as an athlete, not as a scholar.

He left the university the next year. In many ways, I wonder where I would be if he would have stayed. Why? Because he was helping me navigate a system unfamiliar to me. I was given a mentor in the education department, and my track coach, but no one took me under their wing to help me think of myself as a scholar. I needed to declare a major, so I decided to follow through with the advice from my communication's professor. I became a physical education teacher merging my two worlds, my two talents. And unfortunately, I didn't realize the stereotypes I would face because I chose physical education. I heard things such as "only athletes do that, because it's so easy" or "you are paying all this money to be a gym teacher" or "you aren't a real teacher." I discovered I was not only marginalized for being a young Black male, I was also marginalized for the career I chose and for being an athlete. I would have never thought my talents would have perpetuated deficit-laden beliefs in who I was or who I could become.

My communication professor saw something in me. He wanted me to promote myself and utilize my talents to spread the word-to send the message that people matter, that what we do matters. Unfortunately, I didn't meet a professor in my undergraduate work who believed in me like this, who took me under their wing. I held onto what my communication professor said, and his words inspired me time and time again. His words were instrumental to my career as a teacher.

I spent many years in K-12 education. I worked in elementary and high schools, but spent most of my time in high schools, and predominantly in one district. This year, I accepted a position working with children who have been diagnosed with emotional and behavioral challenges. Many of the children have been foster children, wards of the state, and moved from school to school. The same questions were raised when I accepted this position. People asked, "Why in the world would you want to work with 'those' children?" or "Why in the world would you want to change schools now?" or "You do realize you

can't help them" or "You must not be a good teacher if you are going there." In response to these deficit-laden comments, I made it very clear: "I am not afraid of the work...and I want to work with children who need to be empowered." And sometimes, I would ask the same people, "What is stopping you from wanting to work with the children at that school?" Their responses ranged from "I can't work with those kids" to "they are crazy over there" to "I am not working that hard" to "you are crazy to want to work there." As an educator, I realized I would be working with children who were marginalized on multiple levels. The children who were considered "less than." I felt a responsibility to what is right and provide our children with high expectations, a nurturing environment, and meaningful relationships. I wanted to reach out and give back just as was done for me.

Today, my mom is still a part of who I am and what I do. She knows when something is wrong, and I hope, through my work with children, that I am able to form these meaningful relationships with children so they can be successful and find their talents from within. Her love helps me navigate the discrimination I face. I want her to be proud of me and the work I do. I make sure I am a bridge, a comfort, a support for those I serve.

How I Became an Educator

I became a teacher because of the influence of my track coach. In the end, I became a physical education teacher. He thought it was a great idea to combine my two passions: teaching and athletics. There were politics aligned with becoming a teacher. There were connections that needed to be made. It was difficult to get into the educational system. For example, for some people, it seemed easier to be offered a teaching experience. And for others, they are told they need to complete steps one, two, and three. For those given direct instruction and provided background information regarding the need for connections, they seemed to identify as White. For those who had to "learn the game," they were often left on their own, and I happened to be one of them. I believe it's because I identify as a Black male. For those who were People of Color, the pathway to becoming a teacher seemed more difficult. We didn't know the rules of the game and rules often changed.

I was hired as an educational aide in a suburban elementary school. I had a horrible experience. The politics, the cliques, the unwelcomed feeling left me confused. What I thought it meant to be a teacher and what actually happened in schools seemed to be in direct conflict with my ideals. The children didn't seem to be a priority, and providing support for me as a new

teacher and experienced teachers, well, it just didn't seem to matter. I felt as though the district was not interested in helping me. I was considered "less than," even though I had a four-year degree, just because I was an educational aide for a child receiving special services. As far as People of Color, I think there were only three Black teachers, and I was one of them. It was a difficult road.

The difficulty did not lie in working with the child, the challenge was working with a teacher who did not seem to respect me as an educator. I felt used. It seemed as though this individual was more interested in having the school community perceiving the teacher as "someone who can reach out and serve children in special education." However, the child and I worked well together, and focused on what mattered most: providing support for the child and family to help the child succeed in school. It was quite unfortunate to know educators may use a child's diagnosis for promoting their own agenda. I felt the message was, "Look here, Black boy. This is our system and you either play along or you can leave."

The very next year, I was asked to work at the high school. I was coaching and sometimes, I think coaches are expected to work with higher grade levels. I am not sure school communities understand we can work with a myriad of grade levels, and can work together to meet the needs of our children. Coming from both worlds, coaching and teaching, there need to be efforts made to align our work with one another. Moving to the high school, I had to learn a whole new game. There, I had new rules, new politics, and I needed to navigate the system. At the high school, I didn't feel identifying as a Person of Color was perceived as much of a threat as in the elementary school system. In both situations, I am sure the leadership was aware of the underlying unprofessional and discriminatory practices promoted within the schools. In the high school, the school leader seemed to provide more guidance in understanding how to navigate these dangerous waters.

I realized no one wanted to hear my story or the story of the children I served. As an educator, I valued and still value the experiences, thoughts, and feelings of students. Like myself, they have a story to tell. In many ways, their stories define them as my story has defined me. Helping them distinguish more positives in themselves also helps me share my story and know they are not alone in this battle to navigate a system that doesn't really want to hear their story. The power of story is to give knowledge, and share their experiences and how they make sense of the world in which they live. Otherwise, an unknown story becomes a secret. And secrets can be dangerous if shared with someone who is not authentically engaged or truly cares about their lives. As a teacher, this is my commitment to this significant work: story matters.

Introducing Social Justice through Artmaking

Because of my experience in the university course, I utilized that space to consider what it meant to promote justice in schools. I understood sharing our first-tellings, understanding what this means to who we are and what we do in schools, well, story is critical to this work. Throughout this course, I was struck by how often I needed to look within and reflect on my lived experiences, how my identity influenced how I thought about the world, and how my meaning making shaped how I responded to the world around me. It was a process like no other. And in this reflective process, establishing a safe relationship with my professor was critical. When I felt safe, I was able to take risks and share what was on my mind without fear of judgement. It was the first time I felt as though I wasn't to blame for what went wrong in the world or told to just pull myself up by my bootstraps. Throughout this process, what I said, what I experienced, and what I thought about actually mattered. I cannot tell you what a relief that was to me and how empowering it is to know that for the first time, I didn't need to be afraid to speak my truth.

This truth played a central role in understanding what it meant to promote justice and equity in schools. And in the end, I realized the power of relationships in addressing justice issues. For me, this artmaking process is not about making art for the sake of making art. This process is about taking a step back, actually, many steps back when I stop and think about it, and understand how paths led me to where I stand today.

That amount of reflection and using what we learned about systemic oppression was unbelievable and overwhelming. I started to understand how parts of my identity intersected with others. I wasn't just a man. I was a Black

FIGURE 31.1
My artmaking

man, who was an educator, heterosexual, Southern Baptist, an aspiring school leader, progressive, an advocate for young men like me, a husband, raised by a single mom, a brother, a son, opening myself to be friends with everyone, someone who grew up in poverty, a first-generation college student, an athlete, and someone with learning differences. After I decided to focus on the intersectionality of my identity and how experiences, people, and society impacted how I understood myself, I made my artmaking about my journey as a Black male in a predominantly White world (see Figure 31.1).

Below is a copy of my artmaking abstract posted on the gallery all during the exhibit one year before bringing this process to my school.

Artist: Me
Artist Mentor: M
Title: Handling Adversity: A Puzzle of Personality
Social Justice Stance: The lack of understanding regarding systemic equity contributes to the perpetuation of marginalized populations in K-12 U.S. public schools.
Metaphor: Understanding is the missing piece in the puzzle of systemic equity in U.S. schools.
Nonprofit: Passages/Healthy Fathering Collaborative/DVCAC

There is something wrong with the U.S. public educational system. Right now, equal opportunity for all children is simply rhetoric at best (Marshall & Oliva, 2010; Scheurich & Skrla, 2009). I understand educational environments as opportunities to develop a positive self-image (Elfrod, 2002). In doing so, schools are mandated to create inclusive learning environments. What does that mean? Providing teachers with professional development opportunities that will enable them to increase cultural awareness with students from diverse backgrounds before they start handling classes on their own. This will help in ensuring that the graduate teachers will develop a culture of treating all students equally regardless of their race or ethnicity.

Underrepresented groups of children (i.e., Children of Color, women, cultures) should have their contributions and histories interwoven throughout curriculum (e.g., Geneva Gay, Lisa Delpit, Joanne Dowdy, Gloria Ladson-Billings). A culturally responsive curriculum considers differences that should be explored authentically versus designated time slots for acknowledging accomplishments (i.e., Black History Month, Hispanic History Month, Women's History).

What are the consequences of choosing not to interrupt these oppressive practices and policies? While the data indicates that African-American males are not performing well academically, data also indicate that they are affected

THE "RED R" KID: DISRUPTING MY DEFICIT-LADEN LABEL

by discrepancies in discipline, suspension, special education, and labeling. According to Hinojosa, 2008, African-American students are 2.3 more times likely to be suspended from school than the white students (Hinojosa, 2008).

My artmaking focuses on how I came to understand what it means to live as a culturally responsive leader. My personal journey begins with identifying as an African-American male growing up in the hood and having outsiders attend my neighborhood school. When I entered teaching, I shifted from living in the hood to working in an affluent school. I had to be two to three times better than my White colleagues to advance in my profession and to be respected by the community-at-large. This is difficult for me to discuss, because I feel uncomfortable describing my colleagues' racial identity (Lindsey & Terrell, 2009). As I reflect on this, it may seem like it's a me versus them. Some people say they do not 'see' color, but that suggests they do not see me. I see them. I hope they see me. And I hope my colleagues see their Whiteness.

Lived experiences alone do not help educators understand the inequities Children and Communities of Color face every day within U.S. public schools. My art making weaves my childhood, discrimination, and institutionalized oppressive practices embedded throughout my schooling and experiences as an educator. The weave represents the need to integrate the personal narrative, lived oppression, and systemic inequities apparent throughout my life. I had to learn how to navigate through an oppressive system, not by fear, but through a deeper understanding of self, family, and who I wanted to become (Elfrod, 2002).

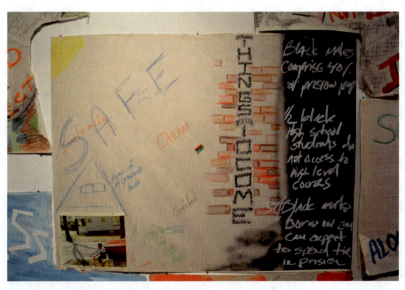

FIGURE 31.2 A young child

First, you see a young child riding his bike (Figure 31.2). That's me. I had no idea what demands would be placed on me. I was happy to be ignorant of the ideas that

would later become part of my anxiety and make me question my ambitions. My journey continues with deep thought of defeat, constantly second-guessing myself and asking the questions why, who, what and when? These thoughts, although I am a very happy and jovial person, raised my defenses causing me to always be on alert to defend and protect, while wearing a mask to navigate the rough waters. I chose to focus on educational progress as the ticket to move forward but soon discovered through constant battles, took joy from my achievements. I will not sacrifice my integrity, nor lose myself in the battle to enforce systematic equity. I am not a puppet and a checklist will not define me. My success was not truly recognized as success and was not acknowledged; yet my achievements are minimized. Why? So, now I sit asking why do I have to go through these obstacles? I feel defeated but continue to be the messenger. If that identifies me as a leader, then so be it.

In this section of my artmaking (Figure 31.3), "Why?" is a question I have always asked myself. I wonder why I continuously encounter discrimination. Once I understood the impact of systemic inequity, the school-to-prison pipeline, and historical social justice issues facing marginalized populations, especially those who identify as Young Men of Color, I realized I was onto something. I always had a feeling systemic inequity existed, but once

FIGURE 31.3 The system told me I didn't matter

THE "RED R" KID: DISRUPTING MY DEFICIT-LADEN LABEL 233

I entered my doctoral program, it became clear to me when I engaged in this artmaking. I learned in this course that I was NOT insane. I was NOT paranoid. I was NOT someone who deserved less. The multiple photos illustrate I am me and will always be me and I am proud of who I am and who I have become along the way. The brown smudge across the photos is symbolic of feces or shitting on the "little man" or those who the system chooses to keep oppressed.

Over the years, I had the opportunity to work in an environment that allows me to experience a specific lifestyle. However, that monetary compensation will never be enough to "buy" my integrity. This understanding is symbolized by the red dollar sign with a line through the center of it. I am committed to interrupting these unjust practices will remain at the core of who I am, who I was, and who I want to be.

I have continued to think about the obstacles I faced throughout my childhood and the challenges I continue to face as adult. This section of my artmaking focuses on how often people and society predicted I would be defeated and the effort I made in my mindset to overcome these deficit-laden beliefs and practices in school and society. I ask you: Who understands the passion I have to make sure other under-represented groups are recognized and have tools to overcome these hurdles? What do I want the individuals who are privileged to do to help recognize and stop the minimization? Wake up! When will this stop? But more importantly, what will you do to disrupt these oppressive practices and policies?

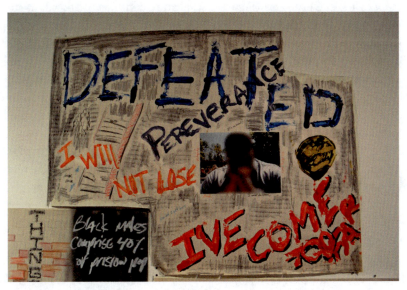

FIGURE 31.4 I will overcome

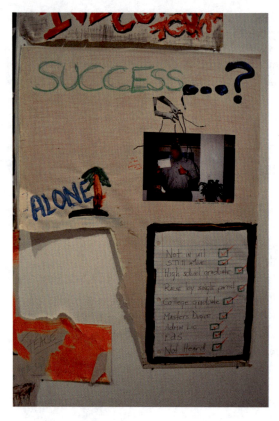

FIGURE 31.5
I am not a puppet on string

This puzzle piece of my art (Figure 31.5) clearly identifies the power of stereotypes and oppressive practices and policies that continue to impact me. And through it all, I was able to overcome these obstacles and attain success. However, these obstacles often led me into oppressive systems that left me feeling like an island. I was alone many times in multiple contexts attempting to navigate my way through systems dominated by the cultural majority. My lived experiences as a Black male identified as the "Red R Kid" runs parallel to injustices faced by Black youth who also walk in my shoes.

These realities are a call for social action. Want to be involved as an educator? If yes, then connect with "A Teacher's Guide to Rerouting the Pipeline," which highlights common scenarios encouraging young people into marginalized spaces and offers practical advice to dismantle oppressive practices. Here are questions for you to consider:

- How can school districts divert the school-to-prison pipeline?
- Increase the use of positive behavior interventions and supports.
- Compile annual reports on the total number of disciplinary actions that push students out of the classroom based on gender, race and ability.

- Create agreements with police departments and court systems to limit arrests at school and the use of restraints, such as mace and handcuffs.
- Provide simple explanations of infractions and prescribed responses in the student code of conduct to ensure fairness.
- Create appropriate limits on the use of law enforcement in public schools.
- Train teachers on the use of positive behavior supports for at-risk students.

Sharing My Artmaking with the Children I Serve

I shared my artmaking abstract with the children at the school. It was a humbling experience. I had no idea what to expect. I was the new kid on the block. These were kids who I could relate to because I was in the same situation when I was their age. I was not homeless or a ward of the state, but I understood what it meant to be an outlier. I understood what it meant to be isolated, because my peers growing up were not with me when I was learning in school. So many times, as I mentioned earlier, I was alone. I was taken out of class. And in this special school, so many of the kids were here because their experiences and understandings were often overlooked. They were ostracized by their schools. And often times, they were bullied. I began by telling them a little bit about myself. The room held about 50 students and I could hear a pin drop. They were interested in what I was sharing with them. They seemed attentive. I asked for volunteers and each volunteer held up a different part

FIGURE 31.6 Limitless

of my artmaking. I told the students, "I am sharing my artmaking with you because I want you to know a little bit more about me and understand what Christa will be working with you on this year." After sharing so many of my lived experiences with the students, I continued to scope out the audience and try to get a feel for their understandings. They really connected with my artmaking. It made sense to them. I told them a little bit about Jean Michel Basquiat and how he was the artist who inspired me to do my work. Basquiat's work provided his audience with opportunities to experience art at a new level. It seemed primitive, as though anyone could engage in artmaking. However, although his art may have looked primitive or simple, Basquiat's work was symbolic and powerful. I tried to share that same power with the students as I described my lived experiences as a young Black male who was identified as the Red R Kid. The students raised their hands and offered their insights. Their comments ranged from "that's really cool" to "I like the pictures" to "I learned so much about you and I don't even know you" to "that took courage" to "thank you for sharing this with us" to "no one has ever done anything like that before" to "do you think I could actually do that?" and other comments regarding the symbolism within my artmaking.

The presentation became the foundation for their work with Christa. She continued to work with them as she worked with me. Christa asked questions and then more questions to help each of us critically examine our journeys. I can't begin to tell you how many hours Christa spent with me as a graduate student trying to help me think about ways to translate my lived experiences into artmaking and how many opportunities she afforded me to dig deeper and think about how my experiences influence my understandings as an educator, activist, and school leader. I explained to the students Christa would spend time with them throughout the year learning more about each of them and providing them with spaces to learn more about themselves and what mattered to them. So many of the students were excited to work on their artmaking. They wondered if they would work on the same project as I did or if they would experience something new. I reassured them their artmaking would be a new experience. Christa reiterated the importance of their voices and how their understandings would play a crucial role in their artmaking, because they were going to help educate teachers and school leaders around the word. Christa noted, "You will have the opportunity to help us know what we are doing well and what we may need to consider when working with students, especially students who receive special education services."

From that moment on, artmaking as sensemaking was no longer some abstract idea. It was a lived reality for an entire school year. I was afforded efforts to mentor students and I continued to share my artmaking with the

children as well as reflect on my own experiences. The artmaking itself was a moving process. It moved me emotionally, physically, socially, and cognitively. I thought differently about myself and discovered things I had obviously tucked away, such as the Red R Kid. I still to this day cannot believe I forgot about that aspect of my life until I engaged in this work with Christa. The critical reflection and understanding what moved me to think in new ways influenced my artmaking as well as watching the students engage in the same life-changing process. I was not the same man I was when I completed my artmaking. I was transformed, and so too were the children. They were different: confident, articulate, courageous, and vulnerable. I never saw anything like this before. As an educator serving over 20 years, I can tell you, this experience turned my world and our kids' worlds upside down and then back around. They were activists. They were children who were silenced and found their light through their artmaking as I found mine.

References

Elford, G. W. (2002). *Beyond standardized testing: Better information for school account-ability*. Lanham, MD: Scarecrow Press.

Kohn, A. (2000). *Case against standardized testing: Raising the scores, ruining the schools*. Portsmouth, MN: Heinemann Press.

McNeil, L. (2000). *Contradictions of school reform*. New York, NY: Routledge.

Scheurich, J. J., & Skria, L. (2003). *Leadership for equity and excellence*. Thousand Oaks, CA: Corwin Press.

Schilling, K. M., & Schilling, K. L. (1999). Increasing expectations for student effort. *About Campus, 4*(2), 4–10.

CHAPTER 32

Living the Dream

M

I grew up in the projects, which is known as GV. Growing up, I knew society looked at people like me as the "throwaways." How did I know this? People outside of our community never took time to know us or investigate what was *really* happening in the neighborhood. We were just the "throwaways." I easily related to the students and their artmaking, because I too was a throwaway like the students and one of their teachers who shared with me his experiences at school. The artmaking has a powerful impact on the students and all of those involved. I am a supporter of the arts and have witnessed the way the arts can influence the lives of kids as well as a community. And in this case, the children at this school were changed for the good through engaging in the arts and making sense of their lived experiences. For me, I didn't have these opportunities. I grew up in the projects. For me, the arts were not available so I turned to athletics to overcome the belief that I was society's "throwaway."

In my community, society thought we did not have the means to live on our own. They also did not believe we were qualified to be employed. So many of the people in our community were unemployed, and were poor, not because they couldn't do, but because they didn't have the means to do for themselves or their families. That's the difference. It's having the support and resources to better themselves. It seemed easy for society to turn a blind eye to what we were living in the projects.

In our neighborhood, there were two pathways you could take. One, you could be involved in a life of crime through gangs, drugs, prostitution, or stealing. Or two, which was a very small group of people, you could try to make it out of the projects without involving yourself in prison. For me, I realize what contributes to young kids choosing a life of crime when you live in the projects. All you see is poverty around you. You are so isolated socially and emotionally; and yet, the only way you see the rest of the world is through the media. Growing up, you look at what you see on television as society. The media is society. Media tells us what we are supposed to value and aspire to; and with this in mind, the media tells us we all can have a piece of the "American dream." Commercials and advertisements depict what it means to "make it" in America, what it means to be successful, and all of the material resources you

LIVING THE DREAM 239

must gather if you want to be "one of them." Otherwise, you are excluded from society. You remain a "throwaway" like I noted earlier.

The notion of "living the American dream" attempts to tell young people you have made it when you: (1) live in the suburbs; (2) hold an ordinary job; (3) have the "correct" financial portfolio; (4) made good investments; and (5) have a wife and family you can take care of. And who are these people who are deemed "successful" and "living the American dream"? These people are White. And that's all I saw growing up in the media. I never saw Black people making it. I never saw a successful Black person on television or in an advertisement who "made" it.

The media has an overwhelming influence on the minds of young people. Why? Because the media can make you feel like this is what you can have, and that is simply not as easy for some people versus others like the people I grew up with in the projects. And when you start to realize this is not how you live, these are not the schools you attend, and these resources are not available to you, then you can start to feel excluded. Yes, they can make you feel like you don't belong there. You don't belong in certain neighborhoods or in the suburbs or in certain schools or can wear certain clothes or have certain experiences. You are excluded because of where you live, who you call family, and who you are. This is the injustice so many young Black people face, especially in the projects.

And when I think about what it means to live the American dream, when I think back to who is seen on these commercials, none of these people looked like me, talked like me, and therefore, I knew, they must not be considering me as someone who should have access to those resources. When I think about the possibility of being a "throwaway" today, with the outside influences kids have today, it's really the roll of the dice. There are so many influences that can take a young person down the wrong or right path; and for the kids living in the projects, if they don't have someone guiding them along the right path, which is more often than not, then they don't stand a chance. It is really about society creating this pipeline, this pathway, this vicious circle of poverty and crime, so good luck breaking out the projects.

This pipeline, this vicious circle is something created by society and thrives in the heart of the projects. That circle is lives and thrives in these neighborhoods. It's a process. We send kids to certain schools; keep them socially isolated from the rest of the world; limit their access to resources; tell them what they need to be "successful"; some kids believe they are nothing unless they have "these things" by any means; kids commit a crime trying to be recognized by society; and then, the criminal justice system gets them on the books. Now, the kids are put in jail and the system creates a file. Now, the kids are in the

system. They get used to jail. As they spend more time in the system, because good luck getting out of there, they just get harder. The same people who started out as innocent children just trying to be accepted, valued, and recognized by society find themselves in a system in which they become harder criminals. And when you are with criminals themselves day in and day out, all that happens is hardened criminals share stories with each other about ways to commit future crimes in better ways without getting caught.

What role does society have in helping youth living in the projects break through this cycle? Is this society's fault? I know this: We, as a society, need to do something about millions of Young Men of Color who are in prison. We are the wealthiest industrial society, and yet, we have the most Black and Latinos in prison in the world? I realize the millions of Black males who are in prison is a problem. It's almost as though society is creating a pendulum. Society seems to make a concerted effort to separate people, especially Black and Latino people. As long as society separates people and places certain groups on the dark side, the side that desires this infectious American dream, then will have young people attempting to figure out ways to make it or hustle. What we need to do is bring people together. We need to share resources, but if we don't do that, and continue what we are doing, then the people who are profiting from privatizing prisons will continue to gain from efforts to make a larger pool of criminals. Knowing seven million people are in our prison system is criminal, but the people involved in making this a possibility, of creating this school-to-prison pipeline a reality, don't seem to care about what is happening to our young Black and Latino men and women. This is not the right way of addressing what happens across this country in the projects. We aren't solving anything except figuring out how to keep the rich safe and putting people, like the kids from my neighborhood, in jail.

I was a kid who grew up in the projects, but my friends and made it out. The odds were stacked against us, but we made it out of there, but let me make this clear, we did not make it out on our own. We made it out with the support of our families and friends; and those friends I call my brothers. Every day we were either outside playing as a group or inside moving from home to home playing Atari or other video games. We ate dinner at each other's home, spent the night, worked on homework together, and never let anyone fall to the wayside. We were brothers. Our families knew one another. Our neighbors knew one another. And if anyone thought about getting out of line, well, our families knew they needed to take care of business as though they were our parents. It was a supportive neighborhood with everyone looking out for each other. No matter what the media said or still says, that's how it was. You don't get out of the projects on your own. You need resources. And if society wanted

LIVING THE DREAM 241

to turn the other way and exclude us, we needed to make sure we were invited to the table.

I realize now, not everyone had what we had growing up. Not everyone had two adults under one roof. And although we had small homes, I mean very small homes, these were our homes, and we would crowd in and be a family made up of friends and relatives. However, most people in my neighborhood did not have what I had. They didn't have families who supported them or friends who chose the paths we chose. Many people were just doing

Growing up, and looking back at my life in the projects, no one ever took time to find out what was going on in my neighborhood. Since society didn't pay attention to us, we took care of our own business. Unfortunately, this is the way the world works. It's reality for so many people living in poverty. Blame is placed on you for not pulling yourself up by the bootstraps, but some people don't even have access to straps.

In my neighborhood, there were two groups of kids: (1) the group who committed crimes and (2) creating our own family within our own environment and build a protective wall so we could make it. Those who wanted the nice clothes, cars, and jewelry, well, they ended up in a life of crime. Why? Because they did not have the guidance or support of people or access to resources that would help them understand what it means to be successful or how to reach your goals. My friends and I were not motivated by what we saw in the media. We were motivated by sports.

My friends and I created neighborhood sports teams like basketball and football. We didn't know at the time these teams, dreams, and drive would save our lives. I cannot think of day we were not outside playing games against each other and in other communities.

We made our own leagues. We played every sport imaginable from football to basketball to baseball. Every season was covered so we would stay focused and on the right path. My friends and I were extremely creative. Our families supported our imagination and commitment to our neighborhood team.

As young men, we became our role models, our favorite sports team members. We were the professionals we watched on television. Each of us chose a professional football player. That person's name was now *our* new name. We found a way to contributed monies, put them together, and had a jersey for each one of us. My friends and I dyed these jerseys. We made sure our professional names were on the back of the jerseys. We became these professional athletes every day when we played together. This is what we did, because no one was looking out for us, except our families.

We made our own football organization every fall and winter season. During baseball season, in the spring, my dad organized a baseball team in the

projects. I will never forget that about my dad. He was there to help us form an actual league. There were eight or nine of us that year. That team, that official baseball league protected my friends and I from the criminals and the negative activity. And even though society continued to turn a blind eye on us and our community, we continued on the right path.

No one from the media ever offered to write a story about my dad or my friends and how we made our own league; rather, they sure did know how to make their way down to the projects and broadcast a stereotypical side of what it meant to live in our community. Every day the media was down there capturing every crime someone committed; but not the good things, no, the media couldn't have any part in that. Why? Because it was easier and profitable to keep the negative stereotypes going, and to keep the school-to-prison pipeline open.

I called the world we created our bubble. The media wasn't interested in our bubble nor was society in general. But we invested in our daily lives and in our future. This neighborhood sports league took us through elementary school and junior high. It saved our lives.

We didn't play on school teams, because none of our schools offered sports as an opportunity. However, when the time came for us to have access to formal athletic teams, we were ready when we entered high school. Everyone in our neighborhood went to south high school. My friends and I participated in sports, because that is what helped us stay on the right path.

In 1985, when I entered 10th grade, I moved out of the projects. In 1986, I transferred to Unknown High School. It was hard to play against the guys I called my brothers, because we grew up together. And despite being on separate teams and competing with one another, we honored each other and remembered where we came from.

It is important for you to know each and every one of us made it. We disrupted the title assigned to us as young people living in the projects: the "throwaways." What does that mean? We made it out of the projects. My friends and I never went to prison. All of us have professional careers. My friends and I used our bubble, and in our case, our neighborhood sports teams, to protect us from the crime and negativity that surrounded us. We called on one another and our families, and we made it through.

In my life, that neighborhood childhood sports team was the foundation for every decision I made in my life. I am not kidding. Athletics and what I learned through being a member of sports teams means everything to me. Today, I use it as a platform to teach. And in regards to my family life, I preach what I learned to the next generation, which are my own kids. My daughter is a starting guard, and my son plays sports too. My wife played basketball at a state university and I played at another university.

LIVING THE DREAM 243

From a family's perspective, our theme as a family is camaraderie, respect, competition, and succeeding. That is what the concept of sports does for our family. Knowing sports the way I do and living what I lived, I don't think I would have made it out. I don't think I would have been strong enough to handle what I handled as a kid if it were not for sports. I was a "throwaway" or so society said, but as the children here used artmaking, I used sports to express myself. For me, sports was my artmaking.

As artmaking is used for the students here, I used sports as my art. Sports in an art in many ways. It is a physical expression and passion of expressing myself. I know I could never have stayed away from drugs, gangs, and prostitution, if it wasn't for using my imagination and creating those sports teams. We filled our heads with becoming the athletes we admired most. And for my dad, bless his soul, he gave me what I needed to make it through. He passed away when I was in high school. He was a positive force in my life. I kept everything I have from my early days in sports and with my dad. He created the first little league team in our neighborhood. And I knew, at an early age, I envisioned using my talents eliminate that title of being a "throwaway." One day, I knew I would make it in professional baseball. And one day, I did. I made it into the major leagues. I played for a professional baseball team that experience helped me get to where I am now as mayor. I played for this team and traveled the world.

My success was determined by being a member of a cohesive group. All of my friends and I had two-parent families. I don't know if that was the difference, but I know we all had moms and dads in our families. My friends and I were all family-oriented. We met over at each other's houses. On any given day, you would find nine or ten of us piled into a friend's house. Even though they were such small spaces, we crammed in and made it home. We spent time playing video games and having fun with each other. Even though we played hard, the atmosphere was always peaceful competition. I attribute our attitudes to sports.

We all realized whether we played little league or the big leagues, we needed the same things. All of us needed to a place to call home; a place where we could use our imagination; a place where we could be free; a place where we could feel safe and loved; and a place where we could grow together, because these were my brothers. To this day, my childhood friends, my brothers, attend each other's weddings, special occasions, and support each other. I cannot explain what specific element glues us together, but I know they are my brothers and we are there through thick and thin.

When I got into the major league, all of my friends came to the games. They actually saw me play. I remember coming out after a game with a good outing.

I saw all of my friends from the projects in the stands supporting me. I cried. Memories of my brothers walking five miles as a band to practice flooded my mind. I remembered winning and losing games as a band. Those times held me together and helped me be the man I am today.

It's funny. Just yesterday, I met with a great baseball slugger. I did not remember he was the speaker when we won our city championship in 19XX. My buddy on Facebook reminded me of that. Those times were crucial to me making it today.

I also have a couple letters from the mayor from that time. I ran into him recently. We had such a connection. I couldn't figure it out at first, but he too was there for our city championship banquet.

When you put good things out into the world, I believe, good things happen. Because if you stop and think about it, Black pitchers never make it into the majors. Because one, you have to be 6' 5" and White and throw the ball a hundred miles an hour. I didn't fit that mold. There were whispers made about me and not fitting the stereotype of a major league pitcher, but I made it despite the odds.

Back then, there weren't Black pitchers and now, there aren't many either. I didn't let society's perception of me as a throwaway stop me from becoming what I envisioned for myself. I kept my mind on the bubble, and had a vision. I used the laws of attraction to get me to where I wanted to be. And it worked.

Throughout my life, I learned how to make things happen. However, I am not here to tell you it was easy, because it wasn't. It was and still is hard to screen out discrimination you live with. You constantly tell yourself it's not there when you know it is. Those messages of being told you are a throwaway try to creep in, but I don't let them. I have a vision for myself and I do whatever I need to stay focused. It's the law of attraction. That's how it works. Whatever I wish for myself, I need to see myself doing. I need to feel it and experience it in my mind. And when those negative attitudes about me, my neighborhood, and growing up try to reign in on my vision, I can't say it's easy, but my vision trumps it. Doing this, well, it is difficult sometimes. Why? Because, if you are not "perfect" or do not seem to possess all of the "necessary qualifications," then there is a chance you may achieve what you desire. However, who would have thought someone like me, a kid from the projects, would be a major league pitcher and now, mayor of a city? Who would have thought this when we were playing football as kids and wearing the jerseys of our favorite players?

Today, I am a mayor. And someday, and I mean someday soon, I want to be a general manager in the major leagues. Why? There have only been two or three Black managers since baseball started. I realize baseball will still have its

LIVING THE DREAM

problems growing the game, and race will be an issue, but I will be a general manager someday.

I have government experience, executive experience, a small business owner, and an education, but I am still not qualified because of the color of my skin. I try to fight this off and where my blinders, but as a Black male, I don't have enough power to fight it off. It will always be there.

I think their art was powerful. The students used art to create spaces to understand how to navigate difficult waters and to reflect on the impact these difficult waters had in realizing who they were and who they became. There is no color on it. There is no color on art. These artists are their lives and their experiences. They made sense out of these experiences and translated all they understood and felt into their art. It was an expression of self and it is and was all they had. The beauty of this artmaking was the reality they may have faced for the first time: They could not get persecuted for having an expression. Art was a way of healing. They looked deep within and discovered things about themselves. They made decisions about what they would and would not share with the world. And in the end, each and every one of them made the decision to be courageous. They made the decision to become their art and their art became a part, if not all, of who they were as young people. Different people have different ways of healing themselves, and in this case, the children were given the green light to explore with eyes wide open. I think the students used their artmaking to heal. I think people can heal through art. The process seemed to allow them to grown within. They were able to stabilize what is, and then they had the capacity to use their artmaking to get a result. And in their case, the result was exhibiting to over a thousand people and write these chapters to help teachers and school administrators around the world understand what they may need to do differently to serve students in special education.

And this is similar to me. People make judgements or assumptions about me as a Black man who is a mayor of a city. I am more than my skin color and my title of mayor. I am also a craft wine maker. I make apple, peach, wines. And what excites me is seeing a five -gallon barrel, sugar, mesh, and yeast go through a process that creates sugars into alcohol, which is wine. That creation helps me cope with stresses. I like to process in a way that gives me energy to see a creation of anything.

I thought the art abstracts were right on target. I share the same views about how we are perceived from a societal perspective. It is unfortunate to know one person cannot change the world. What we can do is to become a person people like to see and to become a respectable individual. I think their art can inspire people and pave new roads by taking your journey in a way no one

else may have considered. You can catch people's eyes and help them recon-sider the negative thoughts that might be in their heads about marginalized students because of their ability, race, class, or other differences.

I am on a daily fight against kids trying to be like other kids. The baggy pants thing really urks me. I just want kids, especially Black kids to know I represent them and they represent me. It's not only embarrassing for me, it is embarrassing to our people and takes us back. People make judgements on what they see.

When I think about what these kids have endured, I realize I didn't experi-ence any of this in school. I don't know if I ever experienced direct racism. Maybe in sports, but direct discrimination, and I didn't want to and I don't believe I did. I did, however, experience it vicariously through others.

When you are on a journey, just like artmaking, and my first years out was to be a major league baseball player, there are so many unknowns. I never thought I would travel the world. I have seen so many different cultures and people who look like me. I can't really can't say I experienced this outside of base-ball. I went to a southern state before I went to another university. There were real American Indians and people from all over the world. I didn't experience it. I think I put on blinders sometimes. But no one can stop me. This is why I had a 17- year career in baseball. I played in other countries on exhibition games. I played baseball on both ends of the world. I never thought about rac-ism or being discriminated against never came up. I did experience something in Asia. I had the best ERA and most strike outs and there was a player of the month. He gave it to the White guy and this guy's numbers were nowhere near mine. Being in Korea, I don't know what it was called. Is that discrimination? It's just life.

We need to create arts-based curricula to allow children to use their vision. They need to be able to have spaces to think about their lives and imagine pos-sibilities. I think our curriculum is too focused on test scores versus creating a platform where people can use their minds appropriately. Students need to meditate, visualize, engage in creativity, and develop a strong spirit. I believe these are key to success. You create goals and plans within those things. And when considering my journey and what helped me, with regards to the law of attraction and wanting to be a major league baseball player, with 13 years to get to the big leagues, there was nothing else short of that, and released four or five times, well, I came back. And in 2000, I finally made it to the major leagues. If I didn't have this in mind, to dream about them, and to constantly work on these things, I would have fallen off the wagon a long time ago.

Kids don't know how to really use their minds. And using art to make sense of their world can seem quite far-fetched, especially when you are in schools

LIVING THE DREAM 247

where art is not afforded to you or it is predetermined and closed to new ideas. This artmaking provided children who were often "thrown away" with an outlet to visualize something new, something far-reaching. And since the arts play a pertinent role in a child's understanding of himself, arts-based programs need to be available for all children, especially those who are considered the "throwaways."

CHAPTER 33

Afterword: The Power of the Artmaking as Sensemaking

Christa Boske

We struggled, Miss Christa, but it was worth it all because we are artists and that's what artists do, right? They work through their stuff and their art is who they are. We had something important to say and people need to listen.

∴

Arts education engages the imagination and provides opportunities for people to realize the deep connection to and responsibility for lived experiences and relationships with self with others (see Eisner, 2002; Gardner, 1983; Green, 1995). For these authors, artmaking as sensemaking plays a critical role and provides unique contributions to their cognitive development as well as opening their minds to imaginative possibilities of self and self to others. Eisner (2002) argues artmaking fosters aspects of cognition in two ways: authentic engagement and sensory development. Nurturing authentic imagination has the capacity to cultivate critical thinking, and this thinking has the ability to transform shared representations into imaginative possibilities. These transformations often lead to new creations. The arts also play a role in developing individual sensory capacities. Authors perceive their lived experiences and critically considered the extent their meaning- making influences their ways of knowing and being. For example, seeing, recognizing, or observing is passive. However, seeing, as a means of engaging in understanding an individual's feelings or making sense of lived experiences, was considered an active learning experience. Youth's sensory perceptions translated into artistic productions that provided them with unique ways of seeing, knowing, and responding. The artistic process carefully considered their values and school community characteristics as well as their academic and personal needs.

Youth identified as "less than," "those sped ed kids," and/or "throwaways" due to deficit-laden labels given to them by prior teachers, peers, and community members. Adolescents came to understand artmaking as a sensory-based constructivist-oriented pedagogy. The process deepened their understandings

AFTERWORD

of their lived experiences in special education and the role they played in addressing these oppressive conditions in schools. Each author utilized artmaking to demonstrate how they understood their sense of self, how this sense of self influenced their relation of self with others, and how these relationships impacted their learning. And although most teachers in this book often struggled initially with constructing tasks that afforded learners with authentic productions, all of them emphasized artmaking not only played a fundamental role in representing students' ideas, thoughts, desires, fears, and lived experiences, but influenced their capacity to learn in school. Therefore, artmaking became a tool for not only sharing first-tellings, but actively engaging students in developing critical consciousness and a stronger sense of self. Each adolescent engaged in complex representational tasks throughout their artistic productions. These productions provided them with a social justice framework for demonstrating how they made sense of their lived experiences and how these lived experiences impacted their sense of self as learners within an oppressive educational system (see Cox, 1999; Eisner, 2002).

Initially, teachers and school leaders in this book did not make a direct link between an arts-based curriculum and thinking skills. Math, science, language arts, and other subjects were not aligned with students' lived experiences or organized to deepen their understanding of the world. Learning shifted from being standards-based to incorporating arts-based pedagogies to integrating lived experiences to examining the ability of teachers to teach in these new ways. The climate of the school began to impact the way in which teachers worked with students and students worked with teachers. School community members expressed their emotions, understandings, and courageously engaged in meaningful dialogue regarding their personal growth. Youth discussed the influence of hidden expectations within their schools, especially for children receiving special education services, and the influence of explicit and implicit curriculum: what is taught and not taught as well as what is included in their lives at home and school. Students came to understand that the arts play a critical role in learning; and the absence of the arts might suggest that these pedagogies are not valuable. However, for these learners, artmaking shaped the climate and culture of this school community. Together, they interrupted a common misunderstanding of artmaking, which often centers on the belief there is no time for the arts, because students "have so much to learn" and teachers are restricted by meeting and exceeding state standards.

This school community came to understand the extent the arts aligned with their curriculum standards and how often they exceeded state standards. Let's be clear: artmaking as sensemaking was not one lesson or a planned one-time school-wide event. Youth were provided daily opportunities

to engage in their artmaking to address their inquiries through limited materials. Over time, children engaged with their artmaking and became acquainted and comfortable with artists' materials as well as ways to navigate their challenges.

Youth assert current curriculum and pedagogical decisions often endorsed by schools, especially in special education, do not focus on promoting cognitive development and critical thinking skills associated with the arts. Teachers and school leaders came to understand artmaking as a social justice pedagogy to support not only student cognition and activism, but a student's capacity to utilize their understandings to engage in meaningful work. Throughout their artmaking, children took advantage of their unanticipated developments and surprises of uncovering a new sense of self, discovering relationships between self and others, and authentic connections with the general public (see Eisner, 2002). Their artistic productions played a critical role in finding connections among their lived experiences, meaning-making, and artmaking. These connections altered the way in which they understood themselves and others.

Each experience utilized their personal narratives as a conceptual centerpiece. Students' lived experiences, knowledge, and artmaking offered a process and fluid rules of practice. Their artmaking revealed a myriad of strategies and methods within the use of these diverse elements. Without the critical reflective process, a deepened awareness of the conceptual nature of the student's artmaking may have been lost. Their attention focused directly on actively engaging in the process itself. Their artistic productions served as reinterpreted identities within diverse contexts. As children engaged in these artistic productions, they came to understand and demonstrate a deepened locus of knowledge from within (see Salomon, 1993). This understanding influenced how they made sense of their lived experiences and how these lived experiences impacted their own learning of self. Their artmaking evolved from critical dialogue to artistic production to action and self-transformation. This artistic process externalized adolescents' robust understanding of their learning of self as individuals and activists who wanted to transform the way in which school communities engaged with them as learners, as activists.

This artmaking production provided a rich context for understanding the role external representation played in transforming children's attitudes toward self as learner, self with others, and self as a social justice activist. Their ideas, thoughts, desires, fears, accomplishments, and other ways of knowing were transformed into visual art that eventually converted their mental images and emotions into external representations (see Eisner, 2002).

cultural, personal, and societal narratives. Authors were free to create throughout their artistic productions. Their work attempted to cast their transformed selves in a comprehensible, memorable, and shareable way (see Olson, 1990). Their autobiographical experiences promoted representational opportunities that engaged this school community in self and organizational identity exploration. They actively participated in constructing external representations of self, which were intimately connected to their sense of self, self with others, and self with society. Their artmaking gave students voice and provided them with opportunities to represent a myriad of marginalized groups in public spaces.

Teachers, staff, and school leaders played a vital role in this process. They were open and flexible to not only integrating artmaking as sensemaking throughout the curriculum, but provided opportunities for students to express different perspectives. Students were also provided a myriad of art materials and media in their classrooms. As adolescents deepened their understanding of self and engaged with their teachers and staff members, students experienced a rebirth. They perceived themselves in a new light, spoke of hope and imaginative possibilities, gained self-confidence, and formed relationships with their artistic materials. Students explored how to transform these materials into authentic meaning-making. Teachers and staff inquired about the ways in which youth made sense of their world; and in turn, adolescents shared their insights with them. These exchanges encouraged meaningful thought and fostered caring relationships. As students increased their capacity to know and share their meaning-making, they experienced a deepened level of intimacy and love for self and others. Adolescents witnessed a transformation of mind, body, and spirit. This transformation impacted not only how they understood themselves as learners, but as friends, family members, and citizens responsible for contributing to something larger than themselves.

Their artmaking moved people in unexpected ways. Authors hope this book plays a significant role in promoting a progressive educational movement: bringing much needed attention to structures and linguistic interactions within this integral process, aesthetic responses, and learning. Teachers, school leaders, and staff may need to pay closer attention to artmaking as sensemaking. They may begin by recognizing artmaking as an authentic complex cognitive mode of thinking and being.

Students are story-telling organisms. How they draw meaning from their world is embedded in their ways of thinking and learning. Youth remind us their sense of self must be nurtured. They contend artmaking is an extensive and pervasive holistic curriculum that has the capacity to foster intimate connections that nurture the whole child.

AFTERWORD

This fundamentally creative process provide youth with a new level of intimacy. Artmaking afforded them with opportunities to deepen their ways of knowing, recognizing their potential, engaging in convergent and divergent thinking, and constructing mindful authentic artistic representations of self as learner. Throughout the process, they deepen their understanding of potential, which requires convergent and divergent thinking. Ultimately, an individual engages in constructing mindful, authentic artistic representations of self as learner. The strong parallels between lived experiences and creative acts of artmaking as sensemaking provide all those involved with opportunities to create meaningful constructive images that pay close attention to their personal journeys. Their narratives were often representative of something else and constructed from symbolic materials (i.e, shoes, stones, mirrors, clocks, human figures, lyrics), all of which, were metaphorical (see Siler, 1990). Their artmaking represented ideas and their work implicitly relates to a myriad of lived experiences. Throughout the process, their metaphors (i.e., shoes used in their artmaking) are weaved throughout their new understandings of self, self to others, and self to society.

Adolescents, teachers, and school leaders also recognize the extent these artistic productions were guided through scaffolded instruction. We began with open-ended conversations regarding students as learners, the power of relationships, the sharing of first-tellings, engaging in the creative process, working with meaningful images, and eventually, publicly sharing their artmaking.

Authors assert artmaking as sensemaking needs to gain recognition within teacher and school leadership preparation to engage them in authentic social justice-oriented work. Artmaking has the capacity to provide children with opportunities to create artifacts that demonstrate their evolving understandings of self, first-tellings, and symbolic new understandings. The discourse creates a social and emotional latticework including story, imagery, and text (i.e., blended, arranged, and rearranged). Artmaking as sensemaking, therefore, emerges as a mind-thought-altering pedagogy in which learners utilize their artistic productions to deepen critical consciousness, ways of knowing, and ways of being. The representations themselves and the discourse generated around these representations afford school community members spaces to explore the relationship of self, school, community, and marginalized populations. The multimodal representations are sophisticated, mindful artistic representations that capture autobiographical first-tellings, ways of knowing, and ways of responding to injustices often faced by disenfranchised populations.

This artmaking was especially potent as students continued to emerge as independent voices. Their artmaking became a negotiation among the

References

Cox, R. (1999). Representation construction, externalized cognition and individual differences. *Learning and Instruction, 9*, 343–363.

Eisner, E. W. (2002). The state of the arts and the improvement of education. *Art Education Journal, 1*(1), 2–6.

Gardner, H. (1983). *Frames of mind: The theory of multiple intelligences.* New York, NY: Basic Books.

Greene, M. (1995). *Releasing the imagination: Essays on education, the arts, and social change.* New York, NY: Teachers College Press.

Olson, D. R. (1990). Thinking about narrative. In B. K. Britton & A. D. Pellegrini (Eds.), *Narrative thought and narrative language* (pp. 99–112). Hillsdale, NJ: Lawrence Erlbaum Associates.

Salomon, G. (1993). *Distributed cognitions.* New York, NY: Cambridge University Press.

Siler, T. (1990). *Breaking the mind barrier: The artscience of neurocosmology.* New York, NY: Touchstone.